IMAGINARIUM _

The Process Behind the Pictures

—

Claire Rosen

rockynook

Imaginarium: The Process Behind the Pictures
Claire Rosen
www.claire-rosen.com

Project editor: Ted Waitt
Project manager: Lisa Brazieal
Marketing manager: Jessica Tiernan
Copyeditor: Robyn Thomas
Proofreader: Valerie Witte
Layout and type: de.MO design / Giorgio Baravalle
Cover design: de.MO design / Giorgio Baravalle
Cover image: Claire Rosen

ISBN: 978-1-68198-198-7
1st Edition (1st printing, December 2016)
© 2017 Claire Rosen
All images © Claire Rosen unless otherwise noted
Copyright © of photographs in the *"Artist Interviews"* section
belong to the artist on record.

Rocky Nook Inc.
1010 B Street, Suite 350
San Rafael, CA 94901
USA

www.rockynook.com

Distributed in the U.S. by Ingram Publisher Services
Distributed in the UK and Europe by Publishers Group UK

Library of Congress Control Number: 2016941047

This book is printed on acid-free paper.
Printed in China

rockynook

*For my parents
who instilled in me a sense of wonder & adventure
then made sure I've never lost it.*

TABLE OF CONTENTS

INTRODUCTION

*A*nyone who has ever tried to make something has experienced both the frustration and the rewards that go hand in hand with the process: the elusive nature of creativity, the search for the muse, the gut-wrenching disappointment when things don't go as planned, and the moment when vision and execution coalesce into a magnificent, finished piece. I found photography in my early years at Bard College at Simon's Rock. Photography gave me a voice and outlet for expression. The artwork born of that journey shaped my identity and my life. Through *Imaginarium: The Process Behind the Pictures*, I hope to share the gift that the process of making art and photography has been for me by describing a path toward a fulfilling and sustainable art practice for readers.

Creative thinking and imagination combine to form a fundamental skill set that is useful across all fields and industries. This skill set is leveraged to solve problems and make improvements, big and small. Creative endeavors are not limited to the traditional idea of "the Arts," but exist in any field requiring cognitive engagement. Although photography is my personal medium, you can apply many of the concepts in this book to other creative pursuits, as well as to your day-to-day life. Employing creative thought while problem solving daily issues and obstacles will open up many possibilities.

NOTE: Rarely is there just one way to do something. In photography, as in life, charting your *own* path is the surest route to sustained success. Rather than providing a step-by-step primer on how to replicate my pictures with quick tips or tricks, this book illustrates a way of thinking about your *own* work holistically, with a goal to integrate "creating" into your daily life and encouraging experimentation. Some advice will resonate and some will not. Embrace what works for you and leave the rest.

The advice I give comes from a variety of sources, in addition to my personal experience. I explore insights from experts in a range of disciplines and include writings and personal guidance that have been most helpful to me. Where possible, I include links to original sources to allow more in-depth reading on each topic.

This is not a technical book. Many people believe they have mastered photography once they have conquered an

understanding of the camera, lighting, and computer software. Understanding equipment and mastering the skills to use it properly is fundamental to expressing yourself freely, uninhibited by technical blind spots. However, it's the *storytelling* that makes imagery compelling. With that in mind, this book focuses on crafting compelling imagery through idea cultivation, concept development, previsualization, pre-production, efficient productivity, and problem solving.

The ultimate goal is for you to imagine images that you care deeply about—deeply enough to do all it takes to create them. It's not always easy. It will take time and effort, and there are no shortcuts. But it will be worthwhile.

On Art

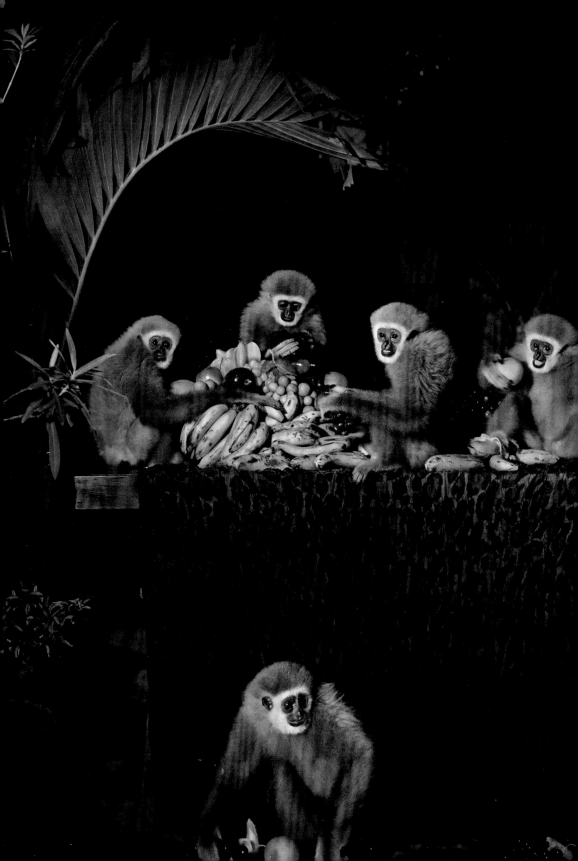

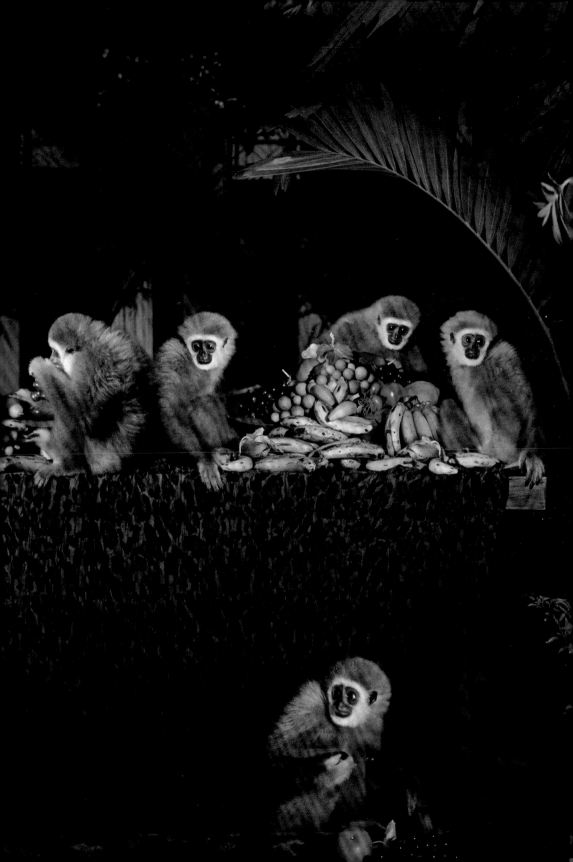

THE PURPOSE OF ART

Since the dawn of civilization, the Arts have been the physical expression of the ideas of each age, giving form to its realities, aspirations, and fears. Although art isn't necessary to basic human survival, it's much more than an indulgence. The creation and appreciation of art and beauty are essential transcendent experiences for mankind—a testament to what it means to be human.

Art [...] is a reminder of who we really are,
or perhaps who we ought to be.

And life [...] is what we find when we slow
down and allow the
 BEAUTY
to envelop us.

When we embrace what is right in front of us
and believe it's worth our attention.

But in order to do this, in order to find the life
we all want, we must be stopped,
thwarted from our petty pursuits and LED
DOWN A NOBLER PATH.

JEFF GOINS,
"The Wonderful Ache of Beauty (Why We Need Art)"

In *Living with Art*, Mark Getlein suggests the following functions of contemporary artists:

Create EXTRAORDINARY *versions of ordinary objects.*
Record and commemorate.
Give tangible form to the UNKNOWN.
Give tangible form to feelings.
Refresh our vision and help us see the world in NEW *ways.*

For the artist, the creation of art is an exploration of the world around us.

It allows us to <u>represent</u>, <u>interpret</u>, <u>illuminate</u>, <u>reject</u>, <u>question</u>, or <u>celebrate</u> any aspect of life that captures our attention and fascination—

FROM THE EXTRAORDINARY TO THE MUNDANE.

For me personally, two purposes drive me to create my images. First, the act of creating enriches my life with people, places, and scavenger hunts that become part of a whirlwind adventure to build the world of my imagination into images. The process of making my hidden, interior life visible is therapeutic as I engage in a psychological examination of different concepts. Making pictures allows me to explore the world, work out how I feel about it, and find my place within it.

*We nurture an endeavour which lies at the deepest levels of the traditional function of art: the uniquely human quest for establishing personal meaning in a **possibly** meaningful universe.*

—

PETER LONDON,
No More Secondhand Art: Awakening the Artist Within

Secondly, once the images are made and released into the world, they create a relationship with a viewer. I find satisfaction in expressing myself and connecting with others in a visual way. My hope for my images is that they provide an escape from the everyday world—even if momentary—transporting the viewer to a whimsical place where anything is possible.

The purpose of art is in washing the dust of daily life off our souls. —

PABLO PICASSO

This chapter is designed to help you unearth the root of your own interests, to encourage you to think about what draws you to photography and what you can use to explore it in your work.

What are the kinds of experiences you want to fill your life with?

The people you want to meet?

The stories you want to tell?

After you release your images into the world, what do you want to happen next?

Exploring these questions will help guide your work and bring intentionality to your artistic practice.

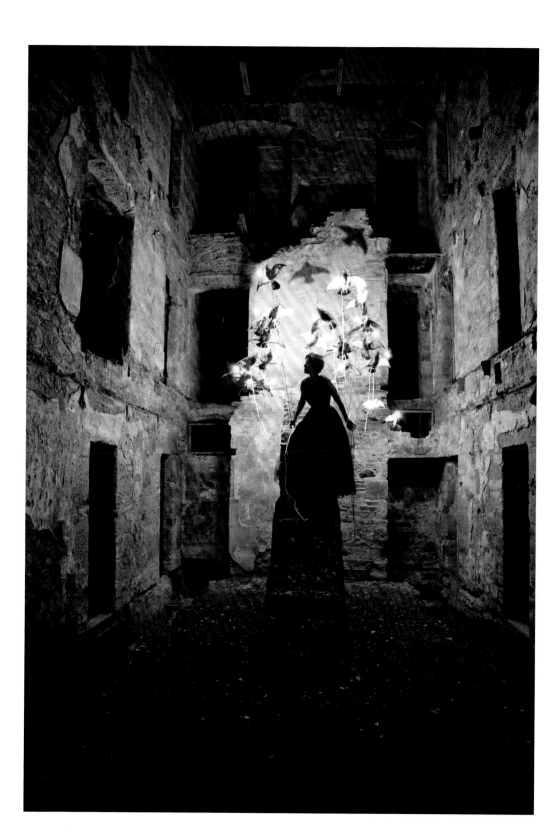

STRONG IMAGES

We live in a fast-paced, information-saturated, distracted *time*. We are bombarded with images at a dizzying rate, making it increasingly difficult to capture anyone's attention. As visual creators, this makes our job all the more challenging.

Think back to the images that have really had an effect on you. The ones that struck you like a lightning bolt. Most likely, those images were not merely beautiful or technically well-crafted. Ask yourself, *what about those images inspired you and moved you? Left a lingering feeling? What was captivating about them?* Make a list of the characteristics common to the artwork you find yourself really drawn to. You can refer to these characteristics when analyzing and editing your own work.

> *The aim of art is to represent not the outward appearance of things, but their inward significance.*
>
> —
>
> ARISTOTLE

An indefinable

"SOMETHING"

makes a picture special, *draws you in*, and makes you think.

Typically not derivative, obvious, or literal, memorable photographs are nuanced and infused with mystery; they whisper meaning rather than announce it. Work that speaks deeply to a WIDE AUDIENCE addresses questions common **to all of us** and offers a fresh perspective. Who am I? Why are we here? What is this all about? Why do I feel this way?

Work like this illuminates collective and personal thoughts on the everyday happenings of life and the mysteries beyond. Often it's what's left unsaid in a picture that gives it that haunting quality.

Memorable

images don't answer all our questions; rather, they *suggest* new ones.

This fits with how our minds are made to engage with the world: We want to work things out, make connections, solve problems, and investigate. A picture that invites that level of examination and reflection is not easily forgotten. You can view the image over and over again, and it will still hold your attention. I don't mean that all imagery must have the weight of the world's existential questions infused within it, or that it must be overly complicated. On the contrary, a very simple picture can have this effect on you. Whatever the subject matter, the image should strive to move you to laughter, tears, reflection, or awe —the critical thing is that it moves you.

Plenty of guidelines are available on how to make a picture technically "good," but pinpointing what makes a picture interesting or important can be difficult.

Gestalt, from the German word "whole" or "form,"

is the visual perception theory that the whole is more than the sum of its parts. Taken separately, each element of the image has limited impact or power: It's how the parts come together that defines the success of the image.

›

Anatomy of an Image

SUBJECT(S)
person, animal, object

EXPRESSION AND POSE

STYLING
wardrobe, hair, makeup, set

SET ELEMENTS AND PROPS

BACKGROUND / LOCATION

LIGHTING
ambient, studio, blend

COMPOSITION
& ANGLE OF VIEW

MOOD

COLOR PALETTE

POST-PRODUCTION

All of these elements must be considered when crafting an image. The choices you make for every aspect of your frame determine the success and visual interest of your image.

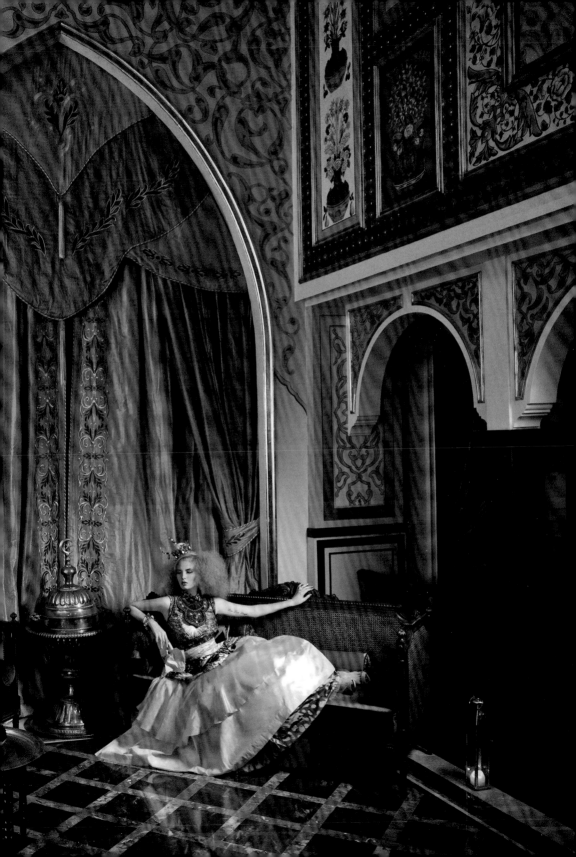

A lot of moving parts go into constructing an image; everything is done consciously and with intention. When all the elements come together seamlessly, the viewer forgets the fabrication and becomes lost in the narrative of the story. Creating these conditions for a viewer is the art of the photographer.

It's critical to be able to judge the interplay of all these elements—from the pre-production stage, to working on set, to post-production—and to be able to evaluate what is working and what is not. Although there are some guidelines, there are no concrete rules on how to achieve a perfect balance of all the elements in an image in order to make it interesting and engaging. To quote photographer Bobbi Lane, "Everything depends on everything." It's difficult to set down absolutes when there are so many variables.

A strong image must be interesting in both aesthetics and content. The aesthetics of an image should intelligently correspond to the content. Elements that are visually interesting in isolation but that don't come together successfully, or that are in the wrong place, will not create a strong image. You can have all the right visual elements and correctly execute everything technically and still end up with a boring image. Conversely, everything can go wrong, and things that seemed as if they wouldn't work together do, and the result is something unexpected and wonderful.

The important thing to remember is that the process is fluid, with no set formula: It's paramount to pay attention to every element of the photo story you are telling, critically analyzing your frame constantly. It gets easier with time, and there is a "you know it when you see it" instinct that develops the more you critically analyze images. Exposure to classic masters and contemporary "strong" art, which I'll discuss later, helps inform and improve this instinct substantially.

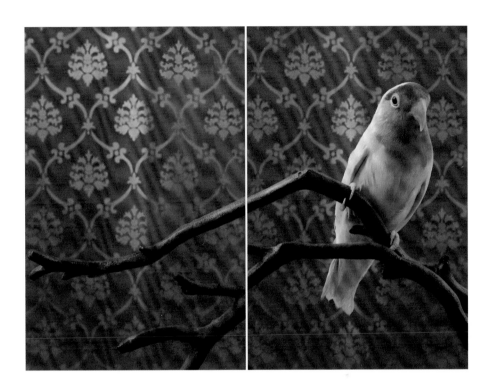

PEACH-FACED LOVEBIRD NO. 7523

(2012)
Diptych from the series *Birds of a Feather.*

DEVELOPMENT OF AN ARTIST

As outlined in Robert Greene's book *Mastery*, an artist's developmental trajectory typically follows some common steps:

DISCOVERY OF INTEREST/PASSION: According to Greene: "An urge out of nowhere, a fascination, a peculiar turn of events struck like an annunciation: This is what I must do [...] looking back, you sense that fate had a hand in it."

I remember the exact moment I fell in love with photography. I was in school and watching an image emerge in the darkroom tray of developer chemicals for the first time and thought, "This is like magic!" At that moment, I knew that photography was what I wanted to do. I later learned of my family history in photography, which reinforced this sense of fate.

PASSIVE OBSERVATION: Look to masters in your field of interest and absorb as much as possible to find what you are most drawn to. The world has a rich and diverse amount of artwork, but many people won't ever come upon it without consciously seeking it out. Discovering the master artists who resonate with you provides a deep sense of connection and inspiration for your own work. I regularly look to those masterpiece images that have physically resonated with me. They motivate and drive me to improve.

SKILLS ACQUISITION OR PRACTICE: Learn skills and techniques from many hours of hands-on practice and repetition, copying or emulating the work of the masters. This can be frustrating as you wait for your technical abilities to catch up with the ideas forming in your mind, but eventually, according to Greene, "you enter a cycle of accelerated returns in which the practice becomes easier and more interesting."

While still in school, I would find photographs or paintings that interested me and, as an exercise, try to emulate them to develop my technical skill. After you master the mechanics, you free up mental space and attention to commit to your concept, vision, and style.

EXPERIMENTATION: Deviate from imitation of the masters and begin to incorporate personal methods and narrative. A personal identity is formed and your vision develops over time. This is an important turning point, when you transition

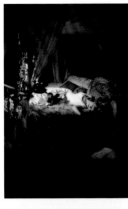

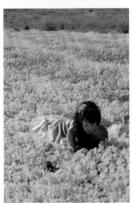
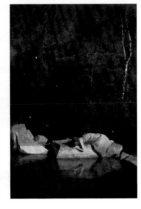

LOOKING INWARD

Working on this series allowed for self-reflection—of my technical process and my interior emotional and psychological state. This exploration yielded personal and artistic growth as I learned to use visual symbolism and archetypal themes to express my internal world.

from reproducing the work you have seen to using your artwork to ask and answer personal questions about life and beyond. Develop your own aesthetic visual language and method of storytelling.

My self-portrait series, *Fairy Tales and Other Stories*, was the first body of work I created after graduating from college. I was working as a photo studio manager in Maine at the time. But every free moment I was making self-portraits. Working primarily alone and with no pressure to share these images with anyone, I was free to experiment, develop, and refine my technical skills and my own storytelling methods. I made hundreds of images for this project, though only 30 or so remain in my portfolio. Each shoot was an important learning experience. Although I was still influenced by those around me, my vision began to emerge.

MASTERY: Become an artist with a unique, identifiable voice creating work that is authentically and recognizably your own—work that is the byproduct of your own internal and external inquiry and resulting journey through life. Mastery occurs when personal vision and technical skill solidify and become second nature. As Greene states, "The road to mastery requires patience [...] 10 years or 10,000 hours of work."

I continue to develop my personal vision and point of view as I work to refine and evolve my own voice. I'm finally making work that feels like it's mine, and although I'm still improving, I'm confident in my direction.

Each phase does not have a specific timeline for how long it will take, and the evolution does not always feel like a linear ascent. Each step along the way comes with its own set of frustrations, but patience, practice, and the knowledge that you are on a path helps you to endure and remain committed. Use the theories, questions, and tools outlined in this chapter. They will direct your passions and facilitate experimentation as you identify and develop your personal vision and style.

THE WORKSHOP

(2011)
Alex Randall Bespoke Lighting campaign.

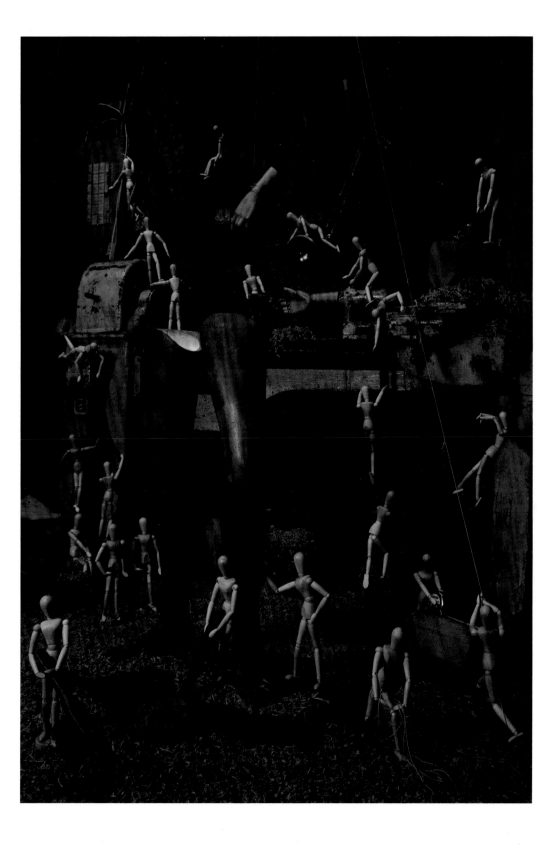

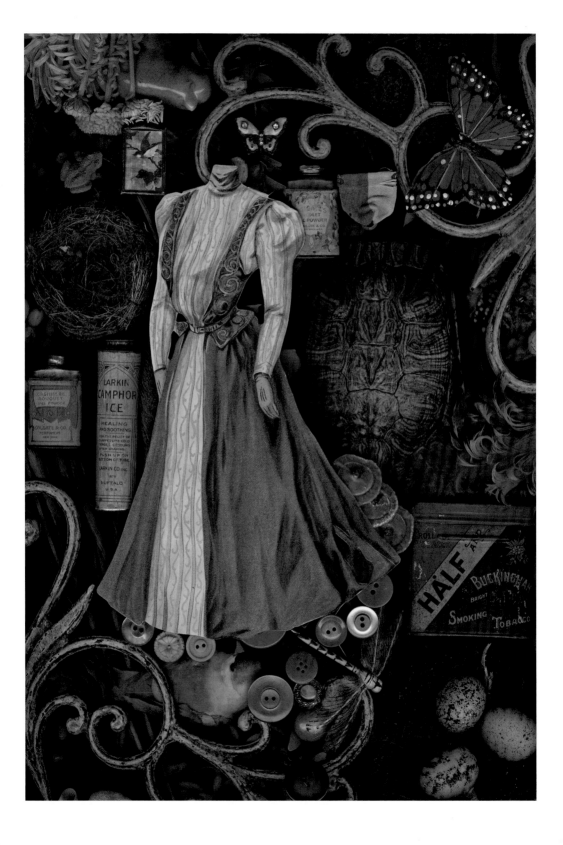

Personal vision is the manifestation of a recognizable, intentional approach to image-making with a point of view that can be characterized by continuity in aesthetic, content, theme, and/or technical style.

Personal vision is not something that can be rushed or forced. You always have it—IT'S YOUR VOICE—but it takes time, experimentation, and trial and error for vision to evolve and crystallize. Be wary of letting external elements push you into a particular style and then calling it vision. Your personal style is much broader and changeable. Style is how you express your vision through a combination of methodology, technique, and technology.

Many artists have been trapped by the first successful image or body of work they make. They enter a cycle of repetition, making and remaking that same, successful image, time and time again in the name of personal vision. But this repetitive cycle promises little growth because it lacks true vision. Vision is about identity and expression, not redundancy. It's deeply personal, and only you can develop the truest and most consistent form of that vision.

Artists with a powerful personal vision have achieved it because they put in the time to explore how they want to express themselves. This is the journey of photography, and it's as much about self-discovery as it is about making pictures. Over time as you come to know yourself better, your own voice will ring more truly in the images you create.

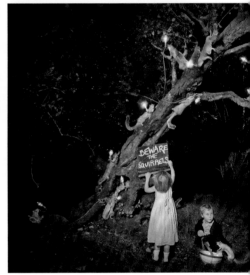

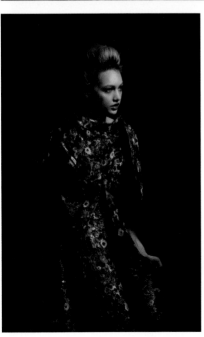

PERSONAL VISION

Whether I'm photographing for myself
or for a client, whether my subject is a
model, animal, or object, there is a
consistency across my work—like a
fingerprint. Though the approaches may
vary in style, the images maintain the
same vision.

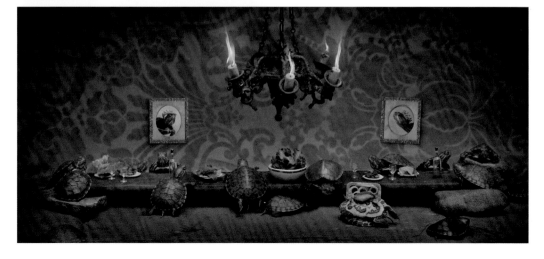

Reflect on your work and the work that you DREAM about making:

> Which other artist(s) is your work similar to?
>
> What are your influences?
>
> Who are your artistic role models?
>
> What features make your work uniquely yours?
>
> What is the work about?
>
> What do your pictures say about who you are?
> *(Or, what could a third party infer about you just from looking at your work?)*
>
> What themes do you repeatedly explore?
>
> What mood or emotion reoccurs?
>
> What techniques and tools are you using that affect the aesthetics?
>
> What is the format?
>
> What reoccurs aesthetically?
>
> What color palettes do you gravitate toward?

Don't fret if these questions are tricky to answer, especially early in your career. There is not one correct answer. The questions are just a jumping-off point for self-reflection as you think about your work as a whole. The thought process that these questions provoke and how you approach the answers are more illuminating than the specific answers themselves. Over time, your answers will most likely evolve and crystallize as your work grows.

The *Random House Webster's Dictionary* defines the psyche as

"the mind, soul, or spirit; the PSYCHE is the center of *thought, feeling,* and *motivation*, consciously and unconsciously directing the body's reactions to its environment."

Understanding the psyche and being aware of your own personal traits can inform not only the type of images you make, but also the process by which you make them. This understanding and awareness form the core of your ability to create self-aware authentic work.

The concepts of self and the unconscious are fundamental to Jungian psychology.

CARL GUSTAV JUNG

(July 26, 1875–June 6, 1961)
A Swiss psychiatrist and psychotherapist who founded analytical psychology, also known as Jungian psychology.

Your unconscious self, called your "shadow aspect" by Jung, is described by psychologist Carolyn Kaufman as the "repressed, suppressed, or disowned qualities of the conscious self." These qualities can be positive or negative. According to Kaufman, Jung believed that "in spite of its function as a reservoir for human darkness—or perhaps because of this—the shadow is the seat of creativity."

The shadow of our unconscious is the home of our IMAGINATION. All ideas stem from the unconscious; it's a repository for the accumulation of all experiences, both personal and collective. In the next chapter, I share tools to access your unconscious through intuition, meditation, and dreams. This process will help you generate original ideas that, while deeply personal, also have universal resonance.

A person's psyche has constructive and destructive aspects. In its more destructive aspects, the shadow can represent those things people hate or do not accept about themselves. We tend to reject traits that we consider to be negative, but the "light" elements of the trait cannot exist without the shadow. For example, being focused and meticulous can lead you to create rigorously conceived images with exquisite attention to the details of execution. However, being very meticulous can also make you relentless, demanding, and obsessive. The shadow manifestations of the attribute are inevitable, although we do tend to engage in an internal, unconscious battle to kill them off. It's more constructive and positive to embrace your "shadow" attributes and understand how they inform how you function, and the powerful engine that they provide in your creative process.

THE MESSENGER TO VICTORY

(2011)
Alex Randall Bespoke Lighting campaign.

DEVELOPMENT OF AN ARTIST | *Psyche*

A few years ago, I began consulting with Brand Strategist and Creative Director Beth Taubner of Mercurylab. Beth has developed a proprietary approach to helping individuals, artists, and companies formulate more conscious ways of thinking about their work and bringing it to market, using a combination of psychological and analytical processes. Her work is rooted in brand methodology, business strategy, Jungian astrology, psychology, interviews, analysis, motivational and focusing exercises, creative direction, design, and marketing strategy.

When Beth and I began working together in 2013, I was already involved in my personal artistic journey, but I needed to push further to become a more adept photographer to fully realize my voice as an artist and as a person. I was also interested in working across different markets, including fine art and commercial, but I wasn't sure how to knit the pieces together. I picked Beth because her work is deep and psychological, and since then, she has helped me to finesse my skills, analyze my markets, and understand what drives me and my work. The process we undertook helped me discover my peak attributes and use them as the core of everything that I create, say, and do.

Here, Beth explains her Transformational Branding process:

Entering a transformational discovery process with me is the same no matter where you are in your work, and no matter what kind of work you do. When Claire came to me, she was already on her path to becoming the artist she is today. She arrived with an ambitious flowchart printed on acid green paper. She had devised a complicated map showing all the ways in which her work hooked together. It was fantastically interesting but didn't include the core—the emotional attributes and repetitive themes and patterns that drive her as an artist.

Let's take a moment to define what an attribute is. This is important to understand, because working with the concept of attributes and differentiation is fundamental to the brand definition process, though I find that many people have trouble wrapping their heads around this particular word. An attribute is a trait or characteristic. For example, if you are describing your Uncle Joe, whom you know well, and you say that he is loyal, jovial, and warmhearted, you have described his primary, or

peak, attributes. In Transformational Branding, we define and focus on your peak attributes so that you can work with them more consciously and successfully.

As with all my clients, Claire and I spent hours talking about her family, going back generationally, and looking at the visual work she had already created. For everyone, this excavation process uncovers the parts of yourself that you are in touch with, and almost more importantly, the parts that you don't yet know. This is what I see as the Jungian part of the work. Jung understood that the shadow—that is, the parts of ourselves that are hidden from view—are frequently more powerful drivers in our beliefs, actions, and lives than what we may be consciously in touch with. The initial proprietary Discovery process I work with at Mercurylab is emotionally and psychologically based, and then ultimately we use more traditional analytical and deductive brand methodology to arrive at your peak attributes. These attributes hold light and shadow aspects. In other words, what you know about yourself and your work and tend to think of as "good" sits in the light side of the attribute; and what you don't know (or don't know well) and tend to think of as "bad" sits in the shadow side of the attribute.

Once the attributes are defined, we use a pyramid branding tool to visually organize and rank the attributes, starting from the base (which contains attributes that anyone in your discipline would have) up to the four peak attributes at the aspirational top, which are the attributes that are specific to you—based on all the material we have excavated in our Discovery session. As you travel up the pyramid, we place the attributes that you know intimately, that you know somewhat, and the one that you don't know yet—your aspirational attribute. Your best artistic work will embody all four peak attributes and will call out the light and shadow aspects so you can work with them more consciously.

The Transformational Branding process stimulates a big, internal "aha" shift, and clients say that embracing and following their peak attributes changes their lives, not just their work. Your peak attributes form the core of how you will work going forward, governing everything from how you run your day-to-day business or practice to what you shoot, how you shoot, how you edit, how you present, the people you

shoot for, your collaborators, the shows you enter, and the galleries you approach. It's a blueprint that provides you with the tools to be yourself more fully and to come to market in a more focused and conscious way that is specific to you and your work—not in a formulaic, pasted-on way, but in a way that is truly authentic to who you are as a person and as an artist.

EXERCISE

Find a journal or bound book that you will enjoy writing in, and begin your brand transformation with the following exercise. Put yourself in a quiet place with no distractions, no phone, no internet, no music.

Write for an hour about your goals, your dreams, and where you are right now—with your career, how you run your business or practice, and your creativity. Don't feel that you need to write it in perfect sentences or list format. Write in whatever form is comfortable for you, but it IS important to write for a full hour. Also, try to quiet the little inhibiting or judging voice in your head. Write freely and without judgment. Most importantly —be honest with yourself! Write about the good, the bad, and the ugly so that you can see what you stand for and begin to define and build your work authentically.

DEVELOPMENT OF AN ARTIST | *Psyche*

ATTRIBUTE PYRAMID

**EXACTING /
FINESSE**
sophisticated,
cultivated, refined,
stylish, nuanced,
subtle, painstaking,
meticulous, restrained,
guarded, petulant, irritable, airless,
impatient, unapproachable

FANTASTICAL / CHARISMATIC
conceptual, magical, whimsical, fanciful,
fictitious, dreamy, mythical, poetic, narcissistic,
escapist, eccentric, esoteric, childish, macabre,
gothic

FERTILE
abundant, lush, exuberant, feminine, romantic, sensitive,
overdone, excessive, superfluous, over-the-top, dramatic,
operatic

TENACIOUS
focused, relentless, self-reliant, adventurous, resourceful, ardent,
enduring, loyal, obsessive, demanding, dogmatic, stubborn, self-
involved, extreme

ATTRIBUTE PYRAMID FOR CLAIRE ROSEN

Abbreviated version of my personal
attribute pyramid created by Beth Taubner
at Mercurylab.

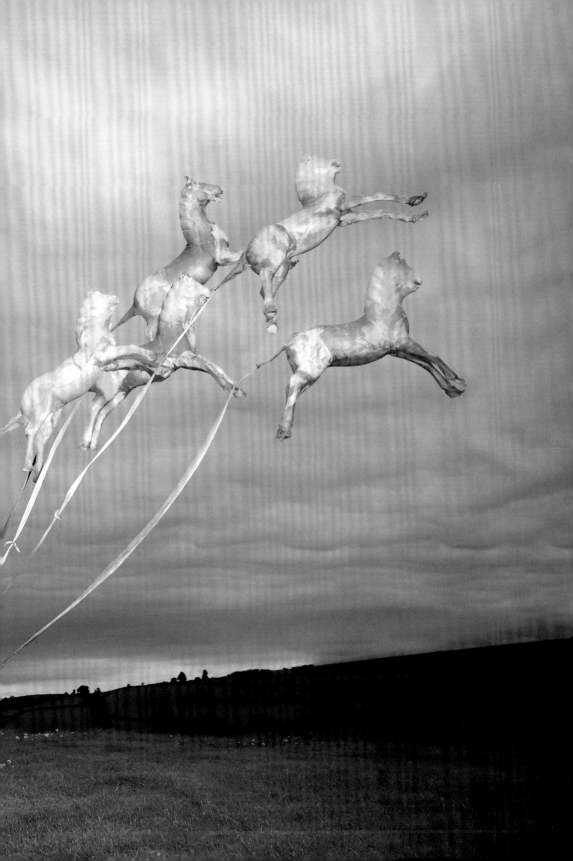

Our childhood experiences fundamentally shape the adults we become, helping to determine who we are, what we care about, and what we are drawn to conceptually and aesthetically. Looking back into your past to identify pivotal, formative experiences and then using those experiences to trace the manifestation of your identity in your work can be very illuminating.

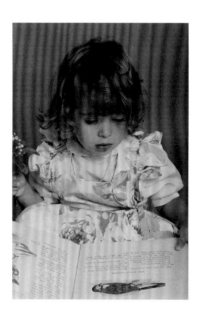

FAIRY TALES

Einstein famously advised that reading lots of fairy tales to children would ensure the development of intelligence and creative imagination. This collage (right) features influential books from my childhood. I am pictured here at age three. Childhood photo by Ken Clare.

I grew up in a Victorian house in Montclair, New Jersey, the eldest of four sisters. My earliest memories are of trips to the Metropolitan Museum of Art, the Museum of Natural History, the Big Apple Circus, and the Central Park Zoo and Carousel, as well as elaborately designed themed birthday parties, and bedtimes filled with *Grimm's Fairy Tales*, *Alice in Wonderland*, *The Wizard of Oz*, *Aesop's Fables,* and Greek mythology. The imprint of these childhood experiences on my own work seems obvious in hindsight, but it wasn't until later in my career that I connected this thread that had been with me since my very first photography class.

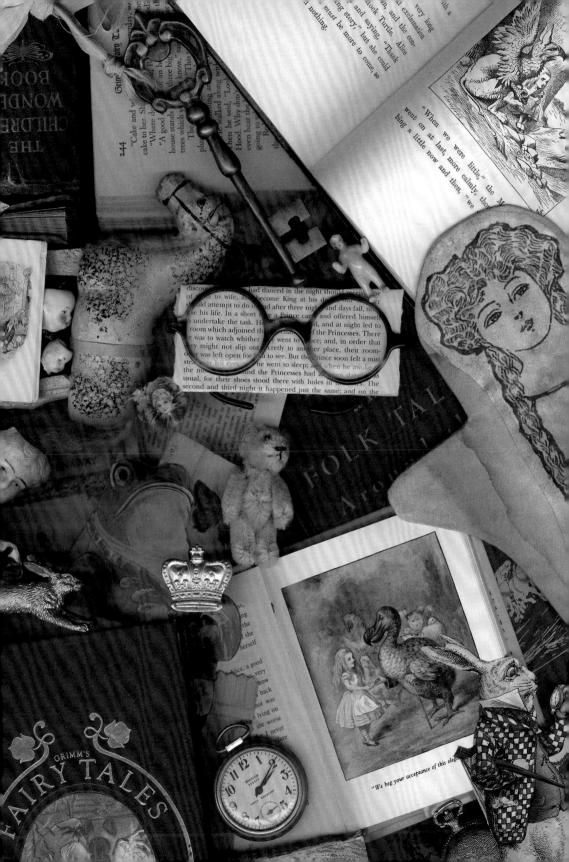

DEVELOPMENT OF AN ARTIST | *Artistic Roots*

EARLY WORK

I was first introduced to photography at Bard College at Simon's Rock, where I rediscovered a love of learning and curiosity about the world that I had lost in high school.

When I continued my studies at Savannah College of Art and Design (SCAD), I acquired the formal, technical foundation that I needed, and I benefitted from the freedom and support to explore my own perspective and vision.

I always wanted to construct my images and tell the story of the world as it appeared in my imagination. My early student work, though not necessarily well-executed, involved many of the same themes that I work with today: nostalgia, childhood, memory, dreams, the feminine, beauty, unconscious, mythology, fairy tales, fables, and archetypes. In addition, aesthetic continuities have carried through in my work in the styling, locations, composition, and quality of light and mood.

Although I was not conscious of this evolution early in my career, I now understand how my history informs my work. I have a lot more clarity, and my choices (conscious and unconscious) have logic to them. This revelation has been very helpful to my process, both psychologically and creatively. Being aware of my artistic roots provides a narrative for me to articulate more clearly what my work is about, where it comes from, and why I make it.

STUDENT WORK

(2001–2006)
I experimented with my storytelling using fellow students, my younger sisters, and their friends as models. I started searching for bizarre props and interesting locations, and I made dresses by pinning pieces of fabric together. The collaborative nature of student shoots was particularly influential.

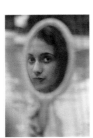

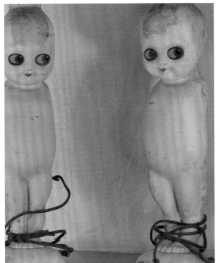
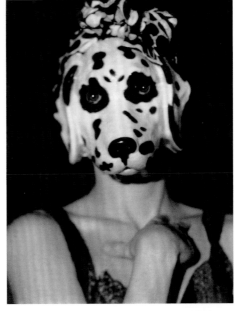

DEVELOPMENT OF AN ARTIST | *Artistic Roots*

FAMILY HISTORY

My grandfather passed away before I was born. Decades later, when I was well into my own career, I was encouraged by creative consultant Beth Taubner to investigate this further. I learned that my grandfather had been a successful commercial photographer in Hollywood, California, in the 1950s. I was surprised to discover the uncanny similarities between my own work and his. Looking at his work confirmed for me that this is what I'm meant to be doing, as if he had been whispering in my ear all along. Genetics aside, the clear thread between his work and my own reinforced my belief that EARLY CHILDHOOD INFLUENCES CREATE A LASTING IMPRINT ON YOUR CORE. He shaped who my mother is, and my mother in turn shaped me. Our strong aesthetic and thematic continuity is a testament to that heritage and legacy.

ALLEN BURG

(1912–1976)
Memorabilia from my grandfather's photography studio.

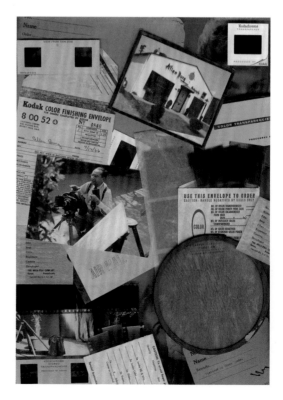

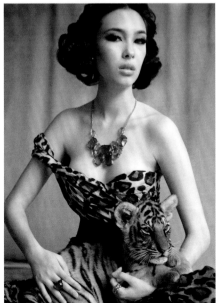

COMPARING WORK

(Top row, second row right)
Fashion editorial by Allen Burg
(Bottom row, second row left)
My imagery: "A Leopard Among Tigers," a
fashion editorial test in Chiang Mai, Thailand, a
year or so before seeing my grandfather's work.

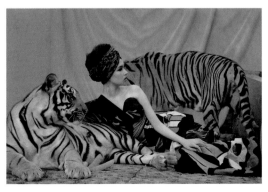

DEVELOPMENT OF AN ARTIST | *Artistic Roots*

Being in touch with early influences facilitates the act of creating conscious, personally relevant art. I feel that my work is the authentic and unique expression of myself, and having a strong sense of the connections that led me to be the artist that I am today is a critical part of that.

In a quiet location, close your eyes and think about your childhood memories:

?

Birthplace

Earliest childhood memory

Favorite childhood activity

Favorite childhood place

Favorite children's book

Childhood hero

Early family dynamics

Relationship to your parents

Parents' birthplaces

Parents' professions

Grandparents' birthplaces

Grandparents' professions

Ethnic or cultural background

Relationship to siblings

Relationship to religion or belief systems growing up

Childhood personal fashion

Childhood room/whole house décor

Childhood town

Earliest exposure to artwork, music, TV, or films

Time periods of interest

Color palettes of your memories

Now think about your work. How can you connect it with these reflections in a way you haven't thought about before?

Photography is a passport to investigate and explore limitless topics, from the extraordinary to the mundane. With camera in hand, you get to peek inside the lives of fascinating people, whether they are complete strangers or those closest to you. Photography can take you to unseen places or help you to see known places in unimagined ways, from remote and far-flung adventures to intimate studies in your own backyard. The exploration list of captivating subjects and thought-provoking ideas is endless.

Create a list of issues, themes, and concepts that interest you. Infinite possibilities exist, but try to think of objects or subjects to which you feel a personal connection. On a piece of paper, make a free-associated list—everything from philosophical ideas to simple niche subjects—and don't worry about the order. Hold on to this list for later.

Here are examples of the potential range of topics:

Memory, *love*, abandonment, humor, *malnutrition*, **hippopotamuses**, feminism, gardening, 1940s, a hero, BOTTLE TOPS, children, 5:45 p.m., MAUVE, global warming, Alex, *Chinese paper lanterns*, FASHION, melancholy, cauliflower, New Hope CT, pattern and repetition, social injustice.

Although this list illustrates just how varied the subjects may be, the topics you generate will most likely be interconnected.

Here is my personal abbreviated list:

Nostalgia, childhood, memory, dreams, the feminine, beauty, unconscious, mythology, fairy tales, fables, the occult, Victorian Era, Pre-Raphaelites, shadow/darkness, whimsy, taxidermy, animals, natural history/natural science, curiosities, antique dolls and toys, imagination, psychology, philosophy, circus, vaudeville, travel, wanderlust, Joseph Campbell, archetype, collective unconscious, individualization, sorcery, castles, miniatures, interior design/decoration, set design, anthropomorphism, stop-motion animation, classic children's illustration, women's issues, history, monarchies, wilderness, entomology, William Morris, wallpaper, witches

The themes and concepts that you generate will inform the content of the work you want to make. They are likely already included in your work in some way. You may be able to identify a common thread that runs through all your work. As you become aware of this thread, it will help you communicate about your work, ideas, and interests with more clarity.

GOALS FOR MAKING WORK

ALICE: *"Would you tell me, please, which way I ought to go from here?"*
CHESHIRE CAT: *"That depends a good deal on where you want to get to."*
ALICE: *"I don't much care where."*
CHESHIRE CAT: *"Then it doesn't matter which way you go."*

—

LEWIS CARROLL
Alice in Wonderland

You can be an artist in many ways—in your personal life and/
or professional life. The depth and breadth to which you take
this is your decision. The goals you set for yourself, whether
consciously or haphazardly, determine the way you live your
life. It's important to be intentional about what those goals
are, so your path leads you to the place you actually want to be.

One of the many interesting aspects of being an artist is how
work entwines with everyday life. For better or worse, you can't
simply start being an artist when work begins, and then stop
being one when work is over. You are an artist all the time. You
have the freedom to create your life around the work you want
to make, and vice versa.

Success has no universal standard. Spend some time thinking
about your own personal aspirations to avoid spinning your
wheels in a lot of directions that won't satisfy your ambitions.

A MAD TEA PARTY

(2011)
From the series *Fairy Tales and Other
Stories*. Inspired by Lewis Carroll's *Alice in
Wonderland*.

GOALS FOR MAKING WORK | *Identifying Goals*
FOR LIFESTYLE

Identify your long-term practical and material goals for making work. This will provide an initial outline to help focus your energy:

?

What do you want to do before you die?

What type of lifestyle do you want to have?

If you could pick any dream jobs, what would they be?

Where do you (want to) live?

Do you prefer to be in urban, suburban, or rural areas?

Do you (want to) have a family?

Do you want to travel?

What other activities do you enjoy?

Do you enjoy working with other people?

Do you prefer one-on-one interaction, small teams, or large crews?

Are you most drawn to photographing people, places, objects, and/or animals?

Do you prefer a fast pace with lots of pressure or a more relaxed atmosphere?

Do you like to be the center of attention or prefer to remain in the background?

Are you detail-oriented?

Do you enjoy building things or working with your hands?

Are you interested in the technological and equipment side of photography?

Having an idea of what you would like to get from your work and what your restrictions and resources are will help create a framework for what you make. Within photography, there are a number of different genres and industries that vary greatly in how they operate. Shooting for a fashion magazine, for example, is very different from photographing food, babies, surfers, cars, forensics, or conceptual artwork. Complicating things further, the same genre can vary by region or market. And even as I write this, the lines between all of these disciplines are blurring ever more as photographic focus turns toward the point of view rather than the subject.

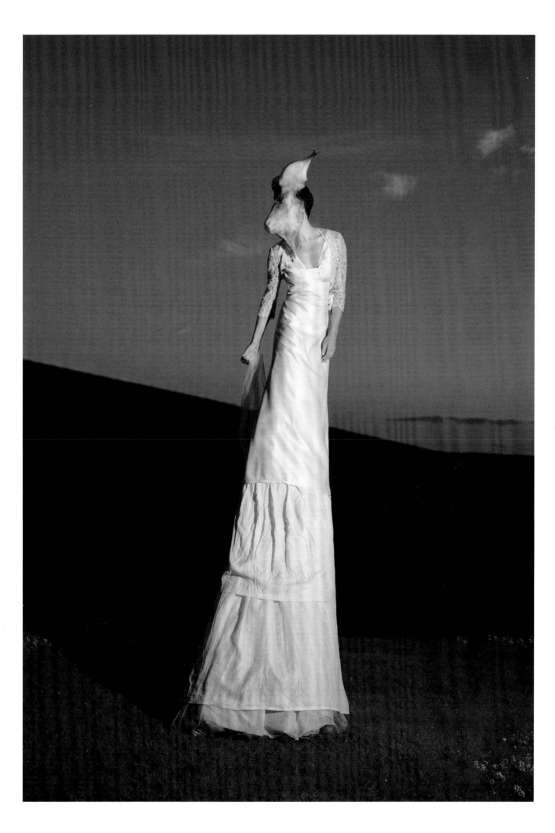

GOALS FOR MAKING WORK | *Identifying Goals*

FOR ARTWORK

Think about where you want your work to be in the world. I'm a believer in making the work you want to make first. Find the commercial arena for it later.

That being said, it's helpful to have some solid goals to work toward. Depending on where you are in your career, you will have short-term goals and you will have goals that are still dreams, five to ten years from fruition. Ask yourself:

Is your work private and only for you?

How do you want a viewer to feel/think after looking at your work?

What types (demographic) of people do you want to show your work to?

Do you want your work to be in galleries or museums?

Do you want to create photography books?

Do you want to do commercial/advertising/commissioned work?

Do you want your work to appear in magazines or newspapers?

Do you want to use your work for commentary or to raise awareness for specific issues in the world?

Do you want to cover events, news, entertainment, or celebrations?

Is it important or necessary that your art supports you financially? If so, how much will you need?

Is it important to you that you have a lot of visibility, attention, or fame?

With your answers to these questions, you can now create a basic set of short-term and long-term goals. These goals are certainly not fixed in stone, and whichever goals you identify, it's important to define success and the path to attaining that success for yourself. There is more than one way to have a "successful" career in photography, but that is a subject for another book.

OVERALL GOALS

⌄

Lead an interesting life based on exploration and curiosity.

Continue to see the world, always via a path less traveled.

Develop compelling bodies of work that allow me to travel, question, learn, and work with my obsessions + fascinations + interests

farm | Artist residency—COMMUNITY
PA educational and cultural destination

Produce WORK

⌄

art books on each series
exhibitions } solo and group
 galleries, museums,
 nontraditional spaces,
 public art installations

print sales
gallery representation
charity
commissions
merchandising

creativity
photography
film
painting
sculpture
printmaking
writing
woodworking
metalworking
illustration
design
calligraphy
papermaking
bookmaking
crafts
cooking
gardening
farming
animals
history

(next 1–6 months)

∫HORT-TERM GOALS

Finish this book! Execute a marketing campaign for book and arrange workshops

Maintain general visibility of artist "brand"

social media
contests
exhibitions
lectures & workshops
networking at events
press

Build relationships with gallerists, curators, collectors, art consultants, interior decorators, etc.

assemble backlogged files
finalize exhibition proposal
reach out to chef list

FEAST SERIES (winter)

THE MILLBROOK COLLECTION : deliver final files to Giorgio
(asap) input data copy
kickstarter

Work on *personal* HEALTH issues

CHAPTER 1 | *Wrap-Up*

This chapter focused on the big picture of the art-making process and what makes for strong imagery, while helping you to identify personal motivations and interests beyond the medium of your chosen artistic expression. This is just the beginning.

Hold on to your responses prompted by the questions in this chapter. You'll need to reference them as you move forward.

- Characteristics of artwork you are drawn to
- Identifying your vision
- Recording childhood memories
- Identifying areas of interest
- Identifying goals for making work

As you move forward through the rest of the chapters, it will become clear how to harmonize your work process with the self-knowledge that you have gained. You'll learn how to leverage what you know about yourself to benefit your work. This will happen organically as you naturally make connections and associations to what you have already been creating. You'll appreciate these connections primarily during brainstorming, pre-production, and self-critique sessions. Some realizations will take more time to clarify. Be patient.

RECOMMENDED READING

*Art and Visual Perception:
A Psychology of the Creative Eye* (2004), Rudolf Arnheim

Mastery (2012), Robert Greene

The Portable Jung (1976), Carl G. Jung and Joseph Campbell

Man and His Symbols (1968), Carl G. Jung

RECOMMENDED VIEWING

Commencement Speech at the University of the Arts (2012), Neil Gaiman

INSPIRATION

Francesca Woodman
Cig Harvey
Lalla Essaydi
Debbie Turbeville
Sarah Moon

Yancey Richardson Gallery
Sarah Laird
VII Photo

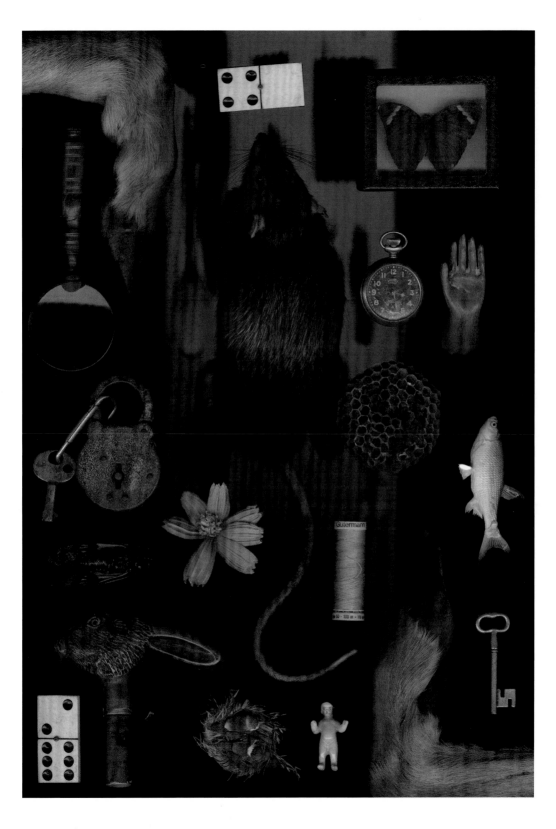

Art

TWO

istic Lifestyle

THE FOUNDATION

I think everything in life is art. What you do. How you dress. The way you love someone, and how you talk. Your smile and your personality. What you believe in and all your dreams. The way you drink your tea. How you decorate your home. Or party. Your grocery list. The food you make. How your writing looks. And the way you feel. Life is art.

—

HELENA BONHAM CARTER

Unlike a typical 9-to-5 job, being an artist is a fundamental identity, as well as a lifestyle. Having innovative ideas is an enigmatic process, and there is little solid science surrounding creativity or where "good" ideas come from. This chapter is about implementing a sustainable practice that will make your life more conducive to creative productivity. This practice is the foundation of producing work as an artist. It's also the first thing to get postponed or dismissed when life inevitably becomes busy. The idea generation and development that comes out of a sustainable creative practice is the rock on which all else rests. It requires you to pay attention to your individual needs as an artist.

Let's look at practical methods you can use to encourage idea generation. We'll examine curation of experiences and inspiration, and then explore tapping into the unconscious through meditation, intuition, and dreams. Further into the chapter, we'll shine a light on some of the potential personal obstacles that may interfere with making work, such as self-censorship and fear, with a process for how to overcome these challenges. Finally, we'll cover how to nurture creativity by creating an individual method for making work, how to deal with failure, how to maintain play in your life, the importance of giving yourself time and space, and how to seek out a supportive community.

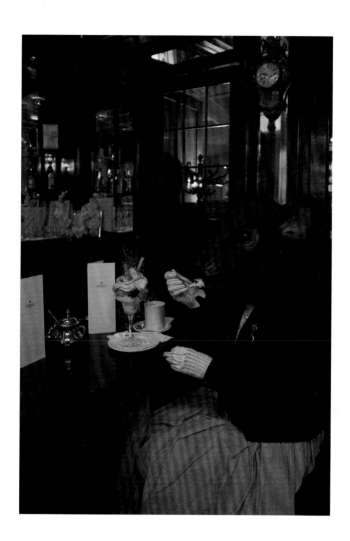

48.2082° N, 16.3738° E
DEMEL PASTRY SHOP

(2015)
Fig ice cream for the Traveling Mouse
from the historic Demel chocolaterie
established in 1786 in Vienna, Austria.

CURATION OF EXPERIENCES

No longer can we consider what the artist does to be a self-contained activity, mysteriously inspired from above, unrelated and unrelatable to other human activities. Instead, we recognize the exalted kind of seeing that leads to the creation of great art is an outgrowth of the humbler and more common activity of the eyes and the everyday life. Just as the prosaic search for information is "artistic" because it involves giving and finding shape and meaning, so the artist's conceiving is an instrument of life, a refined way of understanding who and where we are.

—

RUDOLF ARNHEIM,
Art and Visual Perception: A Psychology of the Creative Eye

Photography, like writing, is about storytelling. Pens and cameras are merely the tools we use to bring self-expression to life. If you have nothing to say, your images will reflect that. It's important to build your own narrative through exploration, learning, and diverse experiences that enrich your storytelling. What you do when you are *not* photographing is just as important to your process as pushing the shutter button on the camera, if not more so.

My first few years as an independent photographer can serve as a cautionary tale. I became so wrapped up and consumed with work that I did nothing else. After two years of working at that pace I stepped back, looked at my pictures, and thought, *These images are boring.* All I was doing was regurgitating the fashion photography that had become my only visual nourishment. As a result, my pictures had no substance to them. They were what I thought would make me commercially viable, but they had no meaning to me.

That was when I realized how essential it is to look at your work as a photographer *holistically*, not merely as the moments when you adjust the settings on your camera. My photographs are similar to dreams in the sense that they are an amalgam of things I've seen recently: current concerns, memories, and unconscious influences, all woven together and represented through visual symbols. The brain puts out

what you put in. Everything you see and do affects and influences you, and your images benefit when you consciously curate that input.

Don't be fooled by our current culture's fixation on myopic specialization and subscribe to the idea that you must do only one thing to do it well. The true geniuses of history were brilliant polymaths with wide-spanning interests. Even today, the most successful innovative thinkers explore a wide range of curious hobbies. Limitless innovations can occur when you blend information gained from one activity or field of study with information from another field. In fact, I find that my best ideas for pictures come when I'm doing things that have nothing to do with photography.

THE ARTIST DATE

Creativity is a well that you continually dip into, which means, at some point, you have to refill that well. Julia Cameron's book *The Artist's Way* is a phenomenal resource for artists of all disciplines. A cornerstone of her method is the Artist Date. Set aside a chunk of time, once a week, to go on a date with yourself. Spend that time doing something that inspires you. Go to a gallery or museum. See a film. Visit a flea market, dollar store, park, grocery store, or zoo—whatever you fancy. The important thing is to go alone, be intentional about seeking inspiration, and never stand yourself up.

Beyond life experiences, the visual
input that you consume has a big
influence, consciously and
subliminally, on the work that you
produce. As Austin Kleon says in *Steal Like
an Artist*, "Garbage in. Garbage out." Seek
out those kindred-spirit artist role models who
excite and inspire you with work that you love. Soak
up work that, inexplicably, you find you must look at
over and over again. Refer back to the characteristics of
artwork you are drawn to when thinking about strong
imagery, as described in Chapter 1.

It's important to look in a variety of places for inspiration, so you are not
influenced too heavily by one artist, style, or even medium. Photography
and painting are wonderful sources for ideas, but there are many
other mediums and subjects to look to for inspiration: film,
literature, dance, performance art, food, history, sculpture,
martial arts, media, illustration, animation, graphic novels,
fashion, design, flower arranging, etc. The possibilities are
ENDLESS.

INSPIRED

(2016)
Collection of random objects in the style
of the *Nostalgia* series.

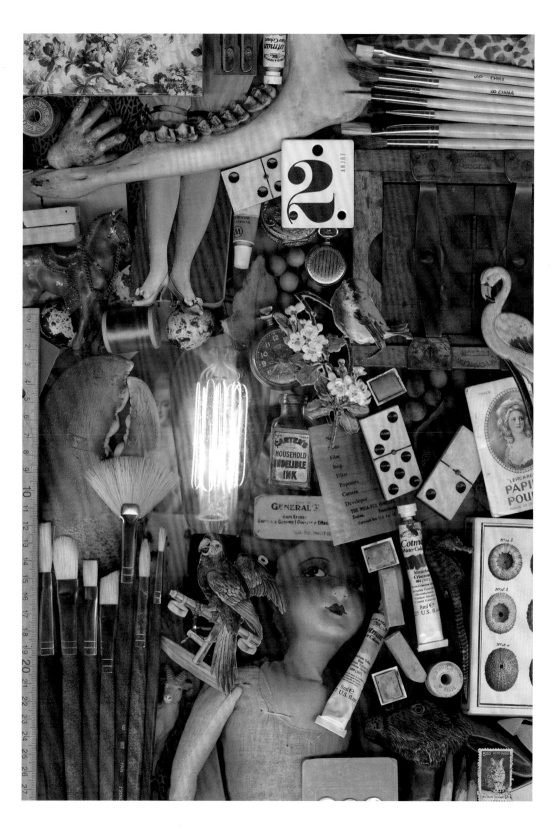

CURATION OF INSPIRATION |
Art History and Contemporary Art

If you want to learn about COMPOSITION, LIGHT, MOOD, EMOTION, DEPTH, and SUBJECT POSING AND GESTURE, spend some time looking at the masters of classical painting. My appreciation for classical artwork and my background in art history has had an enormous impact on my aesthetic sensibilities. The masterpieces can help you understand formal ideals of beauty, symbolism, archetypes, and the continuity of the human condition. These elements can be discussed theoretically at length, but nothing replicates the emotional transcendence that sweeps over you when looking at something truly spectacular.

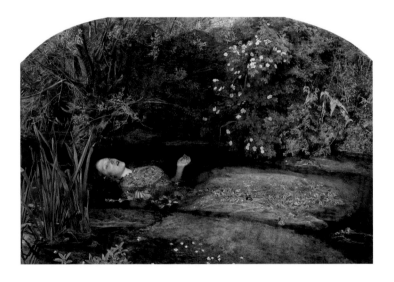

OPHELIA

(1851–1852)
John Everett Millais

In the same regard, you can learn a lot from contemporary artwork. As boundaries continue to be pushed, it's valuable to stay abreast of what is happening in the art and commercial industries. This is not so you can create works that are similar, but rather to maintain an understanding of where the collective unconscious is at the moment, what innovations are occurring, and how you can contribute.

Looking critically at classic and contemporary work also makes you a better editor. As you become more accustomed to dissecting elements of each work of art you view and pay attention to how that work resonates with you personally, you'll progress in your ability to analyze and edit your own work.

CREATING AN INSPIRATION DATABASE

Keep track of the resources that interest or inspire you. Compile an "inspiration database." Create this physically in a folder or box; fill it with books, postcards, and tear sheets from magazines, etc. Or create your inspiration database digitally as a Pinterest board or as image files organized by folders on your computer. Not only do I keep images that inspire me, but I also save locations, resources, and the names of people I would like to engage with in the future. I refer back to these collections whenever I'm in a slump or as a reference for mood board research, which you will learn about in Chapter 4.

(From left to right, top row)
QUEEN MARIE ANTOINETTE OF FRANCE (1783)
Louise Élisabeth Vigée Le Brun.

THE SNOW QUEEN
By Edmund Dulac, Art And Picture Collection, The New York Public Library.

ANNE AURETTI (174-?)
Jerome Robbins Dance Division, The New York Public Library.

(From left to right, bottom row)
HYLAS AND THE NYMPHS (1896)
John William Waterhouse

VERONICA VERONESE (1872)
Dante Gabriel Rossetti

ACROBATS AT THE CIRQUE FERNANDO (1879)
Pierre-Auguste Renoir, The New York Public Library.

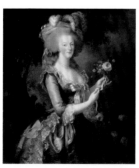
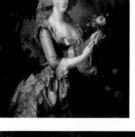

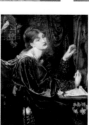

Just as we do not doubt the importance of our conscious experience, then we ought not to second-guess the value of our unconscious lives.

—

CARL JUNG

As important as it is to feed your creativity with inspiring experiences that can be touched, seen, and heard, paying attention to the unconscious realm will also inform your work.

According to Jung, two layers of the unconsciousness are linked together: the *collective unconscious* and the *personal unconscious*.

The collective unconscious is an inherited, instinctive, and universal memory pool that is identical for all creatures of the same species. In humans, regardless of racial and geographic differences, this pool is made up of interdependent opposites: instincts and archetypes.

Humans have five main instincts that influence behavior: hunger, sexuality, activity, reflection, and creativity.

The archetypes are allegorical symbols of which we all share an innate understanding: the Mother, the Wise Old Man, the Shadow, Water, the Tree of Life, etc., all of which encompass the soul of humanity beyond the chronology of a human lifespan.

> *These "primordial images" or "archetypes," as I have called them, belong to the basic stock of the unconscious psyche and cannot be explained as personal acquisitions. Together they make up that psychic stratum which has been called the collective unconscious.*
>
> —
>
> CARL JUNG,
> *The Significance of Constitution and Heredity in Psychology*

Archetypes (as in the following short list) form a language of visual/mythical narratives and have considerable influence over our ideas.

Ego		Shadow
Great Mother		Terrible Mother
Old Wise Man		Trickster
Anima		Animus
Meaning		Absurdity
Centrality	↔	Diffusion
Order		Chaos
Opposition		Conjunction
Time		Eternity
Sacred		Profane
Light		Darkness
Transformation		Fixity

The universality of archetypes makes them of particular interest to artists, since we want our expressions to connect with as many people as possible. Rich both visually and metaphorically, archetypes and symbols resonate with viewers of all backgrounds. They are the foundation of the human condition that unites us all.

Some common examples of the archetypes can be found in folklore, fairy tales, and children's fables. These stories use archetypes to communicate universal life lessons allegorically. The small details within these stories vary by culture, but throughout the world the narratives are essentially the same. My series *Fairy Tales and Other Stories* uses these symbolic narratives. The images are self-portraits, but they are not portraits of me as an individual; rather, I use myself to create a character, or archetype, to convey a universal idea.

As mentioned previously, another layer of the unconscious is the personal unconscious, which is unique to your own experience and found on the edge of consciousness. It includes all that has disappeared from your current memory, because it has been forgotten, ignored, or repressed for some reason. (This is also known as the shadow aspect referenced in Chapter 1 in the section "Psyche.") You can access this area of your unconscious through intuition and meditation, and by tapping into your dreams.

NOT
all behaviors are
learned. Nor are all
thoughts concrete or rational.
Intuition is different from thinking, in
that it originates from intrinsic knowledge.

We all experience "GUT" or instinctive feelings but so often dismiss them, not trusting our internal voice due to self-doubt, personal censorship, or even the cultural associations with wackadoodles and paranormal activity. But intuition warrants our attention. It's at the core of making art, propelling us to follow our mind and hand to see where it leads—to chase whatever is pulling us without requiring an explanation of why or how.

Take conscious steps to listen to your intuition regarding your artwork and art process in order to be more in tune with your unconscious self. Meditation, dream recording, solitude, and practicing mindfulness will strengthen your ability to recognize your intuition and pay attention to it.

STUDY IN LISMORE GOLD

(2016)
From the series *Nostalgia: A Study in Color*, commissioned for the Daniel Lismore exhibition, "Be Yourself; Everyone Else Is Already Taken," at the SCAD FASH Museum in Atlanta, GA.

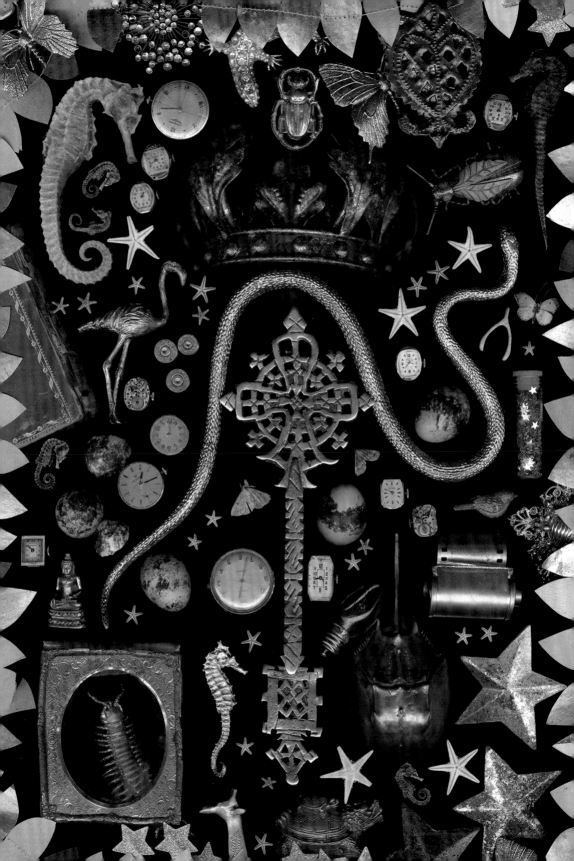

Meditation is a technique used to achieve a deeper level of consciousness where the mind is still, relaxed, and inwardly focused.

The objective of meditation is to go beyond the ever-churning noise of our minds in order to experience our "essential nature"—an awareness of our unconscious self. The mind is difficult to tame and quiet, but with patience and practice, this becomes easier. Meditation creates space between the "self" and your awareness of yourself. This space allows you to be an observer of yourself, to see the elements of "you" without attachment to them and without emotional investment in them. As you become detached from the narrative of who you think you are, you develop control over the thoughts and behaviors that were previously generated mindlessly.

I'm in the early stages of using meditation in order to be more conscious and intentional in my thought processes. I have seen benefits in my everyday life, as well as benefits during targeted application such as brainstorming sessions. Meditation has helped me to be more present and observant on a daily basis. It has positively focused my internal voice and helped me thwart negativity and doubt (which is discussed in greater depth later in the chapter). It's not an activity that will lead to enlightenment if you do it once or twice—it needs to be done regularly (like physical exercise). Some days are easier than others. Stick with it the best you can.

If you sow a seed today, you don't reap the fruit tomorrow, but eventually you will. It takes time to see results.

—

SWAMI RAMA

The more you practice looking inward, the more access you'll have to your unconscious mind, which is the most important reserve of ideas for your artwork. You'll strengthen the ability to override your personal censor (also discussed later in the chapter). All these benefits contribute to higher-quality idea generation and development.

MEDITATION BASICS

Through meditation, you can engage your imagination to visualize images and ideas, as well as successful outcomes to life's events.

Create a quiet, private, and comfortable place where you can sit still. Do your best to practice in the same place and at the same time of day for a minimum of 5–20 minutes.

Keep your head, neck, and body aligned while sitting in a meditative posture (asana position). Close your eyes, and relax your muscles.

Breathe deeply and slowly through your diaphragm. Inhale through your nose, filling up your lungs and holding for a pause before exhaling through your mouth. Focus on this.

Inevitably, many thoughts will occur that incite a reaction: Swami Rama describes these reactions as "a judgment, an action, an interest in pursuing the thought further, an attempt to get rid of the thought." You'll notice how restless your mind is, stuck in an endless whirlwind of anxious activity. Once you learn to follow those thoughts, without reacting, they will pass as you continue to focus on breathing. A commonly used metaphor is to consider yourself a mountain and your thoughts as clouds. Allow them to pass without engagement.

Some people choose to recite a mantra or personal positive affirmation during their meditation to focus their attention on a specific goal.

The technique outlined here reflects the guidance of Swami Rama (1925–1996), the founder of the Himalayan Institute.

A number of guided audio meditations with a range of helpful methods and targeted focuses are available to help you get started. I use an application called Headspace.

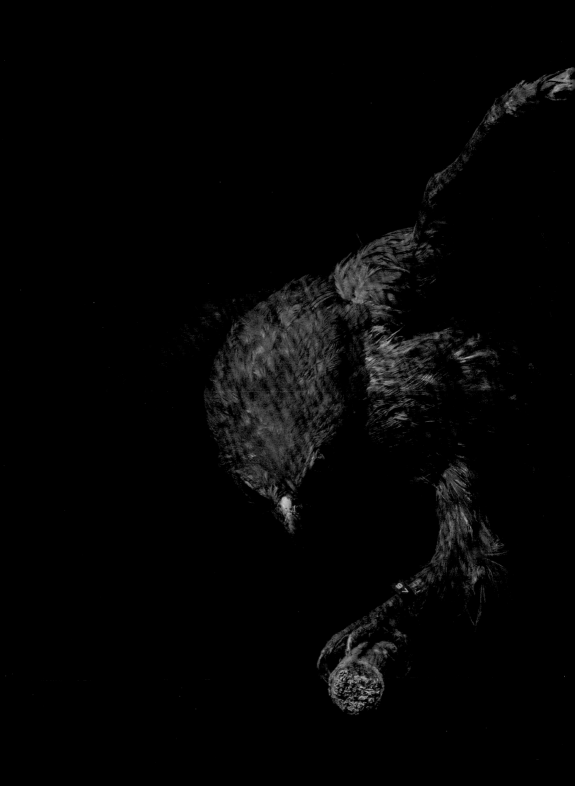

Many of my images have been directly inspired by dreams, a rich and uninhibited reserve of images, symbols, and themes emerging directly from the unconscious mind. I have always been fascinated by the interpretation of dreams. In many ancient societies, dreams were considered a supernatural communication or divine intervention with messages that could be translated by people with certain powers.

Jung believed that archetypes manifested themselves in dreams as symbols or figures, each representing an unconscious attitude largely hidden to the conscious mind. In Jung's view, acquaintance with the archetypes as manifested by these symbols increases your awareness of unconscious attitudes, integrating seemingly disparate parts of the psyche and contributing to the process of holistic self-understanding.

Although Jung acknowledged the universality of archetypal symbols, he contrasted this with the importance of personal context in dream analysis. Dreams, like the unconscious, have their own language. Jung stated that dreams contain "ineluctable truths, philosophical pronouncements, illusions, wild fantasies, memories, plans, irrational experiences, and even telepathic visions" in "The Practical Use of Dream Analysis" from *The Collected Works, Volume 16: The Practice of Psychotherapy*.

Keep a journal and pen on your nightstand, so you can write down your dreams the moment you wake up. Another way to do this quickly in the midst of a morning fog is to speak into your mobile phone's voice note feature. Once you cultivate the habit, it will become easier to remember your dreams.

Once you have mastered the practice of consciously remembering your dreams, you can experiment with facilitating guided dreaming to tap into the resource of your subconscious more intentionally. When I have a picture concept in mind, I try to focus my thoughts on that image before I go to bed in the hopes that I can bring it into my dreams. In almost every case, I wake up with new ideas surrounding the creation of the image.

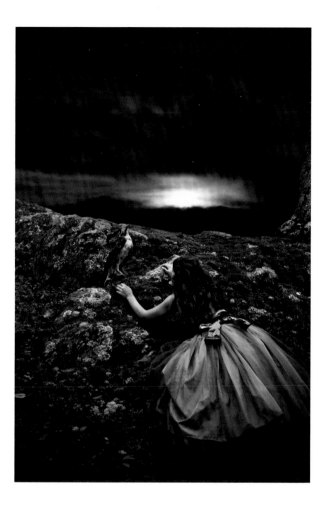

DREAM NOTES

Alone, I traveled a great distance, over beautiful but treacherous terrain, in search of wisdom and advice. I wanted an answer but wasn't sure of the question. I sat at the feet of an enormous bird, wings outstretched (much larger than the one in this image)—as they would flap, the air would swell and spin like a tornado. I listened carefully but didn't understand. I felt I had a long way to go, but something was ending.

At the time of this dream, I was an artist-in-residence in upstate New York at the Millbrook School. I was working on a photo series documenting the school's extensive, vintage taxidermy collection and spent many hours alone photographing the specimens. Not surprisingly, during this project I had a number of dreams that featured animals speaking to me. The day this image was made, I accompanied the students on a class photo field trip to a nearby garden. It was a welcome break from my dark, indoor studio setup. I went with my camera gear, tripod, camera remote, two strobe lights, a bunch of rescued poufy prom dresses from Goodwill, and a few of the pieces from the taxidermy collection. I went with the intention to re-create in feeling a few of my most recent dreams; this image, entitled "The Journey," was the most successful of the day.

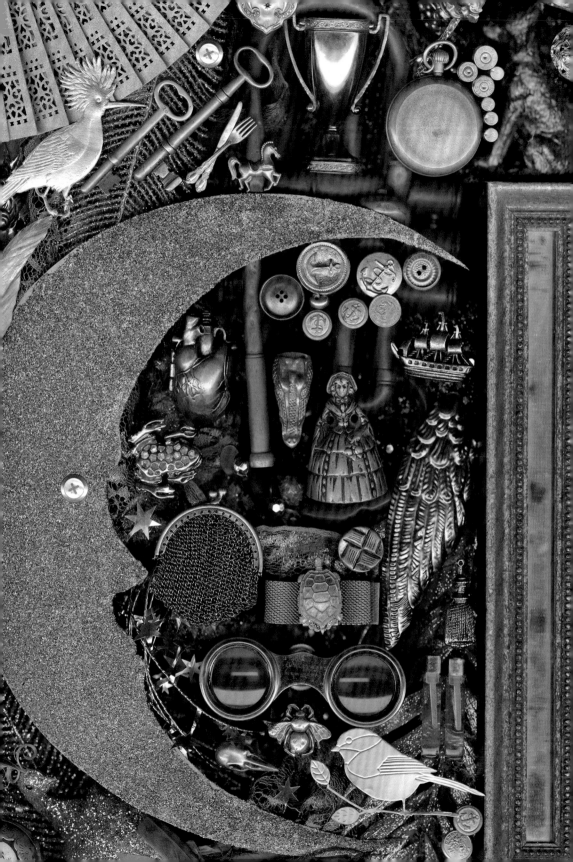

A GUIDE TO BETTER DREAMS

Aim for 7–9 hours of sleep on a regular basis.

Go to bed at the same time every night.

Go to bed earlier (preferably before 11 p.m.).

Create a bedtime routine: Read a book or drink tea before you fall asleep.

Stop eating 2–3 hours before bed.

Avoid alcohol, caffeine (after 12 p.m.), and cigarettes.

Sleep in complete darkness.

Avoid screens (phone, computer, TV) half an hour before bed.

Use aromatherapy; scents, such as lavender, can help with troubled sleep.

Try melatonin. It has been shown to boost REM (rapid eye movement) sleep and make dreams more vivid. Eat melatonin-rich foods, such as cherries, oats, almonds, sunflower seeds, flax seeds, radishes, rice, tomatoes, bananas, white mustard, and black mustard.

Before going to bed, tell yourself that you plan on fully recalling your dreams. Place a notebook or voice recorder at your bedside.

Previsualize your dream. Imagine what you want to dream about, and create a vivid, detailed image in your mind. Tell yourself, "I'm dreaming." Continue until you have fallen asleep.

Put dream influencers, such as a photo, symbol, or object—something that represents what you want to dream about—at your bedside, and focus on it before going to bed.

When you wake up, stay in bed and immediately focus on the details of the dream. Record or write them down right away.

CREATIVE PSYCHOLOGY

Creating is a wonderful and fulfilling process. It empowers us with a voice beyond traditional language. As an artist, you are probably already familiar with the remarkable things that art can do, and you can relate to that uncontrollable urge to create. That being said, the process isn't always easy. Inevitably, artists face a number of psychological and emotional concerns common to the art-making process. Although it's not possible to speak to each individual's set of issues, identifying and understanding your own issues can make it easier to cope with them when they arise.

You may feel all, none, or some of these concerns. They won't necessarily be present all the time, and they can come and go throughout your career. Some dynamics arise at the beginning of your journey; some are present throughout; and some only occur later in your career. Please note that my intent here is not to alienate or paint a doom-and-gloom portrait. Rather, I want to raise awareness of potential issues that may arise, providing support and concrete tools you can use to confront and deal with the emotional and psychological pitfalls of making art.

Everyone is capable of creative feats. But for many, the skill set necessary for creating has been marginalized or drummed out of us by a standardized educational system that crushes creative questioning or by family members with preconceived notions of who we should be. Although we all have creative capacity, not everyone is given the freedom to explore it.

Artists are driven by a curious disposition and a desire to communicate. By nature, we are sensitive and emotional observers—characteristics that can increase our vulnerability. The same traits that make us thoughtful or innovative as artists can also make us susceptible to isolation and discontentment. I, myself, have always felt a little at odds with the world. I struggled through high school and have since met students of all ages who have felt misunderstood or creatively unfulfilled in their lives.

Artists create what has never been seen before. They see the impossible, find the extraordinary in the ordinary, and make new connections and associations between seemingly disconnected things. We are compelled to LOOK at things differently, so it makes sense that we might BE a bit different

GRAND CANYON

(2009)
From the series *Fairy Tales and Other Stories.*
This body of work was a therapeutic outlet
in which I could put all of my questions,
concerns, fears, and insecurities.

from those around us. Or, in the words of neuroscientist Dr. Nancy Andreasen in *The Creating Brain: The Neuroscience of Genius*, "a highly original person may seem odd or strange to others; [the artist] may have to confront criticism or rejection for being too questioning, or too unconventional." This can lead to feelings of depression or social alienation. The following sections examine ways that these tendencies may affect your ability to make work and provide concrete steps you can take to overcome them.

The following are common internal narratives that inhibit or impede work and success.

SELF-CENSORSHIP

Regardless of where an artist is in his or her career, all artists have some level of insecurity about their work—the nagging voice in the back of your head telling you that you are not good enough, that your idea is stupid, or that your image sucks. This voice is typically known as the CENSOR. No matter how much external praise or validation you have received, when it comes down to it, the censor makes you feel like a fraud. Artists are continuously self-censoring because of fears of judgment by others and the terror of disappointment. Learning to quiet this censor takes awareness and time. The most powerful way to silence it is to STOP THINKING OF THIS VOICE AS YOUR OWN. Most often, the censor is not even an accurate authority based on reality. The more consciousness you bring to rejecting this voice, realizing it's a byproduct of fear, the less power it will have over you.

In a study by scientist Charles Limb, a number of improvisational jazz musicians were hooked up to brain-monitoring systems (MRI scanners) and asked to improvise while Limb observed which parts of the musicians' brains lit up. The goal of the experiment was to identify which parts of the physical brain are linked to creativity. Throughout the process, Limb observed hotspots of activity and "deactivated" cold spots without activity. Most notably, the prefrontal cortex of the brain—linked to conscious self-monitoring—was largely suppressed during the improvisation. But the frontal lobe, where consciousness is seated—and which is linked to self-reflection, introspection, and working memory—was activated. The frontal lobe is also the area of the brain thought to be autobiographical or self-expressive.

This study supports the idea that the power of creative expression is within all of us, if we allow ourselves the freedom to give it voice. Art does not come from an ethereal land of inspiration accessible to only a few. You simply need to create the mental conditions for creativity and idea generation to flourish. For this to happen, you must first shut down the judgment center in your brain so you're not inhibited.

FEAR OF FAILURE OR SUCCESS

For artists, fear can be a powerful inhibitor. There is the fear of failure, the fear of investing time and emotional energy into a creation that ends up disappointing us, and the fear of being rejected by viewers. Every artist feels this way. But counterintuitive as it may seem, the best way to neutralize fear is to embrace it. I have found that embracing failure (as described in this chapter's section "Failure") has alleviated a lot of the anxiety I experience around creating.

Conversely, artists also fear success. We fear that if we succeed, too much will be expected of us. We'll be unable to maintain our high status, leaving us embarrassed and exposed in front of a much larger audience with higher expectations.

FEAR OF JUDGMENT BY OTHERS

Showing your work to others can be terrifying—you make yourself vulnerable in the hope for understanding and connection. I frequently find myself fighting the urge to preface my work with a disclaimer such as, "I'm still working on this" or "It's not quite finished yet," just in case the reviewer doesn't think the work is good. Regardless of your own feelings about a project, when you share your work with others you are sharing a piece of yourself and asking to be understood and accepted on some level. This takes tremendous courage.

You must understand that everyone does not have to like your work for it to have value. Some people don't understand it and never will, and others will relate very deeply to it. Having a strong connection to the work YOURSELF—to its importance and value as an expression of you—helps alleviate the need for outside validation.

›

PREMATURELY GIVING UP DUE TO EXECUTION DIFFICULTIES

I see fellow photographers giving up on half-formed but potentially great concepts, because they anticipate that the ideas will be too difficult to execute and that the actual work won't live up to the images visualized in their imagination. Figure out what you want to say first, and then fully go through the brainstorming process to figure out how you can execute it later. With some problem solving and creative thinking, there is almost always a solution, and it's likely not the literal, initial conception of the idea. Although abandoning a difficult idea can SEEM attractive in the short term, you'll experience much greater appreciation for, and validation from, creating the concepts that take extra effort and harder work.

EVERYTHING HAS BEEN DONE

There is nothing more disheartening than coming across work that is similar in nature to an idea of your own that you hatched and worked hard to develop. Except, perhaps, setting out on a project only to discover it has already been done and done again, multiple times, by other artists. The truth is, EVERYTHING has been explored in some way to some extent, but that does not mean you can't make the concept or idea your own. It's important to be aware of projects that exist so you can think about how you can approach your project differently, to learn and grow from what came before so you can make your images even stronger.

It's not where you take things from—it's where you take them to.

—

JEAN-LUC GODARD

TASTE LEVEL VERSUS SKILL LEVEL

Nobody tells this to people who are beginners. I wish someone told me. All of us who do creative work, we get into it because we have good taste. But there is this gap. For the first couple years you make stuff, it's just not that good. It's trying to be good, it has potential, but it's not. But your taste, the thing that got you into the game, is still killer. And your taste is why your work disappoints you. A lot of people never get past this phase, they quit. Most people I know who do interesting, creative work went through years of this. We know our work doesn't have this special thing that we want it to have. We all go through this. And if you are just starting out or you are still in this phase, you gotta know it's normal, and the most important thing you can do is do a lot of work. Put yourself on a deadline so that every week you will finish one story. It is only by going through a volume of work that you will close that gap, and your work will be as good as your ambitions. And I took longer to figure out how to do this than anyone I've ever met. It's gonna take awhile. It's normal to take awhile. You've just gotta fight your way through.

— IRA GLASS

My work is nowhere near where I want it to be, and what I produce is a far cry from the visual concepts in my head. No matter how much positive feedback I get from others, it's simply not good enough yet. At times this still causes me great angst, but I try to think of it this way: I'm making the best work that I possibly can with the resources that I have now, and I'm improving as I go. I'm committed to showing up and doing the work.

PARALYZING PERFECTIONISM

I believe in having very high standards and a strong work ethic. Good work does take time and dedication. There is a point, however, at which needing things to be perfect is paralyzing rather than productive. Let it go.... It will never be completely perfect, but it's important to know the difference between when you have taken a piece as far as you can and when you need to work on it more.

FAILING TO TRY

The safety and comfort of NOT trying something can be tempting when you're faced with the potential scenario of trying and failing. If you are not successful because you know you didn't really try, it's a bit easier to stomach than when you gave it your all, invested everything, and didn't receive the outcome or recognition you had hoped for. But is that really where you want to stay? Embryonic, undeveloped, not having risked? It's emotionally difficult to put yourself and your work out in the world and hope for affirmation. Be honest with yourself, and take courage!

Life shrinks or expands in proportion to one's courage.

—

ANAÏS NIN

ICARUS FALLEN

(2007)
From the series *Fairy Tales and Other Stories.* This image was made on a day when I felt particularly defeated.

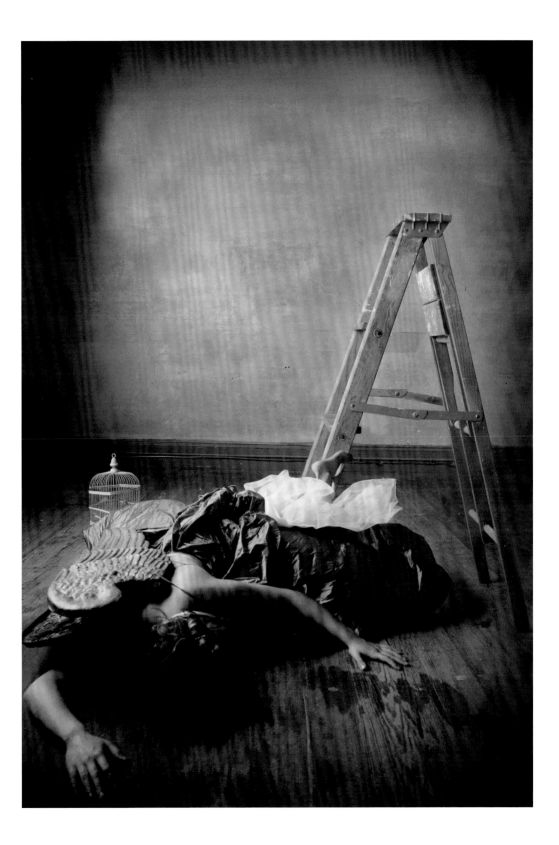

In full disclosure, I have spent my fair share of time alone in my studio crying from frustration following a particularly bitter disappointment. While a bit embarrassing, I think this is totally normal. Because my work is so important to me and I care so much about it, some disappointments feel like they will crush my heart. Like me, you'll experience times when you'll be thrilled with the outcome of a project or with the momentum in your career, and other times you'll feel as if the only movement you are making is the swift progress of a dropped anchor.

Hope and optimism are important...
along with a bit of perspective.

> *Grit, the stubborn* REFUSAL *to quit, is the single best predictor of success. There's one feature that sets highly successful creative people apart from the rest of the pack. Single-minded dedication and the resolve to push through in spite of all obstacles—aka "grit"—is what drives great achievements. In other words, how you react to the inevitable failures along the way will be an important indicator of the end game.*

—

JONAH LEHRER,
Imagine: How Creativity Works

Carol Dweck, psychologist and author of *Mindset: The New Psychology of Success,* has focused her research on how children respond to challenges. She has identified two "mindsets" or approaches that children (and adults) have regarding learning and problem solving. A FIXED MINDSET is the belief that talents and abilities are fixed, that you are innately talented or you're not. Conversely, a GROWTH MINDSET is the belief that talents and abilities can be further developed through hard work, solid strategies, and collaboration with others; no matter who you are or how smart you are, everyone has the same capacity for growth. This shift in perspective has a huge effect on how we approach challenges that arise.

You can embrace the process, strategy, effort, and possibility of
 failure

— SEEING IT AS AN OPPORTUNITY FOR GROWTH —

or you can run from difficulty, never leaving the comfort zone
of what you already know you can do. Instead of thinking, "I'm
not good at this, I'm not talented, I'm dumb," you can shift
your perspective and think, "I'm learning how to think through
problems, recover from failures, and realize I'm getting better."

This reframing of my personal potential is tied into my belief
system around failure. All of these mindful thought processes
have liberated me from some of my toxic mental battles.

Another way I combat particularly thorny challenges in a project
is to simultaneously maintain a few ongoing, low-maintenance
or easy projects. That way, if one of my projects becomes
momentarily impossible to deal with, I can pivot to the easier
one, then return to the problem project when I'm better
equipped to handle it. As you'll read later in this chapter, a
strong, supportive core community can also help you vault
over the low points. Remember: making new, vulnerable work
and putting it out in the world takes courage.

→

ASPECT MEDUSA, BUCHAREST

(2013)
Fashion. Credits: Marta of MRA Models,
Raluca Racasan (styling), Alex Claudiu
Sarghe (hair), Irina Selesi (makeup),
Institutul de Arheologie (location),
Cristian Movila (producer).

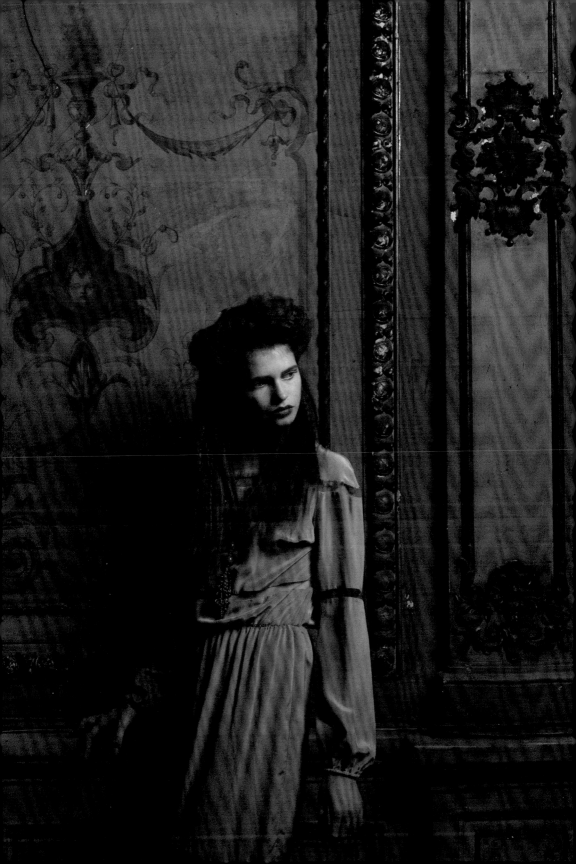

The old adage "Fake it 'til you make it" has a lot of value. If you don't believe in your work, no one else will.

If being confident doesn't come naturally to you or makes you feel like an imposter, then create an alter ego super-hero character who is the confident artist version of yourself, and use your super-hero self to interact with the world. (My character even has a costume, or armor of sorts; when I wear it, I feel protected.) Super-hero me is still me, but an aspirational me with unlimited reserves of confidence in my work.

People's perception of one another comes from nonverbal communication and body language—the way you stand, where your hands are placed, how your body moves, what facial expressions you use, and your overall outward appearance. Being conscious of these things can help you appear confident even when you lack confidence. For some, using a positive mantra, spoken affirmations, or setting intentions can help overcome the anxiety that arises from low self-confidence.

POWER POSES

During a TEDGlobal talk, social psychologist Amy Cuddy offered a free, low-tech life hack: Assume a power posture for just two minutes—and change your life.

In lab tests, Cuddy found that people who adopted high-power poses for two minutes would alter their hormones in surprisingly beneficial ways. The two hormones linked to feeling powerful are high levels of testosterone and low levels of cortisol. Altered levels of these hormones were achieved after only two minutes of adopting any of the following power poses:

> The **Wonder Woman** or **Superman**. Wide stance, chest out, hands on hips.

> The **Starfish** or **Victory**. Wide stance, arms above head in a V.

> The **CEO**. Sitting, feet up on desk, leaning back, hands behind your head with your elbows out.

Two minutes before you go into the next stressful performance situation, configure your brain to best cope with that situation with a power pose. Go somewhere private. Get your testosterone up. Get your cortisol down.

HEALTH

The mind-body dichotomy is a myth of our contemporary society, and one that has particular relevance for artists. The work you produce reflects your internal state, and your well-being will not only impact what you make, but your motivation to make it in the first place. While discomfort with the status quo is often what drives artistic exploration, it is important that the discomfort doesn't reach a degree where it becomes destructive or debilitating. Maintaining a strong awareness of your physical, emotional, and psychological health is critical to successfully making work.

CHRONIC ILLNESS, MENTAL HEALTH, AND DEPRESSION

> *Those who have been eminent in philosophy, politics, poetry, and the arts have all had tendencies toward* MELANCHOLIA.
>
> — ARISTOTLE

Significant anecdotal evidence supports the idea that people in artistic professions have a higher incidence of mood disorders. Not great news, since we all know how difficult it is to make work when we feel terrible—whether from mental discomfort, physical pain, or a combination of the two.

Dr. Nancy Andreasen, psychiatrist and neuroscientist, studies the correlation between creativity, original ideas, and mental illness. The most common conditions include anxiety disorder, bipolar disorder, and depression. Exceptionally creative people are more likely to have a close relative with schizophrenia. In *The Creating Brain*, Dr. Andreasen hypothesizes that "some particularly creative people owe their gifts to a subclinical variant of schizophrenia that loosens their associative links sufficiently to enhance their creativity but not enough to make them mentally ill."

Creatives are adventurous and exploratory risk-takers. The most innovative work happens in uncharted territory with much potential for doubt and rejection. Risk-taking can be exhilarating but also has the potential for pain. We are, after all, often alone in the belief in our work's value. Dr. Andreasen writes, "This can lead to psychic pain, which may manifest itself as depression or anxiety, or lead people to attempt to reduce their discomfort by turning to pain relievers such as alcohol" or drugs.

A willingness to take an enormous risk with your whole heart and soul and mind on something where you know the impact—if it worked—would be utterly transformative. The IF here is significant. Part of what comes with seeing connections no one else sees is that not all of these connections actually exist. Some people see things others cannot, and they are right, and we call them creative geniuses. Some people see things others cannot, and they are wrong, and we call them mentally ill.
— DR. NANCY ANDREASEN

As someone who has struggled with a combination of chronic illness and depression, I know these conditions are not widely discussed, which causes many people to suffer needlessly in silence. I believe in a very strong mind-body connection, and it can be difficult for those who are particularly sensitive to differentiate between the two. Mood and physical disposition affect the work you make in a huge way. Contrary to popular belief, you do not need to be tortured or depressed to make great art. In fact, I find it difficult to make anything when I'm depressed or physically ill. But it's not realistic to expect to be happy all the time, either. I think it's important to experience the full range of human emotions as part of living life fully. You will experience some pain, frustration, and disappointment, and that is okay, provided it doesn't turn into a debilitating depression.

A certain darkness is needed to see the stars.

— OSHO

Unfortunately, I cannot provide a cure for depression, but I have found lifestyle suggestions (listed in the sidebar "Small Coping Tools for Depression" and found later in this chapter) that have proven very helpful for preemptive avoidance of a spiral into depression and illness. Seek help when necessary. Build a support system to surround yourself with people who understand. Try to understand your mood patterns and triggers. Maintain a space of inspiration. Explore external explanations, such as illness or diet, that may contribute to downward spirals, and find ways to make changes in these areas.

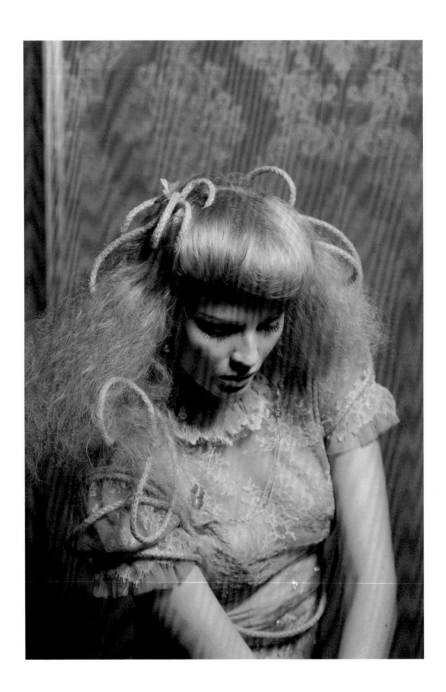

IMPERIUM

(2011)
For the Jumeirah Zabeel Saray Hotel.

MOLUCCAN COCKATOO NO. 7696

(2012)
From the series *Birds of a Feather.*

SMALL COPING TOOLS FOR DEPRESSION

Some of these things may seem like impossible tasks when in
the midst of full-on depression, but try to bring yourself to: shower,
make your bed, get dressed, drink water, go outside, play with
an animal, finger-paint, undertake an inspirational activity, visit
your sanctuary, try aromatherapy, invest in a light therapy lamp,
eat superfoods that are nutrient-rich, and ask for help.

MOLUCCAN COCKATOO FEAST

(2014)
From the series *The Fantastical Feasts.*

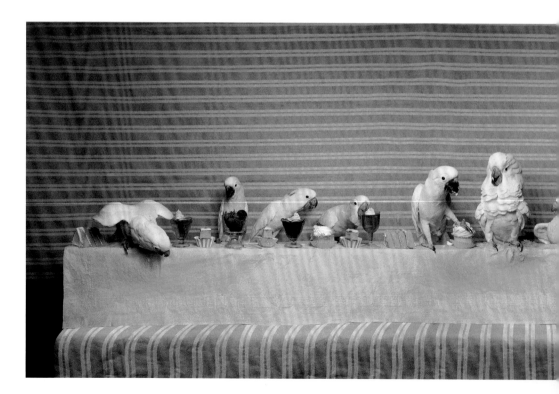

HEALTH | *Diet, Depression, and the Microbiome*

New studies are exploring the link between diet and clinical depression. The data indicates that consuming whole, natural foods helps prevent depression, whereas a diet with lots of highly refined sugars and processed ingredients exacerbates it.

The gut microbiome (which helps to regulate immune response) is linked to mental and physical health. Research shows that some pathologic species that cause inflammation appear to thrive on unhealthy diets, leading to depression. Modifying diets toward more whole foods and away from highly refined, sugary, fried, Western diets can modify the gut bacteria, lowering the risk of developing clinical depression.

📖 RECOMMENDED READING

"Diet, Depression, and the Microbiome," (2015), Emily Deans, M.D.

The Diet Cure: The 8-Step Program to Rebalance Your Body Chemistry and End Food Cravings, Weight Gain, and Mood Swings—Naturally (2012), Julia Ross

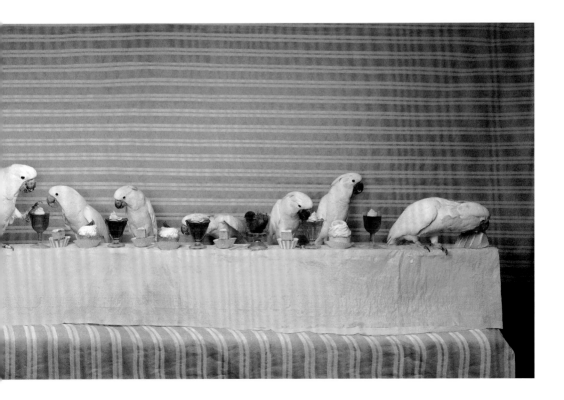

Positive psychologist Shawn Achor's entertaining TED Talk, "The Happiness Advantage," highlights the importance of changing the lens through which our brains view the world to focus on privilege and the positive, rather than the negative. Doing so reshapes our reality.

Achor emphasizes an inversion of the common expectation that "If I work harder, I'll be more successful. And if I'm more successful, then I'll be happier." In Achor's view, this mindset inevitably yields misery; every time you have a success, your goalposts for success change. If happiness is on the other side of success, then happiness is unachievable.

If, however, you change the common expectation that happiness is based on your external world and instead find a way to become positive in the present, then your brain will actually be able to work harder, faster, and more intelligently. The brain in a positive mindset significantly outperforms the negative, neutral, or stressed brain in the areas of intelligence, creativity, and productivity. Dopamine (the happiness hormone) activates all the learning centers in the brain, enabling adaptation to the world.

Because I am hyper-focused on improvement, always striving to achieve a high level of excellence in my work, I can become very critical and disappointed in myself, resulting in unhealthy and unproductive attitudes if left unchecked. Although I'm still striving for the appropriate balance between maintaining high-quality output and a positive outlook, I have found Shawn Achor's framework for thinking and tools for positive psychology helpful in shifting my perspective.

FOCUS ON THE POSITIVE

Shawn Achor's advice for rewiring your brain includes taking the following actions daily for 21 consecutive days:

THREE GRATITUDES. Write three new things that you are grateful for to train the brain to scan the world for positive things first.

JOURNALING. Write about one positive experience that occurred in the past 24 hours, allowing your brain to relive it.

EXERCISE. Exercise for at least 10–20 minutes per day.

MEDITATION. Meditate for at least 5–20 minutes per day.

ONE RANDOM ACT OF KINDNESS. Do one nice thing for someone else every day, even if it's just a quick message to say thank you or something small and thoughtful.

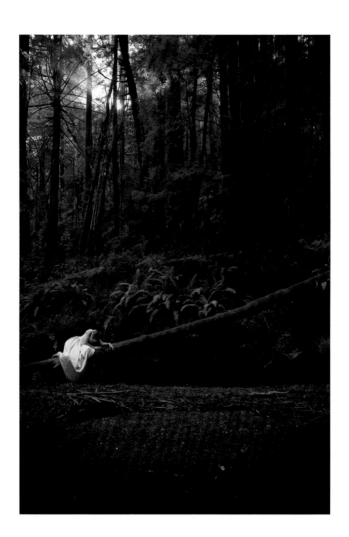

THE REDWOODS

(2008)
From the series *Fairy Tales and Other Stories*.

If you can't get to a forest, even a 20-minute walk outside will help refocus your mind.

Brains are easily fatigued by constant busywork. Slowing down to take in natural landscapes not only restores, but also improves mental performance on creative problem-solving tasks.

The art of healing comes from nature, not from the physician.

—

PARACELSUS

National Geographic highlighted research conducted by a number of scientists in their feature "This Is Your Brain on Nature" by Florence Williams. Yoshifumi Miyazaki at Chiba University has shown that taking

a walk in the woods

for even 15 minutes yields noticeable changes in physiology: a measurable decrease in cortisol (the stress hormone), respiration, blood pressure, and heart rate. A 40- to 50-minute walk yields even greater mood and attention benefits, including "decreased activity in the subgenual prefrontal cortex—a part of the brain tied to depressive rumination" and an increase in activity in "the anterior cingulate and the insula—areas associated with empathy and altruism."

David Strayer, a cognitive psychologist at the University of Utah, is studying what he calls the "three-day effect," analyzing the recalibration of the mind that occurs when study participants are immersed in nature for a period of three days. From "This Is Your Brain on Nature": "Strayer's hypothesis is that being in nature allows the prefrontal cortex, the brain's command center [of conceptual thinking and sustained attention], to dial down and rest, like an overused muscle." Taking this further, Strayer hypothesizes that reducing stress and mental fatigue has a sustained, positive effect on higher-order problem solving.

NURTURING CREATIVITY

There are many things you can do to create the conditions for creativity and productivity. Although everyone is capable of being creative, reaching your full potential requires you to nurture that creativity.

THE INDIVIDUAL METHOD

People are filled with quirks and idiosyncrasies. When it comes to the creative process, the ability to embrace your own personal quirks is vital. Give yourself permission to develop an individual method of creating that works best for you. YOU DON'T HAVE TO DO THINGS THE WAY EVERYBODY ELSE DOES THEM. This applies to the way you work, the art that you make, and the way you present it in the world.

> *The modern individual grows continually in [...] awareness [...], explores the world [...], and questions the assumptions of the operant societal worldview rather than just blindly living life in accordance with dominant norms and assumptions.*
>
> — CARL JUNG

People who are less in tune with their creativity tend to instinctively revert to rote responses when reacting to a situation, whereas those more in touch with their creativity tend to question and think independently, opening themselves to more fluid responses to new situations. Our brain is hard-wired to recognize patterns and create shortcuts, which cuts down on the time spent processing, analyzing, and making judgments in familiar situations. Although often useful, these shortcuts can trick you into following well-trodden paths without questioning them or imagining alternatives, which can lead to blindly following rules and conventions that are a reality only in our mind. Before deciding that something should be done a certain way, ask yourself why. Nothing says you can't print your pictures, burn them, sew on top of them, paint on them, then re-photograph them, and turn the resulting image into a neon sign. Rather than thinking of reasons that impossible ideas can't be done, imagine that they MUST be done, and then figure out how to make them happen.

Pick and choose what works for you, and formulate your image-making process around who you are and your own personal strengths and weaknesses. Think about your individual needs, workflow, and resources. Ask yourself, "Do I work better in the middle of the night? In the morning? As part of a team? Alone? In public? While eating?" Depart from conventions, break the rules, and see where that takes you. If that means having only red food for breakfast on Tuesdays and only working during odd-numbered hours of the day, then so be it. This goes for learning, making, and marketing strategies as well.

SEE THE WORLD

(2014)
Creativity demonstration at Ivy Hall on the SCAD Atlanta Campus. Jillian Christmas (model).

Everyone wants to know the secret to becoming a better photographer; it may even be why you bought this book. Here it is: If you want to be a better photographer, YOU HAVE TO MAKE WORK. LOTS AND LOTS OF WORK. The more images you create, the better you'll become, provided you are analytical about your images as you make them.

I used to think that to be good at something, a person had to have some natural ability. Now I understand that although innate talent is nice and may make things a little smoother in the beginning, there is truth in the old adage "Practice makes perfect."

I wanted to be a painter when I was younger, but I was horrible at it and became discouraged. When I found photography, I thought, "Finally! I can get these ideas out of my head in a way that isn't terrible." After a decade-long hiatus, I recently began taking a drawing class with the new attitude that it just takes time and practice to hone a skill. The levels of improvement I have made are dramatic, and they came purely by sticking with the process, making a lot of rough sketches, and doing the exercises. Although my drawings are far from amazing, I'm enjoying the process of seeing my own learning curve arc upward over time. It has been liberating to allow myself to make work that is "really bad" without judging myself for it and without abandoning the journey.

Artists who are truly great work toward excellence in their craft throughout their lives. Instincts you may observe in an accomplished artist that seem second nature and effortless may have emerged in that artist's life only after years of practice and repetition. Creativity is like a muscle that needs to be exercised. Don't use it, and it atrophies. Use it, and it becomes stronger. Luckily, you can begin using your creativity at any time. Although it may be slow getting started, the more photographs you create, the more momentum will build, and the easier it will get. As a freelance artist, I regularly make my own self-directed work, so in a sense I'm always practicing and experimenting. I shoot often, and the ideas that are good I develop, and those that aren't remain as test shoots.

Success is 10 percent inspiration and 90 percent perspiration.
—

THOMAS EDISON

Failure is important. Photographers often feel pressure to produce portfolio-quality work with every shoot. This pressure produces so many fears: the fear of wasting your time, the fear of wasting your team members' time, anxiety about wasted resources, the terror of being judged as not good enough. As a result, a lot of people are blocked from making work with the things that they have around them. They have built up all these ideas around what a picture HAS to be instead of just getting on with it and making SOMETHING.

Being comfortable with failure relieves that pressure, freeing you up to make work that is more liberated. When I say failure, I'm not talking about not trying; I'm talking about instances when you tried to bring an idea or concept to life and it did not quite work as imagined. Not trying, or not taking the risk, is much worse. If you are making a picture that you know will work, you are not trying. You are choosing not to challenge yourself to try something new, and your image-making will not evolve and grow. It's far better to take risks and to be completely okay with something falling to pieces. I guarantee that even the attempt will inform the work you make down the line. The images that I'm making now would never have been possible without some of the absolute duds I made in the past. If it helps, remember that you don't have to show anyone work that doesn't pan out.

For a seed to achieve its greatest expression, it must come completely undone. The shell cracks, its insides come out and everything changes. To someone who doesn't understand growth, it would look like complete destruction.
— CYNTHIA OCCELLI

I'm not suggesting that you take the shoot-to-fail approach when working for a client. Fulfill the brief first, which is likely an image that you know how to shoot. Then, when you know you have satisfied your client, and if circumstances allow, push the boundaries and try a newer idea on set. This may not always be appropriate or possible in a commercial context. It's vital for commercial photographers to create "personal work" throughout their careers, so they can work without the pressure of performing for a client.

PRACTICE

Musicians and dancers spend hours and hours practicing prior to any performance. In contrast, many photographers go regularly to their performance (making work for their portfolio or an assignment) without ever practicing. I think this is a lost opportunity for improvement. Even painters and sculptors make multiple sketches and maquettes before creating their masterpieces. Because of the instantaneous nature of photography, the "practice" mindset has never been a part of the culture. Approaching a shoot as if it were a performance and practicing accordingly will refine your process and improve your concept development.

PLAY

Play can go a long way toward alleviating some of the pressures and anxieties artists feel when producing portfolio work. By allowing yourself to play, you are excusing yourself from making something "serious" within the confines of traditional grown-up behavior and the rules and consequences associated with it. A state of play allows you to explore new possibilities. Simply play. Play doesn't have a purpose beyond itself, so don't over-think or scrutinize. The freedom and joy that come out of play has the power to recharge like nothing else. The new energy this will give your work will be apparent later. I'm not exaggerating when I say that almost all my most successful projects arose out of play.

Creativity takes time. Long stretches of uninterrupted time. Sadly, we are in such a hurry to produce, make deadlines, and maintain social-media visibility that it has affected the quality of the work we make. The downside is a collective lowering of standards and a bunch of burnt-out artists.

In Jason Fried's TED Talk, "Why Work Doesn't Happen at Work," he likens work to the stages of a sleep cycle. Short bursts of time won't do, and neither will frequent interruptions. To get to deep work, like deep sleep, you can't simply skip ahead or start and stop. You must progress through the stages, one by one.

Typically, the first ideas that arise are the most obvious, literal, or cliché. These are at the front of your mind and are really just a jumping-off point. Given the time to think about a particular idea, it will evolve and improve—like marinating, which infuses, enriches, and creates more nuance. Thoughts become more sophisticated and complex when allowed to steep over time. I spend hours, days, weeks, and sometimes months thinking about images or projects, allowing them to fully form and come together.

Well, I must endure the presence of two or three caterpillars if I wish to become acquainted with the butterflies.

— ANTOINE DE SAINT-EXUPÉRY,
The Little Prince

That's not to say that ideas can't be born and executed in a short amount of time. I have taken commissioned briefs from idea through execution in less than 10 hours. And admittedly, there is an exhilaration that comes with a fast and focused turnaround time. But I don't do jobs like that all the time. And honestly, with more time, I believe the finished product would undoubtedly have been better.

I have shot images and filed them away for months. I return to them later, with new ideas—about how to process the picture, conceptualize the image—that change the work for the better.

Fallow time is a term with origins in agriculture. It's the period of time prior to planting when the fields are allowed to rest, the soil's nutrients are replenished, and the land recovers so it

can produce crops again. Lying fallow is important for artists, too. Giving yourself time to rest your mind and replenish depleted reserves of creativity is a necessity.

Solitude is also an important ingredient for getting in touch with your inner mind and granting it the time to process, reflect, and generate. There are times when quiet will be important. Identify the value that solitude can have for you, and work toward creating a balance between being alone and engaging with the world.

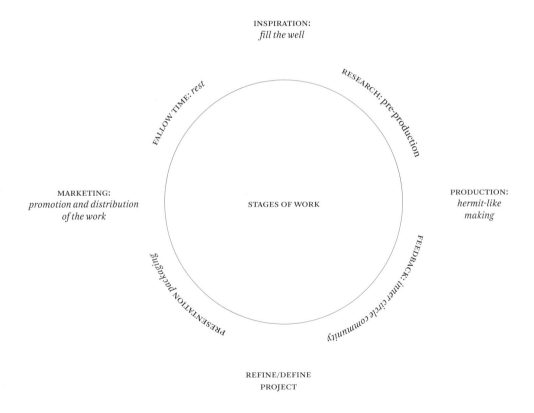

INSPIRATION:
fill the well

RESEARCH: *pre-production*

PRODUCTION:
hermit-like making

FEEDBACK: *inner circle community*

STAGES OF WORK

REFINE/DEFINE
PROJECT

PRESENTATION: *packaging*

MARKETING:
*promotion and distribution
of the work*

FALLOW TIME: *rest*

Allocate your time in stages or cycles rather than trying to fit all things in, all the time. Trying to do too many things at once can lead to doing all of them badly.

You don't need a giant studio with the newest top-of-the-line gear to make great work, but you do need a space that you like to be in. It should be somewhere you feel safe and inspired. And it doesn't require a big budget. Whatever amount of space you have, whether that's a corner you carve out of a room for a desk and a comfortable chair with nice lighting or a part of your garage, you can do small things to make your studio a space you want to be in and one that is conducive to getting work done. The artistic process is difficult enough; make it easier on yourself by creating a space that meets your individual needs. The energy of your space will have an effect on your ability to produce work efficiently. What types of shots do you plan to take? Do you require a lot of props? Or do you need a studio that is largely a "think space" that is clear, uncluttered, and serene? Do you want to be surrounded by objects that you like? A lot of colors? Darkness? Do you work best sitting on the floor? In a chair? On a couch? Outside? In public? Do you prefer a messy space? Pay attention to details such as lighting, seating, what's on the walls, how you store things, etc. With some thought and strategy found in Feng Shui philosophy, you can organize your space to encourage optimal creative output and success.

FENG SHUI

A Chinese system of laws that govern spatial arrangement and orientation in relation to the flow of energy (qi). These relationships are taken into account when designing spaces and buildings. Beyond design and decor, Feng Shui uses psychological principles that affect mental, emotional, physical, and spiritual health to enhance interiors.

The photographic process requires different flows of energy:

CREATIVE / DREAMING / BRAINSTORMING / RESEARCH

ACTIVE EXECUTION / MAKING OF WORK

ADMINISTRATIVE / PROFESSIONAL

When organizing your studio, consider what mood or energy is desired for the specific activity in the space allocated for it. Think, "How do you need to *feel* in order to perform this activity well?"

An artistic practice requires many materials and tools; if not arranged thoughtfully they may look like clutter, but they are not the same thing as clutter. In a busy studio space, clear organization is crucial to maintain the feng shui flow of creative energy. Clutter refers to anything that no longer serves a purpose and should be thrown out.

If you don't use it or love it, then get RID *of it!*

—

TISHA MORRIS,
Feng Shui Your Life:
The Quick Guide to Decluttering
Your Home and Renewing Your Life

Clutter creates stagnant energy that inhibits creativity. It is emotionally and personally draining. Every now and then, a proper clean-out is important, allowing you to make room for new things to enter your life. This is a subjective process—it is not about getting rid of everything—address the things that are piling up and loaded with negative energy.

To make a "mess" while in the midst of a project is completely understandable and encouraged—just put things away once you are done to remain organized and maintain good energy flow.

	NATURAL ELEMENTS		LIGHTING	
	plants, natural light, rocks, etc.			
SENSORY STIMULUS				
set mood / energy	COLOR	MOVEMENT	SOUND	SMELL
	wall paint	*water fountain*	*music*	*oil in a diffuser*
	artwork		*nature track*	

ˇ ˇ

Red Creativity
Orange *Bergamot, Lemon,*
Yellow *Frankincense,*
Neroli, Rose,
Jasmine, Cloves

Focus
Thyme, Lemon,
Fennel, Bergamot,
Basil, Cypress,
Cinnamon

DECLUTTER. Everything from old/unorganized computer files to old supplies. Sweep the floor, throw out the trash. Make room for new work.

Leonardo da Vinci used Neroli oil daily for inspiration.

+

ORGANIZE tools and materials.
Keep "like" things together.

GALLERY
Showcase your successful projects. Also, hang up any letters, notes, or words of encouragement to increase energy for future recognition.

"WILD" messy area
Items necessary for ongoing work BUT you must regularly revise and clean this area.

INSPIRATION area | SHRINE | CREATIVITY TALISMAN
Space for images or objects that inspire you.

PLAY space
Encourage a sense of play for brainstorming...something fun and childlike.

align with
ENTRANCE OF ROOM | POSITION AT DESK

Use the above Bagua Map, or energy map, to designate areas of focus for the room and the area on top of your desk to improve positive energy flow.

Arrange furniture so that you face the main door, in a "commanding position," as it is important that you can see people and "new opportunities" entering the room. If this cannot be accomplished, place a small mirror on your desk to reflect the entrance.

Artwork should be seen as soon as people enter in the section FAME & REPUTATION.

Clean your desk. At least 50 percent of the table should be clear at all times—especially the MIND, BODY & SPIRIT and CAREER & LIFE PURPOSE sections.

Calculate what percentage or amount of space you need for the following:

BRAINSTORMING & CREATIVE SPACE | FABRICATION/BUILDING AREA |
SHOOTING SPACE | GALLERY | OFFICE | MEETING PLACE |

STORAGE
*filing/archive/library/books & reference
materials/gear/prop/set/wardrobe/artwork*

Use this as a guideline to map out and reorganize your workspace for optimal productivity.

If you want to understand how you truly feel about a certain idea or theme, free-write about it without editing. I have never been a confident writer, so I can relate to feeling hesitant about incorporating a writing practice into your work. That being said, stream-of-consciousness writing will unlock ideas. Something about picking up a pen, moving it across the page, and writing the spill of whatever comes out of your mind without stopping opens the path for deeper ideas to emerge. This writing process is an exploration of your own thoughts and should be done unselfconsciously and with reckless disregard for grammar or spelling.

HANDWRITING VERSUS TYPING

Studies have shown a measurable difference in the mental connection that happens when writing something out with your hand versus typing compositions on a computer. Handwriting yields a stronger conceptual understanding than typing. Mind mapping and brainstorming start with paper and pen. If necessary, organize and transcribe your handwritten thoughts to the computer afterward.

Keep an idea sketchbook with lists of ideas for projects and pictures that you want to make in the future. Even if your best freehand drawing is limited to stick figures, sketch out concepts for picture ideas with notes so that you don't forget them. You can also begin the brainstorming process with the mind maps, mood boards, and production sheets covered in Chapter 4. I often have ideas for projects before I'm ready to complete them. With my idea book, I know I can keep these ideas until the time is right. If I ever start to feel a lack of inspiration and am stumped on what to work on next, a quick scan through my idea book unfailingly gives me something to work on.

MORNING PAGES

Another one of my favorite takeaways from Julia
Cameron's *The Artist's Way* is a practice known as Morning
Pages: Simply write two or three pages, stream-of-
consciousness style, when you wake up, before you start your
day. The benefit of doing this is twofold:

> We all have a lot of distracted thoughts buzzing in
> our heads at all times, from the mundane dirty
> dishes, oil changes, and grocery shopping to
> bigger concerns like work, love, health, self-
> worth, and the meaning of life. This chorus of
> concerns runs repeatedly through our minds all
> day. However, if you can clear the "NOISE,"
> releasing it onto paper as soon as you wake up,
> you are free to go about your day and turn your
> attention to creative productivity.

> This activity forces you to write without the
> constraints of perfection or structure. The more
> practiced you become at allowing your mind to
> flow freely onto paper without judgment or
> censorship, the easier it will be to generate new
> ideas in other contexts.

If you do this consistently, you will notice a difference in
your mindset and how you approach the day.

→

CANARY WING BEE BEE NO. 7736–81

(2012)
From the series *Birds of a Feather.*

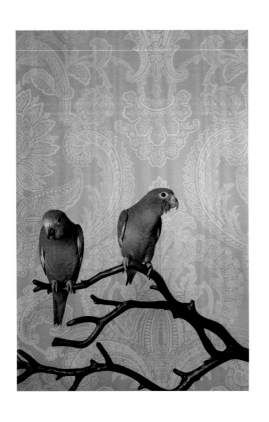
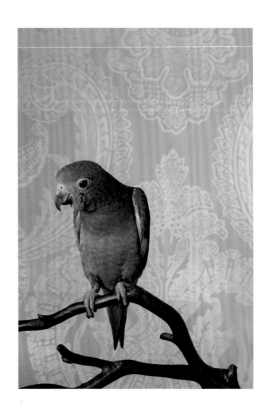
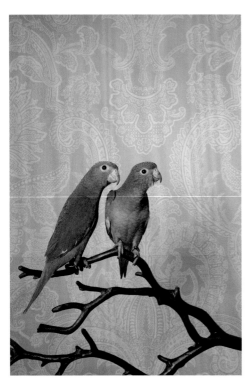
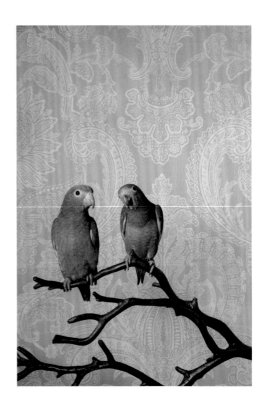

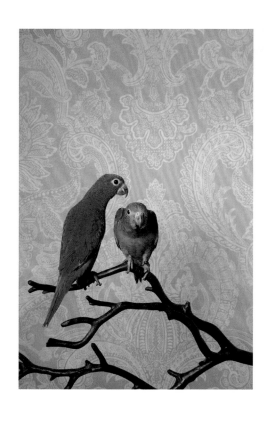
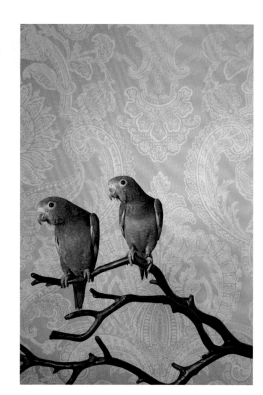

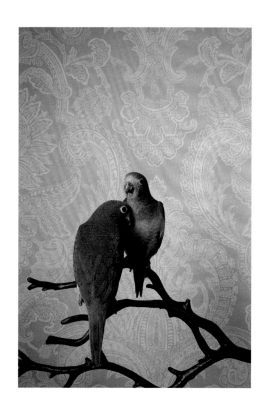

Young artists are frequently beset with anxiety. They are confronted by self-doubt. In addition to the encouragement derived from studying the lives of their artistic models, these individuals also need support from those around them....

—

VERA JOHN-STEINER,
Notebooks of the Mind:
Explorations of Thinking

Considering all the psychological and emotional aspects involved in creating work, it's important and valuable to have a support system of artists who really "get" what you are going through—people who understand you and don't think you're crazy or strange. A strong network of folks like these will provide general support, be a sounding board for new ideas, and act as a collaborative resource for those times when you need help to pull something off.

It's important to identify healthy relationships. Some well-intentioned friends and family may just not fully understand what you do, or not truly approve. Though the "support" these people try to give you may be meant well, it will likely carry mixed messages that will cause you to feel uneasy, misunderstood, or exhausted. You must emotionally protect yourself from these types of relationships.

It's also natural to develop feelings of jealousy and competitiveness with other artists' apparent successes. But things are not necessarily how they appear and it's more important to continue to make your own work to the best of your ability than to make comparisons to, or worry about, what other people are doing.

Two heads are better than one. Finding a kindred spirit to collaborate with can be a magical, synergistic experience with the power to elevate your work to a new level. The benefits of a successful collaboration can be exponential, whether you are working with someone in the same field or partnering with an artist from a different field. In addition to the rich ideas that collaborations can produce, there are also benefits that partnerships bring to a project's execution—both physically and emotionally. Having a supportive ally helps with problem solving and provides myriad other psychological boosts.

Even the best collaborative relationships can come with difficulties—interactions need to be cultivated and based on trust and mutual respect. Be sure to clarify the roles, expectations, and ownership of ideas in advance to avoid potential conflict and fallout down the road.

∞ RECOMMENDED VIEWING

NIX + GERBER, The Drawing Room

The Fantastic Absurdities of Kahn and Selesnick, Chronogram

Historically, apprentices lived and worked under a master for seven years, a tradition dating back to the medieval era. In exchange for an apprentice's labor, the master would provide food, lodging, and a formal education in their respective field of expertise. Apprenticeships offered structured higher learning, tangible skills, and knowledge.

Today this training system is most often linked to academic and vocational institutions. The duration of master tutelage has shortened considerably, with more emphasis placed on internships or on-the-job training.

One of the more effective ways to learn is through active participation in real-life experiences, which allow students to gain empirical knowledge. Because of the unpredictable nature of the arts industry (there is no formula), it's difficult to properly prepare for a future career solely in a classroom environment. This is why internships are so important. They give students an accurate, inside look at how others run their daily business on a creative and practical level. They also provide opportunities for networking and relationship building.

When soliciting an internship position, it's important to be somewhat selective in whom you choose to shadow. Seek someone more advanced in their career rather than a successful up-and-comer, because the up-and-comers are probably still making their fair share of mistakes as they navigate uncharted territory. Look for someone whose career you admire—someone with a practice that resembles the one you aspire to. It's also a good idea to find an internship in the geographic area where you would eventually like to be based.

All the formal education and internships in the world won't prevent you from running into questions and challenges throughout your journey. Although there is not one path to success in the arts and no two careers are the same, it is very valuable to be able to run things by people you respect, admire, and trust, and who are advanced in their career. Whether you have a technical question, a creative question about the direction of your work, or a business question—How much should I charge for this? Is this contract okay?—having someone to turn to will make you more confident in navigating difficult decisions. Admittedly, an abundance of information is available online, but having a dedicated person (or people) to personalize the advice and provide support is very helpful. You may find that you outgrow your initial mentor. As you become more advanced in your career, mentors can become more difficult to find, but it remains an important part of your support system nonetheless.

Learning is a lifelong pursuit. Even if you have completed your formal education, take a class or workshop from time to time to keep challenging yourself. Personally, I like to take classes that are not in my field or specialty in order to bring new knowledge and perspective back to my work. In addition to learning a new skill set, I love the community-building aspect of being introduced to a set of peers outside my field.

If you live in a remote area—or don't have the resources to travel to take a class—a number of wonderful and affordable online learning programs and services exist, such as CreativeLive and Lynda.com.

Although art school is not necessary for all artists, attending SCAD provided me with a solid foundation for my technical photographic skill set and a great community network. Having access to a positive learning environment with faculty who inspire and support you can alter the course of your work and career. I'm so grateful for the education that I received. In contrast to my experience, I've heard numerous stories from other photographers who were discouraged by teachers whose efforts to mold students in their own style created a hostile learning environment, or who damaged students' confidence and love of creating at an impressionable time. If you are thinking about a formal education in the arts, be sure to do your research on the program, faculty, and culture of the school before committing to it.

If you have the opportunity to teach in any capacity, I highly recommend you take it. Teaching is enormously rewarding, and you'll learn as much in the role of teacher as you would in the role of a student. It's important to give back and share the knowledge that you have, even if it's not in the formal setting of a classroom. This is not entirely altruistic, because there is no better way to reinforce your understanding of material than to have to explain it to someone else.

CREATE A NETWORK OF RESOURCES

I'm part of a community of artists
that serves as a reciprocal source of
advice, assistance, friendship, and
support. Fortunately, there is a lot of
interest in both art and photography,
so there are plenty of opportunities
to meet future friends and
collaborators through educational
programs, industry events,
photography publications,
directories, clubs and organizations,
museums, and galleries. Of course,
you are not limited to your specific
medium for friendship and support;
other mediums can also add unique
perspectives to your support system.

CHAPTER 2 | *Wrap-Up*

Chapter 2 outlined the foundational practices needed to cultivate an ideal environment for artists. This space should be physically, mentally, and emotionally conducive to generating ideas and creating work. Using the dissection of the nature and psychology inherent to artists, we discussed basic tools and intentions to overcome obstacles: building confidence through power posing, meditation, better sleep, play, journaling, designing your workspace, and creating a community support network. These practices all promote the creation of strong work while acknowledging your needs as an artist.

I'm in no way perfect, and I certainly deviate from doing all the things found in this chapter. I find that often we already know what we need to do to feel better or improve, but the difficulty is in setting up new patterns of behavior. When following the guidelines suggested in this chapter, I see noticeable differences in my mood, productivity, and output, but at times I fall off the path and have to be shoved back on by concerned family or my inner support circle. It's not all or nothing. Do what you can and keep at it; even small changes make a difference. We are skilled at developing narratives to justify our behavior, rationalizing both external events and our own actions. Be conscious of this. Does your belief system help you to be motivated and more productive, or does it create the crutch that enables you to make excuses and put off projects and goals?

📖 RECOMMENDED READING

Steal Like an Artist (2012), Austin Kleon

The Artist's Way (2002), Julia Cameron

Art & Fear: Observations on the Perils (and Rewards) of Artmaking (2001), David Bayles and Ted Orland

No More Secondhand Art (1989), Peter London

The Hero with a Thousand Faces (1973), Joseph Campbell

The Power of Now: A Guide to Spiritual Enlightenment (2004), Eckhart Tolle

The Art of Learning: An Inner Journey to Optimal Performance (2014), Josh Waitzkin

Mindset: The New Psychology of Success (2006), Carol Dweck

Presence: Bringing Your Boldest Self to Your Biggest Challenges (2015), Amy Cuddy

Originals: How Nonconformists Move the World (2016), Adam Grant and Sheryl Sandberg

"This Is Your Brain on Nature" (2016), Florence Williams for *National Geographic* magazine

Blue Pastures (1995), Mary Oliver

The Life of a Bowerbird: Creating Beautiful Interiors with the Things You Collect (2012), Sibella Court

🔊 RECOMMENDED LISTENING

"What Does a Creative Brain Look Like?," TED Radio Hour, NPR

∞ RECOMMENDED VIEWING

"Your Elusive Creative Genius" (2009), Elizabeth Gilbert for TED Talk

"Your Body Language Shapes Who You Are" (2012), Amy Cuddy for TED Talk

"The Game That Can Give You 10 Extra Years of Life" (2012), Jane McGonigal for TED Talk

"The Happy Secret to Better Work" (2011), Shawn Achor for TED Talk

"Tim Walker Interview: In Fashion" (2009), SHOWstudio

"Why Work Doesn't Happen at Work" (2010), Jason Fried for TED Talk

Apollo Prophecies (documentary, 2005), Nicholas Kahn and Richard Selesnick

📷 INSPIRATION

Khan & Selesnick
Lori Nix
Debbie Fleming Caffery
Leila Jeffreys
Laura El-Tantawy

Catherine Edelman Gallery
Art Partner
NOOR Images

Time M

anagement

MOTION VERSUS PROGRESS

Incessant busyness is an epidemic. Filling your time with tasks doesn't necessarily mean that you are being productive, doing something meaningful, or making progress toward achieving your goals. Reflect on what your goals are, and identify what you ABSOLUTELY have to do to fulfill them. Write a list of "A" tasks—without doing these, the objectives will never be reached. Then write a list of "B" tasks—you may reach the goals without them, but the process will suffer in terms of execution, quality, or efficiency. Finally, write a "C" list—tasks that you want to do but that don't directly promote your goals. Once you have the list, focus your time and efforts accordingly. This exercise may require a ruthless reevaluation of how and with whom you spend your time, but it's important to prioritize the steps that will move you closer to your goals.

For many ambitious people, work is defined to be any activity that can potentially benefit you professionally. For most fields, of course, there are an endless number of things that satisfy this definition—from joining endless committees to maintaining exhausting social media presences. It's due in large part to this generic notion of work that we spawned the culture of busyness that afflicts us today, where the measure of your success becomes synonymous with the measure of your exhaustion. This understanding of "work," however, is flawed. It's more useful to divide this activity into two distinct types of effort, deep and shallow:

Deep Work: Cognitively demanding tasks that require you to focus without distraction and apply hard-to-replicate skills.

Shallow Work: Logistical style tasks that do not require intense focus or the application of hard-to-replicate skills.

The shallow activities are not intrinsically bad, but they're not skilled labor, and therefore offer (at best) a small positive contribution to your efforts to produce value.... Eliminate large amounts of shallow work from your schedule to maintain a priority on deep work. By doing so, [you are] taking advantage of the following crucial but overlooked reality: deep work is what produces things that matter in the world."

—

CAL NEWPORT
"Want to Create Things That Matter? Be Lazy."

It's no easy feat to rise above the pressures of our current cultural, social, and business mentality of pumping out content with insane timetables and deadlines, constant meetings, interruptions, the expectation of instant response times, and round-the-clock accessibility. Overcoming this starts with committing to the goal of making artwork that is lasting and impactful, and prioritizing that work above answering a few more emails or updating a social media status.

In the age of 24-hour accessibility, pleasing team members and clients with your efficiency and responsiveness while protecting yourself from being taken advantage of is a skill in its own right. Setting reasonable boundaries and realistic expectations at the start of a project goes a long way toward keeping everyone on the same page and happy. Of course, unusual circumstances can arise where putting in extra hours to save the day is a worthy investment. However, you may find that some people you work with unnecessarily create a state-of-emergency culture to justify unreasonable demands on your time.

Along with prioritizing comes turning down projects that
don't serve your long-term goals. It's difficult to judge in
advance which opportunities will pan out into meaningful
or important landmarks in your career. Something that
seems like small exposure could lead to an introduction
to one person who becomes particularly supportive of
your work; likewise, something that seems like a great
opportunity can be a waste of time and resources. Very
early in my own career I said yes to everything,
because I wasn't sure what would be beneficial or
not, and I wanted as much experience as possible.
I burned out trying to accommodate everyone. My
health was compromised. Now I'm much more
selective in the opportunities and assignments
that I agree to, which allows me to focus on
what I really want to be doing.

When considering an opportunity, look
back to your goals list and evaluate if it's
something that moves you closer to or
further away from those goals.

TIME

(2013)
Crocodile and pocket watch experimental
still life.

Work EXPANDS *so as to fill the time available for its completion.*

—

PARKINSON'S LAW

I incorporate a few philosophies into my workflow to increase productivity. The first concept is a batch action method. Batch actions make repetitive tasks more efficient by combining them into single blocks of time. For example, instead of spreading your email replies throughout the day, tackle them all during one or two scheduled sessions.

With that in mind, I generate extensive to-do lists. We juggle so many things; without a way to keep track of them, inevitably something will be dropped. Taking the time to create to-do lists will help you get everything down on paper so you don't have to hold it all in your head. I do mean EVERYTHING—if I don't write something down, it's gone from my mind, so I generate both short-term and long-term lists.

Once again, I advocate finding your own best method for doing this (the options include a number of productivity apps, Google Calendar with Tasks, generating your own spreadsheets, good ol' pen-and-paper lists, whiteboards, chalkboards, etc.).

→

(Next spread, clockwise from upper left)

A STUDY IN BROWN *(2013)*
Nostalgia: A Study in Color

SNOW ON TREES *(2007)*
Fairy Tales & Other Stories

BEAR NO. 2676 *(2013)*
The Millbrook Collection

BIGHORN SHEEP NO. 6229 *(2010)*
The Millbrook Collection

THE MOULARD FEAST *(2014)*
The Fantastical Feasts

ASPECT MEDUSA *(2013)*
Fashion

TO DO OR NOT TO DO

Here are a few tips for getting the most from your to-do lists:

For everything you add to your list, first ask yourself if it's essential to moving you toward your goals.
Create both daily and long-term lists.
Give yourself realistic deadlines.
Categorize your list of tasks, as opposed to having a single task list with everything on it.

For example, your daily list might resemble the following:

> Things that can be done in two minutes or less
> Do today (with a maximum of five tasks, in order of priority)
> Calls
> Emails
> Administrative
> Social media
> Errands

Organize long-term tasks by project, type of activity, or agenda. Agendas are individuals with whom you need to discuss an array of topics—each of those agenda names should have a list of topics beneath it.

Long-term tasks sit uncompleted when they are too big to deal with. Break your tasks down into small, specific manageable activities, and attack them one at a time.

Allocate a specific amount of time for each task. Be sure to allow time for setup and getting into a flow (around 15 to 20 minutes), strike time to put things back or clean up, and travel time if changing locations.

Understand your concentration threshold. Everyone has a point when mental fatigue sets in, and you are unable to operate at your full potential. It's important to recognize when you are dealing with these diminishing returns, and then either switch to a different type of task or take a break.

When you have completed a task, take a stretch and walk around to reset your mind and prepare for the next objective.

Avoid multitasking—it's a myth that multitasking makes you more productive. It fragments your attention, making it more difficult to concentrate. Focus on completing one task at a time. If I begin 25 things in a day, I don't actually complete a single one, because I jump around from one thing to another.

When engaging in deep work that requires focus, turn off your phone, email, social media alerts, etc. Close all tabs and applications that you are not using for the task at hand so that you can work in peace.

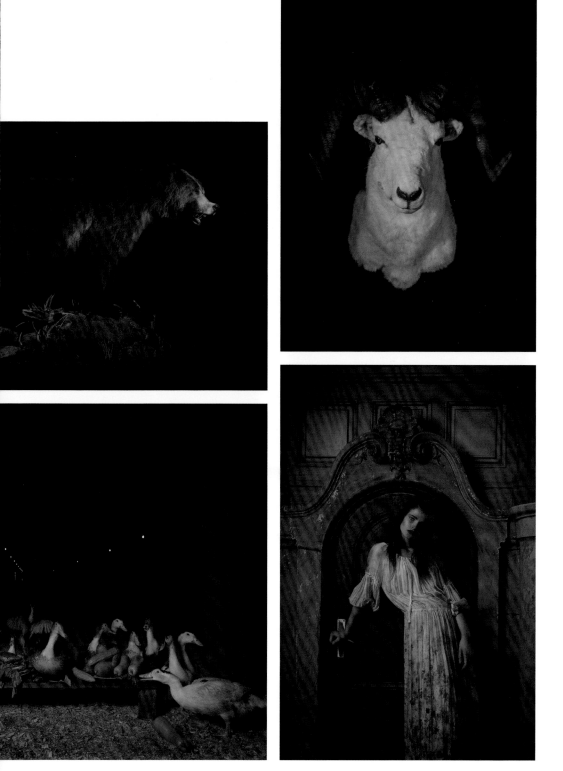

PRODUCTIVITY | *Structuring the Day*

Imposing structure on my life has never come naturally to me.
How I spend my days is rarely consistent, but the following is a
loose outline of how I would ideally organize my time.

WAKE-UP
I keep a notebook on my
nightstand. I write for a few
minutes as soon as I wake up. It's a
modified dream journal and morning
pages combined. In the journal, I have
started incorporating things I'm grateful for in
an attempt to be more positive. Then I meditate
for 10 minutes using the Headspace app.

MORNING
After getting ready
for the day, I go through
emails (I try to resist the urge to
check email the moment I wake up—a
hard habit to break). If I can respond to the
email in two minutes or less, I do. I flag the
others. Then I create my categorized to-do list for
the day in schedule form using Google Calendar. I
place any outstanding requests that came in via
email on the schedule to be dealt with at a specific
date so I don't forget about them.

AFTERNOON
I try to schedule all
calls, meetings, and
appointments after this
organizational period of time. I
do errands, administrative tasks,
and inspiration activities during
the earlier part of the day. I try to
sneak in short breaks of 7–12
minutes to go outside, walk,
or play with my dog.

EVENING
I leave creative tasks like brainstorming, mood
board creation, in-studio shooting, retouching,
and designing for big chunks of evening time
when my more creative mind turns on. Many
people report being their most creative
very early in the morning. It varies
from person to person, but I
have always been a
night owl.

NIGHT
I aim to be in bed before midnight, but I
do my best creative work between
midnight and 4 a.m. As you can
imagine, this takes a toll and needs
to be planned for in order to
avoid burnout.

I'm no role model for this. The ideal schedule flies out the
window on shoot days, days with unavoidable early morning
appointments, during travel, and when I'm not feeling well.
The key is to be flexible and maintain the intention of integrating
the practices into your day, even if it requires shuffling things
around to accommodate them. You will want to find your own
ideal rhythm and rituals for your workday.

THE CLASSICS

(2010)
From the series *Fairy Tales and Other Stories.*

50.1164° N, 14.4128° E TROJA PALACE

(2015)
The Traveling Mouse visits Troja Palace
in Prague, Czech Republic. The palace
was built from 1679 to 1691 for the
Counts of Sternberg.

MOTIVATION

On the TED Talk stage, Tony Robbins described his beliefs regarding human motivation and the hidden forces behind internal drive and performance. He defined two invisible forces that drive our decision-making process. The first is the filter through which we view the world that shapes our opinions. The second is a set of six universal human needs, organized into two areas:

Needs of the PERSONALITY:

SECURITY. The certainty that we can avoid pain and, at minimum, have our basic needs met with a safe home, food, and water.

VARIETY. Contradicting security somewhat, we also need some uncertainty so we are not bored out of our minds.

SIGNIFICANCE. All people need to feel important, special, and unique.

CONNECTION. Everyone needs some form of connection to or love with another person(s) or animal.

Needs of the SOUL:

GROWTH. We must feel we are evolving and growing, and not stuck in the same place.

CONTRIBUTION. We must feel we are giving back something of value to others.

We need all six, but each individual will have one that is the most powerful driving force behind their actions, direction, and choices. By identifying your main need and also striving to fulfill ones that may be lacking, you can channel your emotions, energy, and focus into achieving anything. For example, if you identify connection as your greatest need, then find fellow artists with whom you can explore and commit to these practices, or make artwork that encourages interaction with others. The bottom line is that if you don't care about something, you won't invest time or energy in it.

Great work does not require exotic locations, expensive teams, and big budgets; on the contrary, you can do a lot with a minimal budget. If you are inventive, you will find that you can make great work.

The defining factor is never resources; it's

resourcefulness.

[...] if you [have] the right emotion, we can get ourselves to do anything. If you're creative, playful, fun enough, you can get through to anybody. If you don't have the money, but you're creative and determined, you find the way. This is the ultimate resource.

—Tony Robbins

Think about the current organization of your life, what you spend most of your time doing, and what you have access to in your day-to-day and immediate network. Can you create work around the things and people you already have access to and activities you will be doing anyway? How can you leverage the resources required for one project to piggyback them onto another project?

The restraints and limitations that are put on us can yield the best results. Everyone is familiar with the saying that "necessity is the mother of invention," and the mind actually prefers criteria to be placed upon it when generating ideas. This may seem counterintuitive for creativity, but you can become paralyzed by too many choices. When creating your own work, what kinds of restraints can you impose upon yourself?

Many people claim that they are inspired and make the best images when they are traveling. When away from home, you are hyperaware and focused on taking in your surroundings without the fog of familiarity and everyday concerns. We explore vegetable markets in new cities with a sense of discovery that we rarely apply to the produce section of our local supermarket. This focus and curiosity should become something to channel in your day-to-day life. If you are always looking at and engaging with the world in this way, you will inevitably bring it to your

artwork. Whenever I meet anyone or go anywhere, I feel I'm collecting stories, ideas, and possible resources to use in my photography. You can't imagine the surprises you'll discover in your own backyard when you activate that discovery mindset in your daily life.

EXERCISE

Here are some example assignments that add constraints to your work. Using the framework below, try to make images that still resonate with your personal vision.

Can you make a different, interesting picture in your bathroom every day for a month? CRITERIA: You can bring with you only things that you already own. BONUS if no one can tell it's a bathroom in at least half of the images. ADDED CHALLENGE: Allow yourself only 30 minutes to create each picture.

Assign a specific color to each day of the week. On those days, take interesting pictures only of things that are the color assigned to that day of the week. These images can be constructed by you or can be documentary in style.

Make an interesting picture in which all the objects in the frame start with the same letter of the alphabet.

Get a fortune cookie from a Chinese restaurant. Make an interesting picture based on the fortune inside, using only objects you would find in a kitchen.

Find a stranger with red hair, introduce yourself, and ask to photograph them holding something red that you bought at your local dollar store.

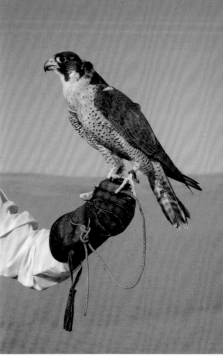

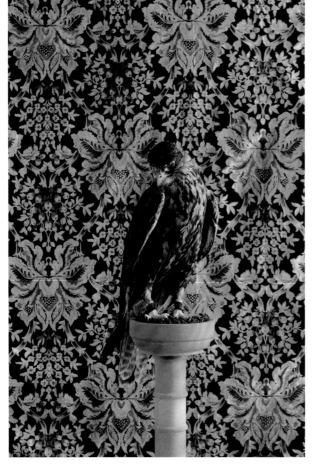

RESOURCEFULNESS

Many of my projects are self-funded; as a result, I have to make the most of all of the opportunities presented to me. I always try to combine resources to get the most out of my activities.

For example, on a recent trip to Dubai for an exhibition at Gulf Photo Plus, I combined the trip with a workshop, public lecture, and photo shoots that added to three different ongoing projects: *Birds of a Feather*, *The Fantastical Feasts*, and the *Traveling Mouse*.

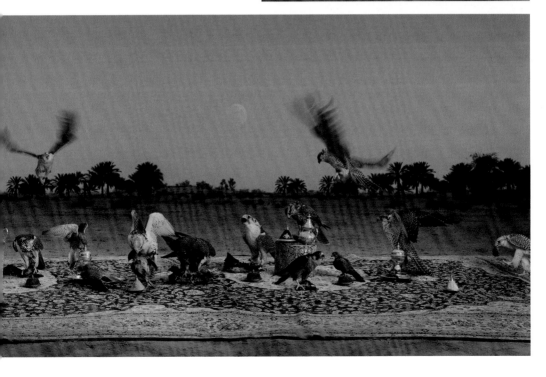

CHAPTER 3 | *Wrap-Up*

Chapter 3 provided a framework for organizing your time, with a focus on setting priorities that lead to the achievement of your goals. It outlined how to creatively organize tasks and create your own best method for working productively.

The next chapter will discuss divergent thinking, which is a crucial skill in problem solving. As you strengthen your ability to think divergently, you will naturally generate multiple solutions to all the situations that arise in your life, and you'll come up with creative ways to delegate your time and make the most of the opportunities presented to you.

📖 RECOMMENDED READING

"Want to Create Things That Matter? Be Lazy." (2015), Cal Newport

Essentialism: The Disciplined Pursuit of Less (2014), Greg McKeown

The 4-Hour Workweek (2009), Timothy Ferriss

Manage Your Day-to-Day: Build Your Routine, Find Your Focus, and Sharpen Your Creative Mind (2013), Jocelyn K. Glei

🔊 RECOMMENDED LISTENING

We Learn Nothing, Chapter 8, "Lazy: A Manifesto" (audiobook, 2013), Tim Kreider

👓 RECOMMENDED VIEWING

"Why We Do What We Do" (2006), Tony Robbins for TED Talk

"Embrace the Shake" (2013), Phil Hansen for TED Talk

📷 INSPIRATION

Erik Almås
Erwin Olaf
Miles Aldridge
Matthew Rolston
Julie Blackmon

ClampArt Gallery
Jed Root
Magnum Photos

Pre

visualization

CONCEPT GENERATION TRIGGERS

Anything can spark an idea: a dream, a life experience, a
current or historical event, a place, a person or animal, a
plant, an object, or a concept. From that first spark, you
develop the idea, and you fill in the gaps for the other parts of
the story based on the resources you have access to. The initial
idea should be something you are drawn to, captivated by, and
curious about exploring. Look back to the list of interests that
you generated in Chapter 1. These topics are a great jumping-
off point to start brainstorming the ideas you would like to
explore with your work.

A DREAM

A CONCEPT OR IDEA

A PLACE

AN ANIMAL

A PERSON

AN OBJECT

A CULTURE

A PROFESSION OR SKILL

AN ACTIVITY

AN EVENT

A HISTORICAL EVENT

A LIFE EVENT

AN ISSUE

A CONFLICT

AN EXISTING PIECE OF ART

THE FUTURE

A NEW TECHNIQUE

A PHILOSOPHICAL IDEA

DIVERGENT THINKING

Divergent thinking is a thought process used to generate creative ideas by exploring many possible solutions, as opposed to just a single solution. Many education systems train students to memorize and regurgitate information in a very standardized way; there is only one correct answer, and being wrong is penalized. The effects of this are hugely damaging to the creative process. Art is about risk-taking and being wrong; there are many ways to create something. I see a lot of people imagining just one way to make a picture, and then deciding it's impossible and giving up. In both the idea and execution of an image, there are always a number of ways to create the image with a little ingenuity and relentless problem solving.

How many uses can you think of for a toothbrush?

20? 200? There are no rules and no wrong answers.
Take some time and a scrap piece of paper, and
write down as many uses as you can think of.

I have done this exercise around the world with groups of varying sizes and all age levels. The first responses typically have to do with cleaning other things besides teeth, and it isn't until a few rounds in that people are able to break from the conventional views of a toothbrush and recommend things like cutting the bristles to make eyebrow extensions. Some have such a strong fear of saying something "STUPID" that they can't come up with anything at all. For many, it takes a long time to realize they don't have to follow any constraints that they assumed were imposed (e.g., you can have as many toothbrushes as you like, at any scale, and they don't have to follow the rules of physics or reality). Although this may seem like a mundane or ridiculous activity, it reveals many people's thought patterns.

The first ideas that you have are the most typical and most cliché,
and they are
likely
to be things
you have
seen or thought
of before.

You have to push past that point to get to ideas that are truly innovative and new. It's also revealing to recognize that we all assume that there are rules we have to follow, and we don't question all the options.

Something as ordinary as this toothbrush activity is a great exercise.

It highlights one of the most important jobs of an artist: looking at the everyday or longtime accepted norms and presenting them in a NEW and INNOVATIVE way that allows the viewer to challenge previous ideas and conceptions.

FREE ASSOCIATION

Free association is the spontaneous, free flow of logically unconstrained, uncensored, and undirected ideas, emotions, and feelings resulting from specific prompts. This activity is used widely in divergent thinking, or problem solving, to generate numerous ideas to explore. According to Freud and other psychoanalysts, free association provides a window into understanding unconscious processes as it prompts uncensored responses and connections.

57 ACROSS

(2015)
From the series *This Is Water.*

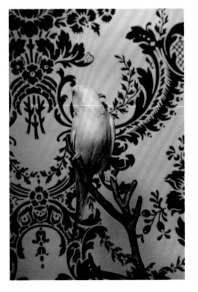

What is the first thing that comes to mind when you read the word cow? Your response is a *free association.*

COMMON PARAKEET NO. 7024

(2012)
From the series *Birds of a Feather.*

VOI

(2011)
For the Jumeirah Zabeel Saray Hotel.
Credits: Bronx of Bareface Agency,
Chrystel Plischke-Livolsi (styling), Katie
Cousins (hair & makeup), Bobbi Lane and
David Tejada (lighting design), Belinda
Muller (producer).

When building upon concepts or
ideas, it's helpful to use free
association to expand on the
narrative possibilities and
determine what elements you can
use to visually represent the
concepts you are interested in
portraying.

An idea randomizer is any activity that generates a concept or constraint using an external, randomly generated word or trigger to initiate the brainstorming process. Random connections are made in the hopes of generating innovative ideas. Here are a few examples:

ONLINE RANDOMIZERS.
Use an online randomizer to generate a word or set of words with which to start your brainstorm or mind map. Here are a couple that I use:

www.randomwordgenerator.com
http://ideagenerator.creativitygames.net

DISRUPTIVE FREE ASSOCIATION.

Pick two numbers: one number between 1 and 300 (call that **x**) and another number between 1 and 10 (call that **y**). Using an encyclopedia (or any book), turn to page **x**. Count the **y** number of lines down and select the first word in that line. Take that word and spend 30 minutes free-associating. See if there are any connections between your original task and all the concepts that have been randomly generated. It's interesting when you force the brain to make connections that never would have happened otherwise.

(This activity was created by John Bielenberg, Bielenberg Institute at the Edge of the Earth in Belfast, Maine.)

BRAINSTORMING | *Encouraging the Impossible Idea*

If you want to come up with truly new, innovative ideas, you cannot, as John Bielenberg has said when describing the concept of "Thinking Wrong," follow "pre-existing synaptic pathways in the creative process. Artists need to be ALLOWED and even ENCOURAGED to

think different."

THE HEDGEHOG FEAST

(2014)
From the series *The Fantastical Feasts.*

We've already discussed the challenges the inner censor imposes on creative thought—how many times have you tried to come up with an idea only to think that it's stupid or will never work? This judgment prevents ideas from flowing freely. Deferring judgment is a must in any brainstorming session to keep ideas flowing and to allow thinking without a filter applied. Anything goes—all ideas, including those that are weird, difficult, unrealistic, etc. Nothing you can say is wrong. Good ideas can come from bad ideas, so you have to allow them all.

With time and practice, this way of thinking becomes easier and easier.

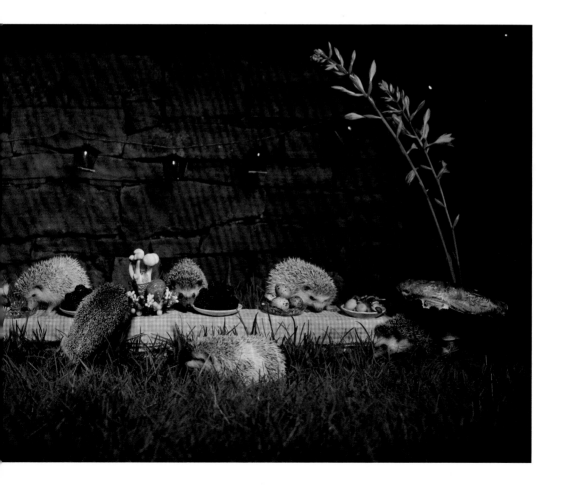

BRAINSTORMING | *Tips and Tricks*

You can brainstorm in a group or independently. Here are some suggestions for effective brainstorming:

Faster is better.

Be quick. You want ideas as they come to mind, before filtering. Energy, spontaneity, and speed work!

Quantity versus quality. More ideas =

Encourage wild ideas

Wild or audacious ideas are needed to break through a rigid problem.

Build on other ideas

An idea can be modified into a new idea (also think of opposites of ideas to spark thinking).

*D*O NOT THINK OF HOW

Come up with the concept before you try to determine how to do it.

more options.

<u>Capture everything</u>

Do not filter ideas. Write everything down. Organize and filter after the brainstorm.

BRAINSTORMING | *Thinking Less Literally*

An initial instinct when starting out in photography is to show the subject of our own fascination very literally. It is as if we are saying, "Look directly at this here!" It's understandable; you are drawn to something, and you want your viewer to see it as you experienced it. But many times this leads to disappointment, because you wind up with a very literal image that lacks all the magic you hoped to share. In image-making, it's important to think of the image holistically and less literally in order to create an artistic interpretation that yields the emotional or psychological response you want to evoke. You are creating a seamless world for the viewer to be transported into—making the viewer feel as you did when you were there, rather than showing a literal snapshot of what you saw.

You can achieve this in a few ways. Use the characteristics inherent to photography to facilitate this artistic transformation; focus attention with composition, create mood with light, generate narrative with gesture and expression, use motion and blur to convey energy. *Visualization* is a thought that is translated to visual images, usually through symbolism. *Symbolism* is the practice of replacing an action, person, or idea with a visually representative object. An entire language of symbols dates back to the dawn of civilization. Many symbols are universal, and some are culturally specific. Numerous examples can be found in everyday life. The archetypes outlined earlier in the section on the collective unconscious ("Tapping into the Unconscious" in Chapter 2) are examples of symbolism. Symbols can be associated with colors, animals, flowers, elements, and objects. These associations are commonly understood by the viewer, and you can use them to your advantage to convey concepts in a less literal and more aesthetically interesting way.

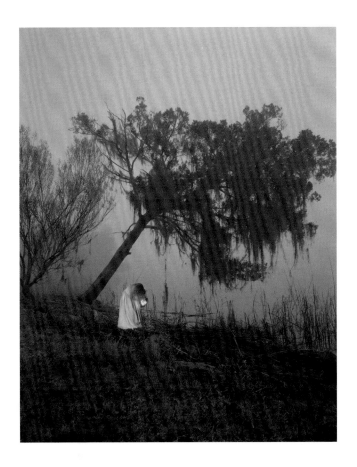

FAIRIE CATCHING

(2008)
From the series *Fairy Tales and Other Stories*. The edge where land meets water holds interesting symbolism as the place where the conscious mind meets the unconscious. A dream in this locale represents a symbolic journey of self-discovery. Dawn suggests illumination and hope, the beginning of something. A lantern represents a light within (a strong desire that motivates us) and is a guide for finding our way in the world through enlightenment, knowledge, or understanding. The willow tree holds further symbolic meaning for strength, adaptability, and development.

**FOUND PICTURES VERSUS CREATED
PICTURES**

For the sake of simplicity, I divide
photography into two basic categories:
photographs that are found and those
that are created. I make the distinction
because the brainstorming, pre-
production, and production workflow
differs between these two categories.
Obviously, my work falls under the
created photographs category, and the
tools in the following chapter will very
simply lend themselves to that workflow.
However, many of the brainstorming and
planning practices in the next few
chapters are also helpful to the found
journalistic/documentary fields for
developing story ideas and the method by
which you will find and execute them.

FOUND PHOTOGRAPHS occur when the photographer goes out into the world to
capture something as it exists, such as in photojournalism, documentary, street,
nature, landscape, travel, or some fine art photography. Found-photography artists
must make conscious technical aesthetic choices and then patiently observe or go
in search of all the external elements to come together in the frame. They may do
extensive research or hire fixers (knowledgeable local guides who make arrangements
and facilitate access for photographers) to increase their chances of being in the
right place at the right time.

BLOOD AND HONEY *(1999)*
Ron Haviv
(LEFT PAGE)

DOLLS & GUNS *(2014)*
(RIGHT PAGE)

The two images shown here both communicate a similar message about the impact that violence has on children.

The left image was found by photojournalist Ron Haviv. It shows the remains of a broken doll left behind by a Kosovar Albanian family that fled Serb forces during the war in Kosovo.

The right image was created by me in response to gun violence against children.

CREATED PHOTOGRAPHS are staged or fabricated by the photographer, as in fashion, advertising, conceptual, and fine art photography. Conscious, technical aesthetic choices are also made, as well as deliberate decisions regarding the sourcing of every element that is in the frame. This includes everything—location, subjects, set elements, props, etc.—as well as all the logistical efforts behind locating, creating, procuring, and scheduling the details to make the image happen.

MIND MAPPING

A mind map is a visual representation of information that includes a central idea surrounded by connected branches of associated topics. These are generated using free-association techniques to fully flesh out and outline all the possibilities when exploring an idea. It's very helpful in brainstorming to get all ideas on paper, allowing you to represent different paths of thought and directions that are connected. As previously discussed, there are a number of ways to approach any topic. Creating a mind map helps you to get all the options on paper, organize them, and see which direction you would like to take.

I use this technique not only for creating picture ideas and concepts to pitch to clients but also for business plans, project plans, and marketing strategies. The picture ideas and concepts provide a visual structure to my thought plan that I find very helpful in organizing my ideas and identifying possibilities.

ASPECT MEDUSA

(2013)
Fashion test shoot in Bucharest, Romania.

Mind map illustrating the brainstorm that occurred prior to the shoot (*next spread*).

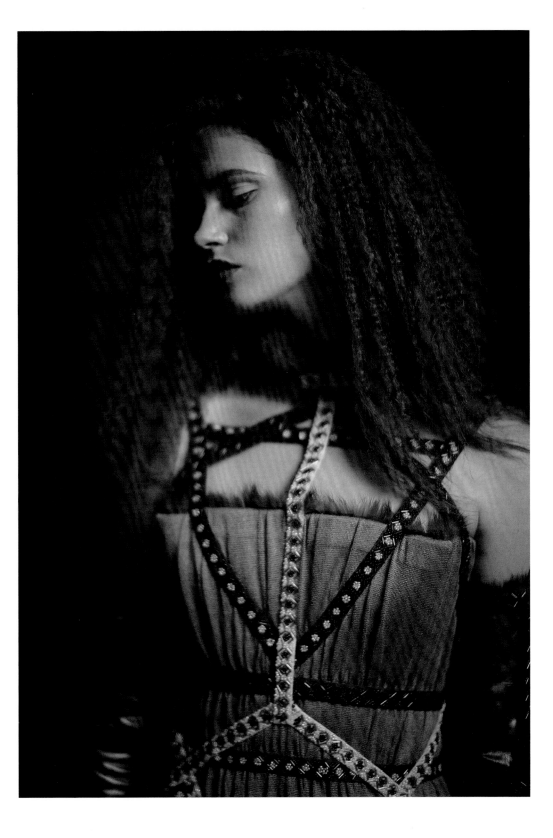

Roccoco
Baroque
1800's

MEDIEVAL
Knights
Princess

Lost Splendor
Crumbling
Concrete
Neglect
Dust
Cobwebs
Falling to Pieces

Royalty
Upperclass
Jewels
Crown
Frivolous

Plaster Dilapidated
Columns
Luxury
Grandeur
Architecture
Decorative
details
Murals
Classics
Grotesques
Tapestry
Statue- Statuesque
Shells -Angels

ROM
Bu

Spiral Staircase

Gold
Jeweled Tones
Desaturated
Wine, Red, Silver, Copper
Creme + Browns
Sparkle
Jewels
Dead Flowers
Armor

FEMININE
femme
femme fatale
apple / fruit
KNOWLEDGE
TEMPTRESS
SIREN
Lady Lilith .
EUROPEAN PRE-RAPHAELITE
OLD WORLD ROMANTIC
HISTORIC dreamY
ANCIENT ENIGMA
TIMELESS GAZE
 BEAUTY
NIA MUSE.....
REST INSTRUMENTS, ARTS
 CLASSICS
 DOLL.
 ROMANTICISM
 decorative

MYSTERY
DARKNESS
VAMPIRE
PERILS, STUCK
LOST, LUST
FOLK LORE
DESPAIR
TRAGEDY
SULTRY
GOTHIC
AIRLESS RESTRICTIVE
INTROSPECTIVE

MOOD BOARDS

A mood board is a collage of inspirational images, text, swatches, or samples of objects in a composition, which aid in previsualization and the communication of an artistic idea that has yet to be created. It may be physically or digitally created. For the artist, it's an opportunity to research and flesh out ideas, see what has been previously created, gather new concepts to try, and have an overall roadmap when on set. It's a wonderful way to round out the brainstorming and research process.

My mood boards typically have examples for mood, lighting, color palette, styling, hair and makeup, props, locations, subject poses and expressions, set design, styling, etc.

Mood boards are also an effective presentation tool when sharing ideas. You can use them to communicate with clients and your team to ensure that everyone has a shared visual language for the image concept. Language can be limited when it comes to describing your ideas or what you would like to accomplish. You are much more likely to achieve your vision if you are able to show someone exactly what you are after. Especially because there are so many ways to tell the same story, you need to be very specific about the aesthetic choices you are making. Your mood board can help you explain exactly what locations, props, or other resources you need and increase your chances of getting them.

ASPECT MEDUSA MOOD BOARD

(2013)
Inspirational images to illustrate the look and feel of the shoot. Typically, I include more contemporary photography in my mood boards, but for copyright reasons I am unable to share the entire board here.

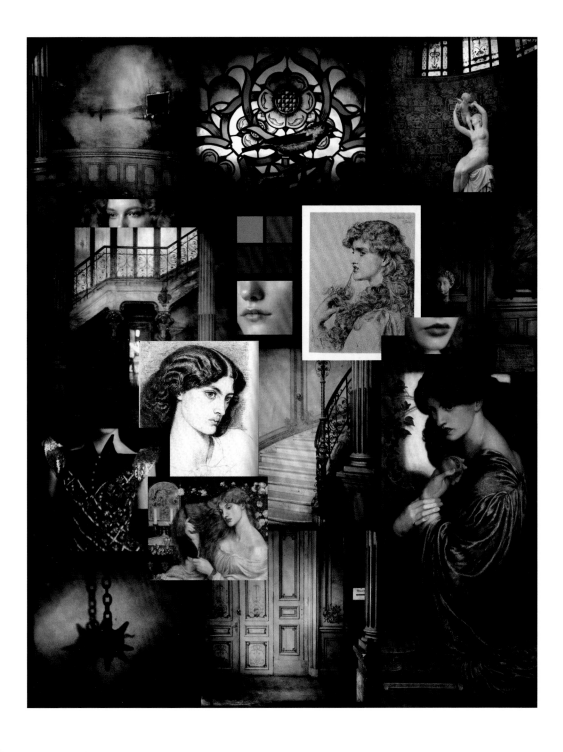

PREVISUALIZATION

The ability to anticipate a finished image before making the exposure.

—

Ansel Adams

Previsualization is the act of visualizing an entire scene for a photograph or set of photographs prior to creating them. It begins in the mind and is then developed through drawn sketches, or a computer, to facilitate the planning and conceptualization of the image(s).

"Picture" the image in advance to give yourself a clear idea of what you want to accomplish. You can also experiment with different visual options in your head, such as set elements, location, styling, model, props, lighting, and camera angle, without having to incur the costs of actual production. When you have a clear visual image in your mind, create sketches or mockups, and then break down all the elements that you need to make your image a reality.

ASPECT MEDUSA SKETCH

(2013)
Explore framing and posing in sketches
for various setups. Use location scouting
pictures as reference.

CONCEPT DEVELOPMENT

You can use any of the techniques in this chapter in the concept-development process, in isolation or in combination with one another. The order in which you use them is flexible. It is an interactive process with the pre-production phase (to be discussed in Chapter 5), as sourcing elements will dictate some aspects of the concept and how the images will be executed.

The exercise below is one workflow technique that integrates the tools I've discussed in this chapter to generate a well-developed concept. The right page illustrates the intersection of pre-production and concept-development workflow using my Aspect Medusa shoot as an example.

EXERCISE

Spend 20 minutes writing by hand on paper, stream-of-consciousness style, knowing that what you write is never to be read by anyone. The important thing is to keep pen to paper, even if you are just writing that you don't know what to write.

Place one word—the first word that comes to mind after you have completed your writing exercise—in the center of a new piece of paper. This is your central concept.

Free-associate using the brainstorming method to generate a list of adjectives and abstractions representing the central concept. Evolve into a series of nouns or visually symbolic items for the ideas on your map.

Previsualize your image, and put your ideas into words by writing a short description of your concept or plan based on the map you created.

CREATE YOUR MOOD BOARD.

The next step is the pre-production phase (coming up in Chapter 5), where you generate an action plan, organizing all of the elements you will need to make your ideas a reality.

ASPECT MEDUSA

(2013)
(Here and following page)

Results of the fashion test shoot in
Bucharest, Romania. Credits: Marta of
MRA Models, Raluca Racasan (styling),
Alex Claudiu Sarghe (hair), Irina Selesi
(makeup), Institutul de Arheologie
(location), Cristian Movila (producer).

trigger › trip to ROMANIA
Bucharest

research & resources
- meet Cristian through Ron
- location scouting
- Cristian introduction to *Elle Romania* photo editor
› connects to stylist and modeling agency
› stylist arranges hair & makeup

development & pre-production
- decide on location
- free write › brainstorm / mind map › mood board
- share with team › cast model › source wardrobe
- sketches for shot list

execute

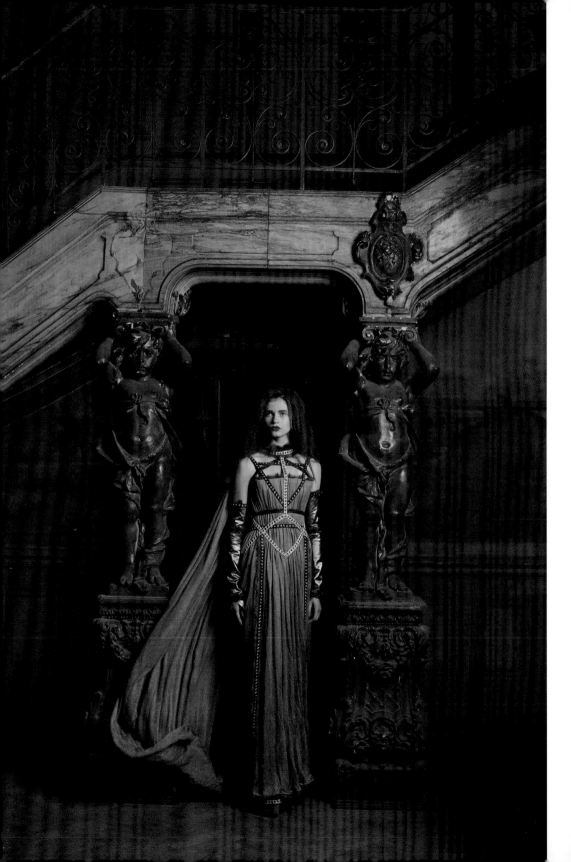

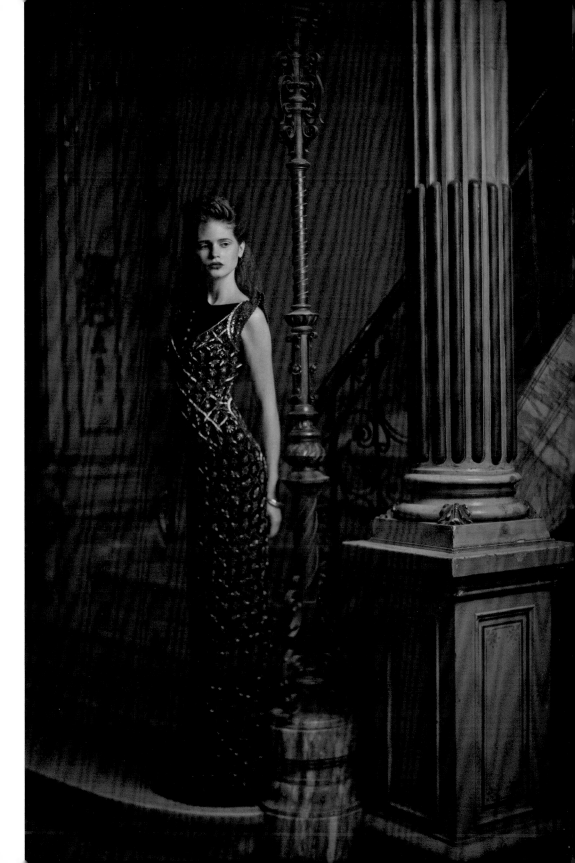

····································

📖 RECOMMENDED READING
*The Creative Process Illustrated: How
Advertising's Big Ideas Are Born* (2010),
W. Glenn Griffin

····································

∞ RECOMMENDED VIEWING
"Changing Education Paradigms"
(2011), Sir Ken Robinson for TED Talk

····································

📷 INSPIRATION
Paolo Ventura
Eugenio Recuenco
Paolo Roversi
Romina Ressia
Zeren Badar

Yossi Milo Gallery
Kate Ryan
Redux Pictures

Chapter 4 broke down the foundation of idea generation with tools for brainstorming and problem solving using divergent thinking and free association, then capturing concepts through mind maps and mood boards.

I believe this is one of the most valuable skill sets that you can apply to any endeavor; it is certainly not limited to the arts. Having a mind that is open to possibilities and that can brainstorm multiple solutions in any situation is an asset regardless of the circumstance.

I find that many students are anxious to rush through the brainstorming process and get on to the pre-production phase. However, without a solid grasp of what you want to say and how best to visually represent that sentiment, the rest of the process falls apart very quickly. Every other phase becomes more arbitrary, difficult, and stressful. Of course, you may have some happy accidents where things work out, but you don't have the same level of intention. Go through all the steps of concept development and previsualization, and the rest will come much more easily.

Production

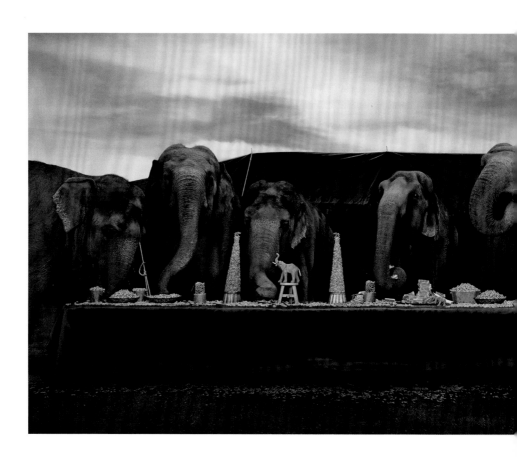

THE ELEPHANT FEAST

(2013)
From the series *The Fantastical Feasts*.

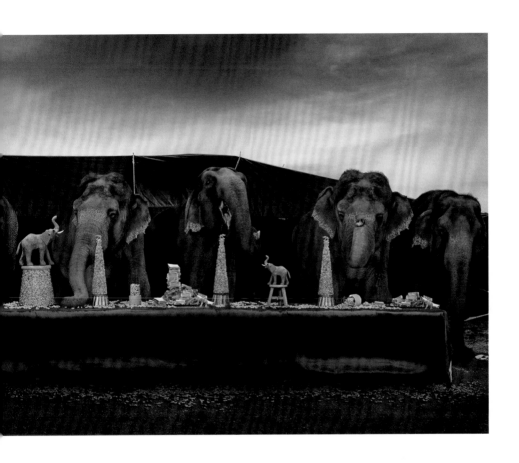

PRE-PRODUCTION | *Getting Organized*

Quite a lot goes into making images, and no two productions are the same. Being thoughtful about the details is crucial for making an image successful. You have to understand what you would like to accomplish with each image, and after envisioning the final result through previsualization, work backward to outline all that is required to make it happen.

With all the elements that can go into the anatomy of an image, having a framework to make sure you have considered all of them in advance will make the process less overwhelming. You must reflect on the lighting, composition, angle of view, mood, background (or location), subject(s) (person, animal, or object), expression and pose, styling, set elements and props, and post-production. Sometimes a few of these elements will be subject to experimentation, with a number of possible variations, such as pose, expression, angle of view, or composition.

TOOLS FOR PRODUCTION

As technology develops, there are a number of great tools that can make your life easier. I like the Google Apps because you can access them everywhere, they update in real time, and they are easy to share with clients and team members.

Google Calendar and Tasks, Sheets, Slides, and Forms are all very handy for streamlining your workflow.

You can execute the same concept in many ways; make sure you are thinking of all the options when brainstorming the how of accomplishing your shoot. Some questions to consider: Do you need to go to a specific physical location? Or can you re-create that location in a studio? Or can you build your set in miniature? Another example: let's say you wanted a wolf. Do you need an actual wolf? Would a wolf-like dog work? A taxidermy wolf? What about a person in a wolf costume? Or a graphic silhouette? Or a painted/printed cardboard cutout? Maybe you could just create the shadow of a wolf? Or use a figurine of a wolf in a miniature set or as a composite? Using divergent thinking helps you discover many options that may not be immediately obvious. Using less literal alternatives contributes to the unique stylization of your image's aesthetics.

Once you have decided exactly what you want to create, you can make lists of actionable tasks to accomplish in order to complete your image(s). Although worksheets are provided with this book to serve as examples, it's most effective to use them as a basis to create your own system of organization designed around your way of thinking and your typical needs on set or location.

PRE-PRODUCTION WORKSHEET: *Brainstorming the Elements*

PREPARED BY	:	
DATE	:	
PROJECT	:	
CLIENT	:	

BRIEF | DESCRIPTION | NOTES

		IDEAS	SOLUTIONS
NARRATIVE	*Time of Day*		
	Lighting Pattern		
	Mood		
	Color Palette		
	Point of View		
SET	*Location*		
	Backdrop		
	Set Elements		
	Props		
SUBJECT	*Main Focus*		
	Model		
	Extras		
STYLING	*Hair*		
	Makeup		
	Wardrobe		

PRE-PRODUCTION | *Production Sheets*

PRE-PRODUCTION WORKSHEET: *Production Checklist*

PREPARED BY :

DATE :

PROJECT :

SHOOT ID :

SHOOT DATE :

WEATHER :

CLIENT & CONTACT INFO :

SHOOT TIME :

OUTDOORS : □ Y □ N

OF SETUPS

NAME, AGENCY, MOBILE #

	Address			
	Contact Person			
LOCATION	*Paperwork Required?*	□ Y □ N	TALENT	WARDROBE MEASUREMENTS
	Parking?	□ Y □ N		
	Phone Reception?	□ Y □ N		
	Access to Bathroom?	□ Y □ N		
	Power Available?	□ Y □ N	*Release Signed?* □ Y □ N	

		NAME	MOBILE # / EMAIL	NOTES / DIET RESTRICTIONS
	Photographer			
	Producer			
	Art Director			
	1st Assistant			
	2nd Assistant			
TEAM	*Digital Tech / Retoucher*			
	Hair Stylist			
	Makeup Artist			
	Wardrobe Stylist			
	Set Designer			
	Prop Stylist			

PROPS & MATERIALS
(*list on reverse*)

PRE-PRODUCTION WORKSHEET: *Equipment Checklist*

PREPARED BY :

DATE :

PROJECT :

SHOOT ID :

CLIENT :

RENTAL COMPANY CONTACT :

		MODEL	QUANTITY	NOTES
	Camera			
	Camera (Backup)			
	Camera Battery + Charger			
	Lens			
CAMERA	Lens			
	Lens			
	CF Cards			
	Tripod with Mount			
	Shutter Release			
	Laptop + Charger			
	Hard Drives			
COMPUTER	CF Card Reader			
	Tether Cords			
	Wacom + Pen			
	Seamless			
BACKGROUND	Backdrop			
	Stands + Pole			
	Studio Packs			
	Studio Heads			
	Batteries			
	Pocket Wizards			
	Sync Cords			
LIGHTING EQUIPMENT	Gels			
	Light Meter / Gray Card			
	White and Black Flags			
	Light Stands			
	C-Stands			
	Boom Arm			

MISC.		QUANTITY
Sandbags		
Gaff Tape		
Clamps		
Batteries (AA and AAA)		
Extension Cords		
Power Strip		
Generator		
Steamer		
Fog Machine		
Equipment Cart		
Step Stool		
Garbage Bags (white/black)		
Model / Location Releases		
Permits		
Promo Material		
Brief / Mood Board		

RESOURCES AND RESEARCH

Now that you know what you want, the scavenger hunt to find everything begins: locations, subjects, models, team members, crew, props, set elements, and equipment. Again, organization is your best tool with these types of productions. Create extensive lists of what you need to acquire, and then begin the research to find all of it. Whether it's a "shot" list for a documentary story or all the elements you need to construct an elaborately fabricated image, getting it all on paper ensures that you won't forget anything.

The Internet is an incredible tool for finding almost anything, but you may have to do some digging. Building your online search skills will open up endless possibilities. I use Google, Instagram, Facebook, Model Mayhem, Behance, Craigslist, Etsy, eBay, TripAdvisor, Airbnb, Pinterest, Flickr, and various production resource and agency websites as resources to find everything and everyone under the sun. Sometimes it takes multiple connections within your personal and professional network (friends of friends of friends) to find what you are looking for.

It's important to develop your network of resources as you go through your career so that you have a solid, trusted, reliable team to turn to with common goals and agendas. I rely on a number of go-to people when seeking out team recommendations or trying to source unusual props or interesting locations. Companies with region-specific websites are dedicated to production, gear and prop rentals, location scouting, and more, to help you find the resources nearest to you.

→

50.0755° N, 14.4378° E MAGNOLIA TREE

(2015)
The Traveling Mouse outside of Strahov Monastery in Prague, Czech Republic.

Your attitude and enthusiasm for the work you are creating will go a long way toward securing the resources you need and enlisting help from others. In addition to sharing the mood board and concept for a particular shoot, I typically include a link to my website or bring my portfolio, either as images on a handheld device or a physical promotional piece, to give a clear example of my work. I have found this very helpful in gaining access to resources, especially when working on personal projects for which there is a limited or nonexistent budget.

When approaching people, I try to imagine the situation from their perspective.

What about participating in this project would <u>entice</u>, <u>intrigue</u>, or <u>benefit</u> them?

What would be their possible fears or reasons for saying NO, and how can I address them in advance and alleviate any concerns they might have? It's important that they be invested in the project and enthusiastic about working with you—I would never pursue a request when the person wasn't interested in the project. I present them with all the information in an organized fashion in order to maximize the chances that they will say yes to whatever the request may be—whether it's the use of a location, a prop, or something else. Some people will need convincing. If you want people to help you, the best thing you can do is make it EASY for them to do so.

Sometimes there is an
unexplainable
phenomenon where, as if by fate or magic,
people or things are placed in our path just
when we need them. Jung explains it as a function
of the collective unconscious, which results in
synchronicity. We all experience these COINCIDENCES:
You think of a person and they call you; you start on a
project and come across a number of artists using similar
references or topics; you need some obscure resource and then
you meet someone who can help. I do think this phenomenon
begins with being open about your needs and making them known.
Then, whether it's your network of friends, the "universe," or a fairy
godmother making it happen, in my experience you get what
you need, all the pieces fall into
place, and it feels a bit like

FATE.

MOLUCCAN COCKATOO NO. 7212

(2012)
From the series *Birds of a Feather.*

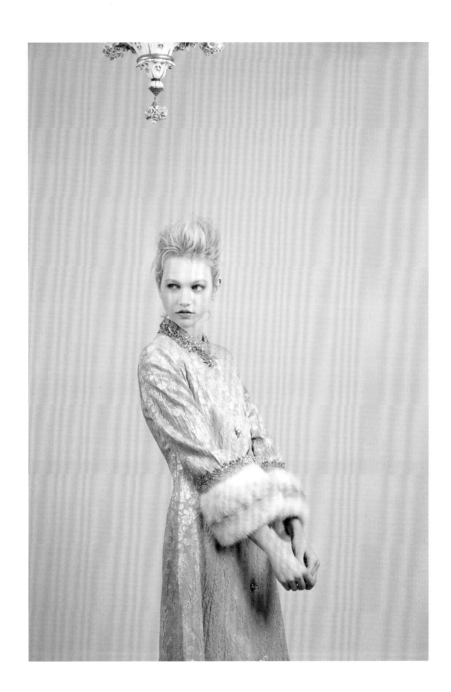

LADY GRAY

(2015)
Lindsey Byard (model), Chris Rivera (hair)

Determining the budget—how much you should be compensated for your images and how much it will cost to create them—is one of the most challenging and inconsistent aspects of the business of photography.

Two financial frameworks dominate professional photographic work today: *commissioned/on assignment*, which is work that you are paid to create at the request of a client (individual or company), and *fine art/personal on spec*, which is self-generated work with the intention of selling the image(s) through a personal site, gallery, dealer, agent, stock website, publication, etc. In some cases, commissioned work can have a secondary resale value as fine art or stock imagery, depending on your arrangement with your client.

The fees and budgets in the commercial industry today vary widely and are influenced by many factors. Fees are determined by the client, usage, visibility, region, time, difficulty of assignment, and reputation of the photographer—to name just a few. To make things more complicated, the cost of hiring other team members also varies depending on their reputation, experience, region, workload, interest in the project, and the usage of the image. Costs for locations, permits, and other equipment or material rentals also vary by region. Due to the variance by location, you'll have to do some research on your specific area to find the average or baseline pricing structures for the resources you use regularly to inform what a reasonable budget would be.

You can use production sheets to generate the skeleton for the budget proposal—again, to be sure you are not forgetting anything. A few line items should be included in a budget sheet that would not be on any of the creative sheets, such as transportation or feeding the crew (which is very important!). A number of resources can help with organizing and streamlining budgeting tasks: BlinkBid and PhotoQuotes are two estimating programs that generate quotes and invoices based on a catalog of industry-standard data.

Sometimes you'll be handed a very unrealistic budget that you'll have to renegotiate, decline, or creatively finesse in order to make it work. There is always a spectrum of expense in terms of people to work with and ways to do things—just keep in

mind that you get what you pay for, and know when it's not in your best interest to make a cut. For example, it may be more affordable to go with a less experienced hair and makeup person, but it might cost you in the long run if their skill level doesn't meet your standards or if they are slow or unprofessional to work with. Ultimately, it could reflect badly on you and your work.

When creating work personally, in a fine art capacity or on spec, you need to determine what the potential revenue for the image will be and allocate an appropriate budget to make it. With this type of work, you have a bit more leeway to leverage, barter, borrow, trade, share a percentage of future print sales, or find some other alternative working arrangement. I have been able to produce a lot of my fine art projects on a very small-to-nonexistent budget. I try to rent or borrow instead of buying. In many cases, for objects I need in an image I'll assemble glue guns and spray paint, cover everything in a tarp, and make what I need myself. If you are a bit handy (or know someone who is), you can fabricate something inexpensively that will work for a picture without having to have the real thing.

If the budget becomes a barrier to your ability to access specific needs or collaborate with people for your shoot, you can use other things that have value beyond money to arrange something that is mutually beneficial. If you want access to photograph something that belongs to someone but don't have a budget to gain access in a traditional manner, is there perhaps something else that the owner needs photographed that you can offer to shoot in exchange? Alternatively, would they be interested in prints once the images are complete? Can you trade access to the resource for your help with another project of theirs? Can you offer a small percentage of every print sale once the project is completed? Is sponsorship an option? Be flexible and creative, and always put yourself in the shoes of the person whom you are trying to make an arrangement with.

It's surprisingly common to be asked to make or license photographs for free or next to no payment. It's something that I experience regularly, and I'm sure many of you are familiar with being put in this position as well. Sometimes the request is for a really interesting project you would like to do, which can make the decision more difficult. I think giving away your photography devalues it and also has serious repercussions

for the entire industry. However, that's not to say that money is the only thing with value. As explained earlier, there are other exchanges beyond money that can be beneficial, as long as your expenses are covered. Many artists, particularly those early in their careers, are tempted to do work for free "for the exposure." Exposure on its own rarely, if ever, has sufficient value to merit working for free in order to gain it. Before producing work without compensation, ask yourself the following questions: Is it a project you need in order to take your portfolio to the next level, and will the client provide the resources to make it happen? Can you get access to something you wouldn't ordinarily be able to get access to? Does it provide an interesting experience or travel? Can you piggyback another personal project off of it? Would the images have any alternative resale value? Would the client be willing to offer you a service or product of theirs to supplement payment?

PRE-PRODUCTION WORKSHEET: *Budget Worksheet*

PREPARED BY :

DATE :

PROJECT :

SHOOT ID :

OF DAYS :

BUDGET :

		FEE	QUANTITY	TOTAL
PHOTOSHOOT MATERIALS	*Location Fee*			
	Backgrounds			
	Set Elements			
	Props			
	Wardrobe			
	Gear (Photo / Computer)			
	Rentals			
	Craft Services			
	Transportation			
	Post-production			

		RATE	DURATION	TOTAL
TEAM & TALENT	*Producer*			
	Art Director			
	1st Assistant			
	2nd Assistant			
	Digital Tech			
	Hair Stylist			
	Makeup Artist			
	Wardrobe Stylist			
	Set Designer			
	Prop Stylist			
	Model			

RESOURCES AND RESEARCH | *Budget*

COST & SOURCES BREAKDOWN

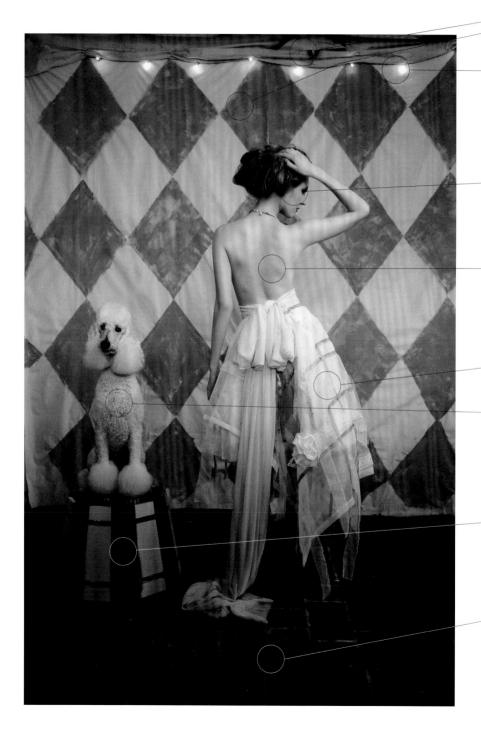

DROP CLOTH: $30.49
FABRIC SPRAY PAINT: $5.15
STENCIL: FREE
Hand-painted using a cardboard stencil
canvas drop cloth from Home Depot

OUTDOOR STRING LIGHTS: $24.99
From Target

STUDIO LIGHTING: BORROWED
Sponsored by Dynalite

HAIR & MAKEUP: TFP
Hair by Eric Dominguez
Known since childhood
Makeup by Gregg Hubbard
Met on a previous job

MODEL: TFP
Sietzka from Fenton Moon Agency
Cold-emailed agency with mood board

SKIRT: TFP
Wardrobe and Styling by Arlinda McIntosh for
Sofistafunk The Skirt Co.
Met on a previous job

POODLE: TFP
Friend of a friend's dog
*Connected after I posted on Facebook that I was looking for
dogs for the shoot*

WOOD PLANTER: $38.98
PAINT: $5.15
Hand-painted a wooden planter from Home Depot

LOCATION: FREE
Workshop of a friend

ASSISTANTS: TRADE
Interns & friends

FOOD: $75

TOTAL: $179.76

BUILDING A TEAM

A diverse cast of professionals can participate in a shoot to achieve the artistic and logistical feats required to capture an image. Depending on your goals and the genre of photography you pursue, you may have occasion to work with some or all of the professions listed in the "Team Members" definition in the next section. In some circumstances—for example, in advertising or fashion photography—these people can make or break your photo shoot. Your needs will change with each shoot. Many times I work alone or with one assistant, and sometimes I have 27 people on set among the client, crew, and talent. Having a solid go-to set of people you trust makes a big difference. It allows you the freedom to comfortably delegate the logistical elements of the shoot so you can focus on being creative while on set.

Teams work best when everyone benefits from the partnership, whether financially, through trade or barter, through portfolio print trade, or by gaining experience.

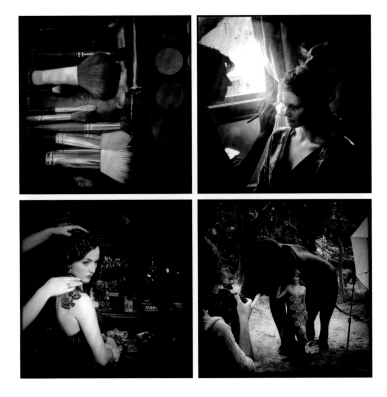

Sometimes it's easy to communicate your ideas with someone else. You find that you are instantly on the same page with little effort, and they are able to execute your vision exactly how you imagined and described it. Other times, communication will be more challenging, and potentially frustrating, as you find you can't effectively convey the concept in your head to the person or people you are working with. Misunderstandings arise, and you need to be able to move forward productively. Be considerate and respectful of others' ideas and feelings. It's an art form to make people feel valued and included in the creative process while maintaining your own aesthetic and vision. A well-executed mood board provides a good tool for visually articulating the goals of the shoot. Providing consistent and specific feedback also helps move the team toward a shared understanding.

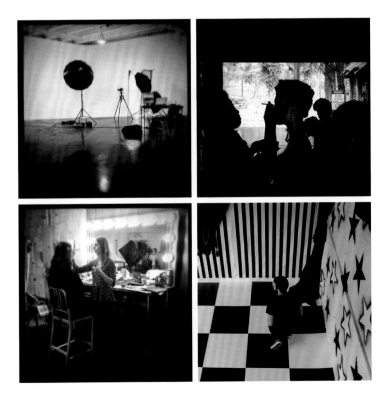

Creative collaborations can inspire and transform your work. Cultivate relationships with people you admire—and whose work resonates with you—that you can add to your team.

Subject, talent, or model(s). These are the muses that inspire and inject life and story into a given piece. They must look right for the story you are trying to tell. It's important that, either through direction or on their own, they are able to move and pose in ways that are natural and expressive, with engaging facial expressions. Discovering and/or casting the right talent for a shoot is an art form all its own, whether it's documenting someone's life; making a portrait; creating a character for a constructed narrative; re-creating a lifestyle scenario; or shooting a fashion, beauty, or glamour image, an advertisement, or a fine art study.

Art director. This team member is responsible for the visual style of the image(s). The art director creates the overall design, concept, or idea, and provides direction to the photographer to develop the photograph.

Producer. This team member is responsible for all the logistics and organization of a production shoot from start to finish: the pre-production, planning, casting, crew hires, equipment rentals, scheduling, travel, permits/access/permissions, paperwork, contracts, budget, management and problem solving on set, and coordination with post-production.

Fixer. This person is local to an area and well-connected in the community. S/he makes introductions and provides access for photographers. A fixer is typically a member of a team for documentary and journalistic work.

Assistant. This team member is responsible for all the photographic equipment, lighting gear, setup, settings, and breakdown. If you have a few crew members, this job may expand to other areas where assistance is needed in digital tech, set building, prop styling, etc.

Digital tech. This team member is responsible for all the digital aspects of the shoot—running the computer system tethered to the camera; confirming the viability of files

(checking for sharpness, exposure, color correcting, and other issues); importing, naming, organizing, and backing up all digital files; and retouching and making adjustments to present files for review with the photographer and/or clients.

Location scout. This person finds and secures an appropriate location for a shoot. The scout typically has a database of potential locations and relationships with the managers of those locations. The scout may travel in advance to a destination to "scout" possible locations for the photo shoot to take place.

H&M (hair and makeup) artists. These people are responsible for hair and makeup of the talent—at times, this is the same person, especially if the budget is low. You can also have manicurists on set, especially for shoots where the talent's hands or feet are featured.

Wardrobe stylist. This is the person who is responsible for selecting/pulling the clothing and accessories for the shoot, styling the complete looks, and dressing the talent. The stylist should also ensure that the clothing has no issues while being photographed, such as wrinkles or straps showing. If necessary, the stylist also provides all the details of the clothing for credits.

Set stylist/set designer/set dresser/set builder. This team member is responsible for sourcing or building and arranging the set pieces on location or in a studio that make up the background of the photograph. This team member can be the same person as the prop stylist.

Prop stylist. This team member is responsible for sourcing or building and arranging the props used in a photo shoot.

Retoucher. This person digitally enhances or alters photographs to outlined specifications, typically in Adobe Photoshop or another photo-editing software.

You have a few ways to research and find team members. You can learn about them through word-of-mouth recommendations from others in the industry and from portfolio websites or social media profiles, agencies, and

directories such as LinkedIn, Model Mayhem, or Behance (sites vary in the quality of work and talent). You can also look through the credits of editorials you admire in order to learn the names of the team members, and then contact them through their websites or agents.

Be a good judge of character when selecting people to work with. Don't undervalue the importance of good set etiquette and professionalism among your team. Technical and creative talent are, of course, valuable, but people need to work well with others—with so much going on, the last thing you want is your work to be compromised when personality clashes materialize on set.

Use shot lists and call sheets so that you can use your time most efficiently, ensure that you haven't forgotten to shoot anything, and make sure everyone shows up when they're supposed to. If you have thought everything out well in advance of the shoot—when you are not stressed or under pressure—then you don't have to waste time making decisions in the middle of your shoot and risk rushing or running out of time. It's great to be able to schedule an efficient shoot where people spend a minimal amount of time sitting around waiting.

A SHOT LIST is a breakdown of every shot (setup or picture) that you want to get on any given shoot day. It can include a detailed and fully previsualized sketch, a list of rough criteria (three outfits or "looks" shot somewhere within a specific location), certain orientations (master in environment, 3/4 shot, beauty, product, and vertical and horizontal of each), a list of narrative necessities (picture of person working, picture at home, picture interacting with family, details of personal items), or some combination of these. Using this shot list, you can start to create the SCHEDULE.

Whether I have one setup or 10 setups for a day, I like to work backward to determine an estimated allotted time for each aspect of the shoot. It can get very complicated working around a number of people's schedules. I use the time criteria of the most important and least flexible element and plan everything around that. I try to pick realistic and accurate time frames for how long it will take to set up, build, light, prop, dress, do H&M (hair and makeup), shoot, switch setups, etc., and then I compile everything into a timetable so that all team members are on the same page.

Once I have the timetable information, I know who I will need at what point of the day, and I can put together the CALL SHEET. A call sheet is a spreadsheet of all the team members, their roles, their contact information, and the time that they're needed on set. I schedule people roughly one hour before they are absolutely needed on set to accommodate for the fact that some people are likely to be 15 to 25 minutes late, and then will need 15 minutes or so to settle in and get to work. Typically, H&M will tell you they need much less time than they do, so I always give them at minimum two hours at the start of the day on any fashion shoot.

PRE-PRODUCTION WORKSHEET: *Shot List*

PREPARED BY :

DATE :

PROJECT :

SHOOT ID :

CLIENT :

NOTES

		SHOT 1	SHOT 2	SHOT 3	SHOT 4
OVERVIEW	*Sketch*				
	Description				
	Location				
ON SET	*Cast / Models*				
	Looks				
	Set Elements *Prop List*				
TECH	*Orientation*				
	Aspect Ratio				
	Gear List				

PRE-PRODUCTION WORKSHEET: *Schedule Worksheet*

PREPARED BY :

DATE :

PROJECT :

SHOOT ID :

SHOOT DATE :

SUNRISE/SUNSET :

OF SETUPS + NOTES

TIME	SCHEDULE	
8 AM	*crew unload gear and organize location*	*arrive and set up h&m*
8:30 AM	*set up for shot 1 and plan for rest of setups*	*model in h&m for shot 1*
9 AM		*wardrobe arrive / unpack*
10 AM		*model dress for look 1*
10:30 AM	***photograph shot 1***	*stylist to pull out look 2*
11 AM	*reset for shot 2*	*model change for shot 2*
11:30 AM	***photograph shot 2***	*stylist to pull out look 3*
12 PM	*reset for shot 3 / order lunch*	*model change for shot 3*
12:30 PM	***photograph shot 3***	*stylist, hair & makeup lunch*
1 PM	*lunch*	*model lunch*
1:30 PM	*download cards / review images*	*h&m touch-up*
2 PM	*reset for shot 4 and afternoon setups*	*model change for shot 4*
2:30 PM	***photograph shot 4***	*stylist to pull out look 5*
3 PM	*reset for shot 5*	*model change for shot 5*
3:30 PM	***photograph shot 5***	*stylist to pull out look 6*
4 PM	*reset for shot 6*	*model change for shot 6*
4:30 PM	***photograph shot 6***	
5 PM	*download cards / review images*	
5:30 PM	*breakdown and pack up*	*pack up h&m and wardrobe*
6 PM		

PRE-PRODUCTION WORKSHEET: *Call Sheet Worksheet*

PREPARED BY :

DATE :

PROJECT :

SHOOT ID :

SHOOT DATE :

WEATHER :

CLIENT & CONTACT INFO

SHOOT TIME :

OUTDOORS : ☐ Y ☐ N

LOCATION

Address

Contact Person

Parking? ☐ Y ☐ N

Phone Reception? ☐ Y ☐ N

DIRECTIONS

TEAM & TALENT		NAME / WEBSITE	MOBILE # / EMAIL	CALL TIME / WRAP TIME
	Photographer			
	Producer			
	Art Director			
	1st Assistant			
	2nd Assistant			
	Digital Tech / Retoucher			
	Hair Stylist			
	Makeup Artist			
	Wardrobe Stylist			
	Set Designer			
	Prop Stylist			
	Model			

PLAN B, C, AND D

Always have a backup plan because, while something will ALWAYS go wrong, the shoot must go on. You'll thank yourself for preparing for the worst and having a backup plan to your backup plan. There are lovely, dedicated, professional, trustworthy people, and there are flaky people. And sometimes even professionals have unexpected things come up. Relying on others can be trying at times: People are late, cancel the night before, or just don't show up; models get double-booked or don't look like their casting photo; equipment breaks; locations flood; animals escape; the stylist fights with the assistant; it rains on an outdoor shoot; the light is bad; someone gets hurt. Any number of things can happen that you cannot anticipate. But you are still responsible for making sure the shoot happens, and you must have a practical solution for everything. This is where staying calm and employing your problem-solving skills comes in handy.

I recommend photography business insurance coverage to help protect you in case of an unexpected event like theft or accident. For the hobbyist, it offers peace of mind; for the professional, it's a must. *Property coverage* protects your technical equipment —studio gear and the gear that travels with you, in addition to studio furnishings used in your workplace—from damage or theft. This insurance may also cover damage to your studio or office's physical structure, depending on the policy. *General liability coverage* protects you if someone is injured while on your set or in your studio. It also provides coverage in the event that you damage, destroy, or misplace any props, rentals, property, or any location you are working in.

If you are a professional photographer, you may also want to consider the following policies: *Professional liability coverage*, also known as errors and omissions insurance, covers you for damages related to professional mistakes. *Data compromise coverage* pays for information recovery and related services if your computer is stolen or you lose data. *Business interruption coverage* covers you in the event that you are unable to work for a period of time; it can temporarily replace your business income after you suffer a major covered loss.

You have to read these policies very carefully in advance to understand what is covered (and under what circumstances) to make sure you are fully protected and won't be left in the dust in the unfortunate event that you have to file a claim.

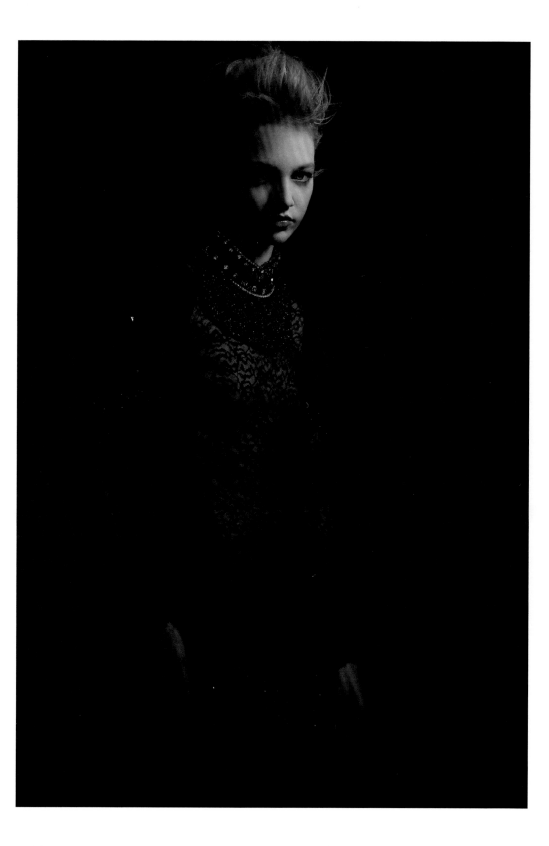

ON SET CHECKLIST

Nothing is more exhilarating than being on set, on location, or in the field on a shoot. It makes all the planning, logistics, and crisis navigation worth it because, at the end of the day, you get to do what you love—make photographs.

Shoots can get a bit hectic, especially if on large productions. To stay focused and creative (and so I don't lose any gear, forget to get a shot I need, or accidentally shoot my whole project with the exposure way off and my file type set to shoot JPEG), I try to maintain a structure or a checklist at every moment of my shoot. Every situation I walk into is different, but here is my basic step-by-step process:

ORGANIZE

Arrive at the location and say hello to the location manager and team.

Assess the location, and determine the areas to shoot in first (if multiple setups are necessary, decide on the order now).

Organize everyone's stations thoughtfully around the shooting plan, and unload gear and shoot materials. Distribute mood boards if this hasn't been done yet.

SETUP

Compose the camera frame on a tripod. If using natural light, consider it when composing the frame.

Build the set, and add props around the frame. Use a stand-in to determine where your subject will be if you're using a person or animal.

If you're using lighting equipment, light the set.

At this time, the subject or model should be in H&M and wardrobe.

The subject or model should sign any necessary model releases upon arrival or in advance of the shoot.

Test and check all camera and lighting settings. Bracket the exposure, make blank frames of the set, and test your image with the stand-in.

SHOOT

Bring in the subject or model, and shoot. Since everything has been checked ahead of time, relax and be creative without worrying about any of the technical details.

Check for a solid frame—and be very analytical. Does the picture tell the story? Is it engaging and interesting? Look at the entire frame—not just the subject. Is it in focus (if it's supposed to be)?

When you know you have at least one usable frame for your purposes, then you can experiment and begin to try other poses, setups, and camera angles. Allow your brain to shift away from self-critique and judgment.

Shoot for coverage and range. Make sure you get additional exposures or blank frames of the set for retouching.

Do not break down anything until you have confirmed that you have at least one good, usable shot. It's best to check on a computer screen, as opposed to the back of the camera.

Reset for the next setup / repeat

STRIKE THE SET

At the end of the shoot, download and back up files to additional hard drives, put them in a secure place, take stock of all the equipment, and leave the location as you found it or better.

Thank everyone. That's a wrap!

BACK AT HOME

Back up files and add keywords.
Sleep on it, then begin the edit.
Start post-production.

BEST PRACTICES

The following are some common best practices to keep in mind before, during, and after any shoot.

Communicate all the details of the shoot in an organized manner. This is where sharing the production sheets and call sheets with the team becomes very helpful. While shooting, be sure to have easy access to copies of mood boards, production sheets, call sheets, shot lists, etc., so you can check in with those documents periodically.

Make sure all your paperwork is in order, from permits to releases. For example, if a model release is needed, send it in advance to the model or agency. If that's not possible, have all the releases signed upon arrival and prior to any shooting.

Confirm and reconfirm call times with your entire team.

Pack all gear and necessary materials the night before the shoot.

Be over-prepared. I would rather have more than I need and not use it than not enough of something—so always bring extras.

It's always a good idea to travel with some just-in-case extras: first aid kit, sewing kit, gum or breath mints, lighter, tampons, rain poncho, blanket and towel, Sharpie, garbage bags (one white, one black), gaff tape, a-clamps, mini toolkit (screwdriver, pliers, wire cutters, hammer, measuring tape, and level), pair of gloves, batteries, and various extra cords and cables.

Check the weather when shooting outside. It's helpful to have an accurate weather and sun-tracking app, such as the National Oceanic and Atmospheric Administration (NOAA) Weather or Sun Seeker.

If shooting in cold weather, bring extra layers, jackets, hats, and gloves in case anyone on set is not prepared. It always feels much colder after standing around outside for a few hours. If shooting in the heat, extra hats, sun umbrellas, sunscreen, and lots of cold water are a must. It's no fun shooting with a team or talent that is more uncomfortable than they need to be.

Create a realistic timetable and shot list. Make sure to include setup and reset, allocate enough time for set/wardrobe/hair

and makeup change time, and schedule in cushion time in case you fall behind schedule. Nobody minds going home early, but problems can arise if people need to stay later than they anticipated.

Don't skip or skimp on craft services. A well-fed team is a happy team. Be sure to find out in advance about any dietary restrictions.

Say thank you. It creates a nice working environment when people feel appreciated and valued.

Deliver files and prints in a timely manner, especially if people have worked for trade on the project. Although it's easy to get behind schedule due to backlogged projects, it's just as important to value your arrangements and the time that people have invested in your work.

Write down everyone's name, spelled correctly, as they would like to be credited for the project.

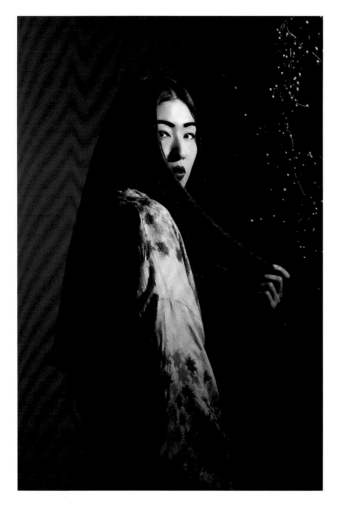

GOLDFISH NO. 2306

(2015)
From the series *This Is Water*.

GEISHA

(2012)

COLOR STUDY IN RED

(2013)
From the series *Nostalgia: A Study in Color.*

Editing is a personal and subjective experience. Two people may look at a folder of images and choose completely different shots for different reasons. Sequencing images together adds a further layer of complexity. Not all great photographers are great editors. It's an often-overlooked skill set in the picture-making process and requires as much care and thought as every other step. For photographers, it requires enough distance from your work to analyze an image for what it is without the emotional backstory of everything that went into making it.

Does this image resonate? Does it have that special something that captivates and enchants the viewer? Is it interesting? Does it tell a story? Does every aspect of the frame and every element within the frame come together to support the story (as discussed in Chapter 1 on making strong images)? At times, the simplest gesture will breathe life into an image. Separate an image that feels alive from those that feel static and staged. I ask myself: Do I want to look at this image longer? Would I hang it on my wall? Have I seen this before? Have I made a picture *of* something or *about* something? Does the image possess the aspirational qualities on my attribute pyramid (from Chapter 1)?

The end use of the image and the goals of the project will affect how you edit. Editing for a magazine editorial is different from sequencing for a book, which is again different from curating a gallery show or laying out an ad campaign. But in all cases, creating a dynamic flow and considering the viewer's experience is important.

It's very helpful when a photo-editing software program allows you to rate photos, compare images side by side, and view them in a specific order. I use a process of elimination to determine which selects will make the cut.

Here's how I do it. Initially, I rate everything with one star, then go through a de-rating process, reducing all images that don't seem interesting to zero stars. With the viewing criteria set to show one or more stars, I am left with the images that are up for consideration. Next, I increase the rating of all the one-star images to two stars. I change the viewing criteria to show two stars or more, then go through a more brutal edit, de-rating the weaker images to one star. Left with only the strongest options, I sequence the images together to discover

the best combinations. For bigger projects (or if shooting film), such as books, portfolios, or gallery shows, I make small 2x3 or 4x6 cheap prints, and move them around on the floor or tack them to a wall. I may have to sit with the images a little while before committing to a particular edit.

If you find yourself struggling with this part, enlisting the help of a photo editor may be worth the expense. Especially early in their careers, a lot of photographers completely miss their most interesting pictures. Or they are unable to see the connections between seemingly disparate images or projects that, in fact, would work well together. A photo editor can look at your work with fresh eyes and provide valuable suggestions. I needed an editor to show me that all my projects had a fundamental commonality, and when I stopped separating them I realized how everything could sit together, with each project reinforcing the others' strengths.

When I asked Alessia Glaviano, Senior Photo Editor at *Vogue Italia*, to explain what she looks for in a photograph, she replied:

Images stream one after another, often too quickly, in the fluid and virtual day-to-day routine. Thousands, if not millions, of photographs have lost their physical and tangible nature. Those photographs that long ago used to fill photography albums and drawers nowadays are loaded into the virtual space of a folder on our computer or phone. Increasingly they become disposable products to be perused and consumed quickly, less likely to become treasured objects to be cherished. I precisely remember certain photographs of my childhood; they are set in my memory. Often I have looked at them and, as if they were keys, I simply recall them to unlock different chapters of my life. The way I mnemonically visualize the images on my Facebook wall or on Instagram is different: They are not objects in themselves; they are more transient, dissolved in that constant flow of visual information that is difficult to linger on. Visual imagery is increasingly changing its function from collective cognizance to language.

If a photographer wants his/her work to be meaningful, that photographer must be aware and act responsibly; he or she needs to identify and understand the very reason why he or she has chosen the photographic medium and not another form of

expression. Photography is the only medium that, in order to exist, needs real subjects; and it is for this very reason—the fact that object and subject have to meet—that photography is so fascinating, magical, and different from the other forms of art.

Photography requires relating to the outside world. The question is what kind of version of that outside world the photographer is going to return. For something to be considered art, for something to be remembered, it must have a transformation "coefficient," which is the variance between reality and the vision of reality that artistry brings with it. After all, without transformation, photography would be a mere paper sheet.

A good photographer is the one who is able to return a unique, personal, and unrepeatable version of the outside world.

Having said that, it's likewise necessary to have a concept and develop a project. Christian Caujolle (founder of the photographic agency, L'Agence Vu) once told me that he believes the only works that are meaningful are those born out of authentic necessity; and I totally agree with him.

I believe that what distinguishes between good and mediocre photography is the extent to which it comes from a true inner need: how significant those images are for the photographer who shot them because it's such an irrational, emotional significance that cannot be translated into language that allows the transfer with the viewer.

Together with the concept and the project, don't forget the importance of technique. Vision without technique does not go anywhere. If you have an idea and you do not know how to translate that into reality—if you don't have the technique— your ideas will be limited.

A photograph doesn't move and doesn't speak, and yet there's a lot happening without it speaking or moving. The limits intrinsic to photography can become strengths in your images. I think that the most interesting images are the ones that are open, that don't explain too much, and that are not didactic. A good photograph should have multiple meanings and offer the chance for the viewer to read the image with his own background, culture, and vision.

I believe that a major and fundamental achievement in an individual's personal growth is managing to let opposites coexist and understanding that absolutes in terms of black/white, good/evil, and right/wrong do not exist; human nature inhabits the gray areas in between. The greatest insights come to those who approach life and experience not with a rigid attitude, but rather, by embracing and accepting the contradictions and complexities. Photography, which is the metaphor par excellence, can be superficial, silly, and meet people's need for a reassuring simplification, or it can be clever and return evidence of the unsettling ambiguity and complexity of the human existence, thereby sowing the seed of true understanding. The photography that interests me clearly falls into the second category.

→

ALEX YOUNG

(2010)

Album cover art for Alex Young. Dress by Arlinda McIntosh.

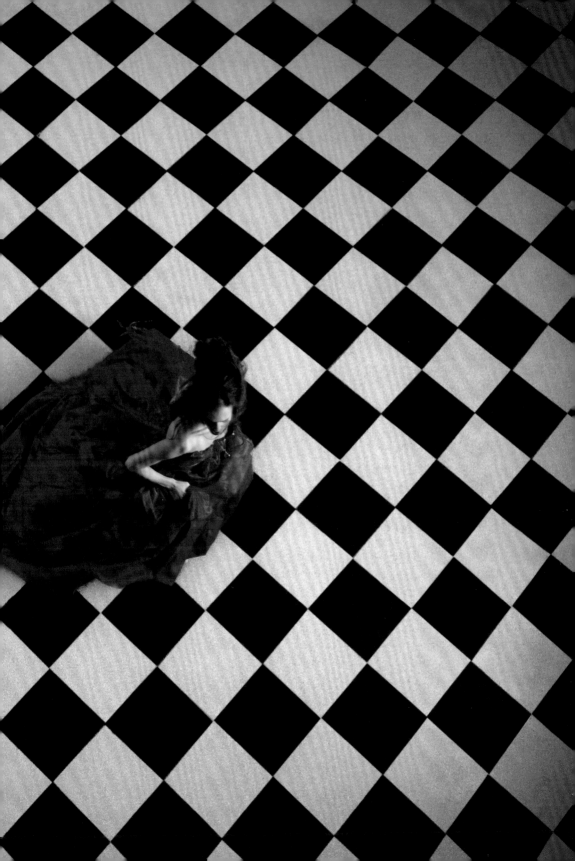

POST-PRODUCTION

Though this is the last section of the chapter, post-production absolutely should not be considered an afterthought. Advances in digital retouching and software have offered incredibly powerful tools and capabilities, though they are not without their limitations. Just because you can do something to an image does not mean that you should. As with every other step along the way, this stage requires conscious creative thought and analysis of the image to determine the best place that retouching can take the image to. The choices you make in post-production have varying levels of impact—but never none. If you do "nothing" to your image, you are still processing it with the factory defaults, which are the settings that someone else decided look good. From basic global corrections for accuracy to stylistic choices to the fabrication of entire worlds, retouching needs to be thought out and planned for right along with the shoot itself. Even if the image has no basis in reality, it still needs to look "real." For the viewer to be transported, you need to remove all the seams.

Post-production considerations vary by photographic genre. There are no boundaries within fine art photography. By contrast, there is less and less flexibility with journalistic or documentary photographs, as organizations attempt to create a global standard to ensure photographic integrity. Fashion and advertising is also becoming more regulated to avoid misleading the public and perpetuating unrealistic ideas of beauty. Be thoughtful about the ethics and responsibility associated with changes made to your images and what is put into the world, specifically as it pertains to post-processing and retouching.

In my workflow, post-production is another integral layer of my creative process. Every image is different. I spend a great deal of time analyzing the file to see how it can be made stronger, visualizing where the image can go. I experiment with different global and regional adjustments to exposure, color, tone, composition, light, etc. Sometimes an image needs very little work—other times you would not believe what I started with when viewing the final image. I aim to accomplish as much as I can in-camera with the resources that I have, but if I'm unable to find an in-camera solution, then I will look into my post-production options.

On my latest project, *The Fantastical Feasts*, I enlisted the help of retoucher Rebecca Manson from the post-production

studio, The Post Office. The partnership with Rebecca has highlighted for me the critical importance of having a meticulous, skilled retoucher providing support in post-production, as her work has taken my imagery to the next level. In addition to the technical improvements to the images, it's wonderful to collaborate with someone who understands the work and can be another set of eyes, providing additional insight while walking through the creative process. Her input from a retoucher's perspective altered the way I thought about shooting in a helpful way.

Here are some of Rebecca's thoughts on the retouching process:

No magic step-by-step guide outlines exactly what should be done in the post-production process. There are guidelines, many dos and don'ts, but every image, series, and campaign is unique.

Either in your own retouching workflow or when working with a professional retoucher, there are factors to consider in advance of the shoot. Talk yourself (or your retoucher) through the whole process, as you probably do for the shoot. "I need these lights, this lens, this body, certain stands, this tripod, etc." Extend this thinking through the whole process to the retouching stage, especially if the image requires heavy work in post. Create a checklist for the essentials you need to capture while on set.

Seamless retouching begins with the perfect puzzle pieces. A lot can be done in Photoshop, but it shouldn't be a crutch for sloppy shooting. Even if something can be fixed in the computer, it's not the best place to do it and isn't best for the image. Pay attention to consistent lighting, exposure, angles, and focus, and address them in-camera. Taking the time to remove that light stand, clean that surface, straighten the object, and steam out those wrinkles before the shutter is pressed will not only save hours of retouching time and frustration, but it will look better in the final image as well. Do not fall back on the "we can fix that in post" mindset. Consider all the time spent on little unnecessary fixes in retouching; that time can and should be used for more important things, like making the perfect mask or tweaking the colors and tones until your image sings. This thoughtfulness while shooting will, without fail, save you time and money.

As with any skill set, retouching/post-processing needs to be learned, practiced, and refined. Understand the software and tools at your disposal. You also need to understand your vision beyond the image in your head, and understand how you are going to get to that point from the camera and shoot through to the RAW images (or scans) and into Photoshop. How the final image looks and the story it portrays are extremely important. It will be about the feel and emotion. You need to take those adjectives and translate them through retouching tools (Photoshop) onto your image. In my retouching career, I've often had instructions from photographers and creatives that sounded like a sommelier tasting wine. To be able to take an abstract expression and come back with an adjustment they can "feel" is right takes experience, a good knowledge of the software and, importantly, an understanding of visual psychology: how the eye is affected by composition, color, light and dark, balance, tone, etc.

I work in close collaboration with the photographer and art director or designer to create the final interpretation of the images, translating their vision into reality. I want to understand a number of things from any photographer I work with. How do you work? How do I work? Where do we overlap? Where do we differ? How can we help learn from and inspire each other? I want to understand what the photographer needs or wants from me, or more importantly, what they want from their image(s). Good communication and mutual understanding are key. On jobs that are heavy on post-processing, a discussion with the retoucher early on when planning the shoot can open up more creative possibilities. The photograph's potential expands when brainstorming with a knowledgeable retoucher, who can provide answers to technical questions and predict problems before they have a chance to happen on set.

RETOUCHING ADVICE

Work on a calibrated, large screen.

Use a tablet.

Practice drawing skills for better hand control.

Work nondestructively so you can always go back and make changes.

Avoid heavy-handed and unnatural retouching.

Images should be believable (even when not realistic).

CHAPTER 5 | *Wrap-Up*

Chapter 5 offered an array of tools to help organize any type of shoot, from a documentary to a high-production project.

While Chapter 4 offered tools to give your vision depth at the idea stage, Chapter 5 provided the concrete steps to bring that vision to life through organization and research. This included how to strengthen your skills in sourcing materials, negotiation, and gaining access. It broke down all the moving parts into manageable tasks to make the pre-production process easier, using spreadsheets to help account for all the details. It also provided tips for producing work on a budget, a necessary skill for building a portfolio and experimenting with personal work.

Once all the elements have come together, the shoot should go off without a hitch. In the case of hiccups or all-out disasters, a back-up plan and some creative problem solving can ensure that the shoot goes on, and you still leave with a usable image. With that image, you can enter the final stages of the creative process: editing, sequencing, and retouching to round out post-production.

There are many more aspects to the business side of photography, which are not covered in this book. I would encourage you to investigate further the business standards and best practices found within each specialty of photography.

📖 RECOMMENDED READING

Getting to Yes (1981), Bruce Patton,
Roger Fisher, and William Ury

*Best Business Practices for
Photographers* (2009), John Harrington

∞ RECOMMENDED VIEWING

Gregory Crewdson: Brief Encounters
(2012), Ben Shapiro

📷 INSPIRATION

Gregory Crewdson
Alex Prager
Julia Fullerton-Batten
Annie Leibovitz
Ellen von Unwerth

Fahey/Klein Gallery
Casey Photo Agency
The Photo Society

The View

er Experience

PHOTOGRAPHY
is a form of
expression for
communicating
and engaging with the
world, so spend some time thinking about
how others will experience your work and
what you want them to take away from it. That
is not to say that you should cater to what others
may admire in a way that makes your work
inauthentic, but rather, to make sure you are
consciously considering the viewer experience that you
want to elicit through your work.

This book has tried to consistently outline an approach
centered on thoughtful, conscious, and appropriate
choices—that does not end when the picture is created. You
can apply the same frame of mind and tools to your
presentation methods as well.

PRESENTATION CONSIDERATIONS

How you present your work to the world—regardless of the viewing medium: online, book, zine, prints, projection, installation, multimedia, etc.—should engage the same conscious attention to detail as the image's creation. Once you have a body of work, you still have a number of decisions to make and a lot of room for creativity. The presentation method is part of the art and the viewer experience, so it needs to support the vision without detracting from it. How the work is packaged, laid out, and viewed (everything from paper choice to any graphic/design elements) should intelligently correlate to the work and bring out its best. Viewers are absorbing all of the visual cues of the context where they see your work, and it will feed into the judgments that they make about the work.

With so many advances in smart devices, as well as how we view information online, in print, and through published works (or self-publishing), artists are empowered to have complete control and endless choices when it comes to outputting their work. Research and use these tools to your advantage, as they are a part of communicating your ideas.

Whether I'm selecting paper for prints, choosing frames for a gallery exhibit, creating a book, designing promotional materials, or laying out my website, I want to ensure that my images are presented in the best light and that the presentation is aligned with my brand and personal vision. When in doubt, I refer back to my branding attribute pyramid to see if the presentation materials are in harmony with it.

ARCHIVAL PIGMENT PRINT

Exhibition print on Hahnemühle Photo
Rag 308 gsm FineArt paper.

CRITIQUE AND FEEDBACK

Critique can be very important to an artist's development when it's provided in a thoughtful way. As the creator of a body of work, you don't always have the distance to be able to understand how a viewer experiences your work. An outside perspective can be very helpful to learn what does and doesn't work, and what others are and aren't responding to. Fresh eyes may catch something you didn't notice, provide an alternative perspective, or highlight obscured contextual or narrative issues you thought were clear.

Once you have reached a certain point in a specific project, reach out to your inner support community for feedback to aid in the final evolution of the image or series. When this should be done will vary from project to project, but it will likely be near the final stages when you have sat with the work for a while. You should seek the trusted opinion of someone who understands you and your work. You can gain further insight by having your portfolio or whole body of work reviewed to see what you should be focusing on moving forward.

Whether you're seeking the opinion of a close peer/colleague or a well-respected figure in the industry, it's important to understand a bit about the people critiquing you. Nothing is objective. What are the personal preferences and points of view that the reviewers bring to their review? Are they able to be honest with you, without fear of hurting your feelings? Is their opinion valuable to you?

I have a handful of people whom I trust and respect and will show my work to in its early stages. I value their aesthetic and intellectual points of view. And I feel they understand me. Some are photographers, some are other types of artists, and some are people outside the art world.

It's interesting to get the opinion of those who are not in the industry to have a better understanding of how your work is received by a wider audience. However, be selective about who you show your work to when looking for feedback—you don't want too many competing voices in your head.

Critiquing others' work is one of the best ways to strengthen your own work and improve your understanding of how images are experienced by a viewer. You develop a vocabulary

for identifying and expressing critical feedback, which you can bring back to your review of your own images.

PROCESSING NEGATIVE FEEDBACK: *when to listen/when not to listen*

There is nothing wrong with constructive criticism and feedback. Pictures can almost always get better, and ideas or suggestions for how something can be improved are valuable. However, don't take every comment to heart. There is a big difference between advice that is helpful and guides you to improvement, and unconstructive commentary that does neither. Your work is deeply personal; as a result, you can't always predict how you'll respond to feedback. When you receive a thoughtful and appropriate suggestion, it will resonate with you, make sense, and have an identifiable benefit to your work.

Other times, feedback will be upsetting and difficult to digest. I'm not suggesting that you completely disregard that feedback, but that you try to examine why you are having that reaction. Maybe it wasn't delivered correctly; maybe it's not what you are interested in doing; maybe something does need to change, but the suggestion isn't right for you. At the end of the day, it's your work and yours alone. No one else's opinion really matters.

Generally, people have good intentions and only want to help, but not everyone is in the best position to provide you with guidance, so choose your reviewers wisely. This doesn't mean picking people who will always tell you things are great when they aren't, but rather, selecting people whom you believe have an understanding of your vision and will help make your work stronger.

SERIES AND LONG-TERM PROJECTS

A series is defined as a cohesive, coherent collection of pieces that have a unified theme. I prefer to work in series; I find it a more complete exploration of a topic, where you dive in fully to see what you can discover. Try and fail, make and remake, analyze and improve. The work strengthens and becomes more interesting and meaningful as you learn from each shoot along the way.

Each image in a series needs to be distinct, able to stand on its own, and gain strength and meaning when placed alongside the other images. The images need to be cohesive without being redundant or repetitive in a way that detracts from the series or feels boring.

Although you can certainly tell a story in one image, communicating your story over multiple frames can be narratively fulfilling. A concept for a series can be born at any moment, from a lightning bolt of inspiration, to a single successful shoot you would like to expand on, to a discovery during experimentation or play. Sometimes you'll start out with a very specific and clear idea of what you would like to do. At other times you have no idea what you are doing; you try things to see what works, go in wildly different directions, discover boundaries, and witness the evolution of the concept. Very little filtering should happen early on. Photograph a lot and don't write anything off yet. After a certain point, begin to look at everything together, and start to shape the direction and form of the project. Become very analytical; ask yourself what is working and what isn't. Take these reflections into consideration as you move forward in the project with a more refined plan for the images you still need to make.

How do you know when it's finished? The short and unsatisfying answer to how you know if your image, series, or long-term project is complete is "you just know." It's a feeling in your gut, and the more work you do with mindful thought, meditation, and intuition, the more you'll trust your instincts. If I'm unsure of myself, this is the point at which I ask my inner circle for feedback. It's also valuable to go back to your initial brainstorming list and goals for the project. Have you said what you wanted to say? Are any pieces of the exploration still missing?

Art is never finished, only abandoned.

— LEONARDO DA VINCI

BIRDS OF A FEATHER

(2013–current)

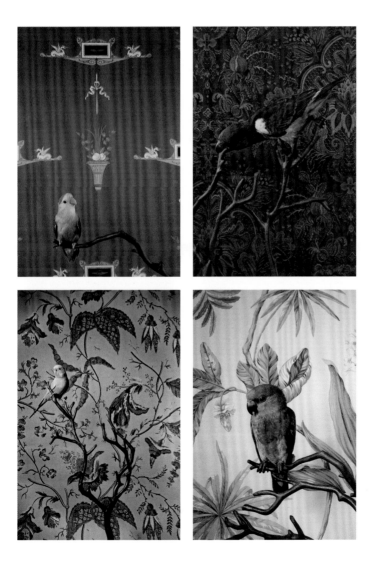

ASSIGNMENTS/COMMISSIONS

The lines between commercial and fine artwork continue to blur as companies realize the value of capitalizing on an artist's point of view or style when it aligns with the brand's marketing. Commercial photography produces imagery that people want to hang on their walls. It's a real struggle for those photographers who are merely camera operators—those who bring no spark of vision—to compete with the sheer number of other photographers able to do the same thing. For that reason, I believe cultivating your point of view is necessary for commercial success, regardless of whether you consider yourself an artist.

A few residual myths remain that alienate artists from commercial work; the most common is probably the "artist's dilemma": Do you stay authentic and "true" to your art, or do you "sell out" in order to put food on the table? I've never put much credence into that dichotomy. Michelangelo's Sistine Chapel was a commissioned piece of art, and patrons commissioned most of the world's classic masterpieces. The challenge for artists lies in finding and cultivating their market so that the commissioned work they are hired to create feels authentic and satisfying.

I haven't experienced a great divide between my personal fine art series and the assignments/commissions that I have been fortunate to receive. This is largely because I'm hired to produce the work that I'm known for making. If you make the work you want to be doing, and if that work embodies your vision and style, then you'll be hired to do that same work. There is always a way to make a picture that has your point of view. You'll most likely be hired for your point of view, so you have to shape that point of view independently. This is why it's so important to create personal work.

I employ all the same tools and techniques when creating an image for a client that I would with personal work, but with different criteria in place, which can provide for some interesting creative challenges. Instead of an inward focus, I look to understand the client and the brand. What are their goals? What do they stand for? What makes them unique? What is the most effective way to communicate with their audience? Then I take the same steps through concept development, idea generation, brainstorming, mood boards, research, pre-production, post-production, and presentation.

Wonderful images can come out of the right commissioned collaboration when agendas are transparent and aligned with each other.

→

CORRESPONDENCE

(2013)
Campaign for stationary and ephemera store Parcel, inspired by the *Nostalgia: A Study in Color* series.

YELLOW NAPED AMAZON & PARAKEETS NO. 9854

(2016)
Commission from *National Geographic* for an article on talking parrots, inspired by my series *Birds of a Feather*.

This book is less about photography and more about using photography to express your personal point of view and experience the world. Your body of work is the manifestation of your perspective and experience. It's the piece of yourself that you leave in the world. Your practices, habits, and fears are the only limits to the depth that you can achieve. If you engage superficially with the creating process, you'll see that superficiality in your work. But if you dive fearlessly into making art, your work can be transformative—for yourself, and for those who experience it.

Reflect, dream, imagine, and transform courageously; live your life as if every sensory and intellectual experience you have is nourishment for your storytelling. I encourage you to

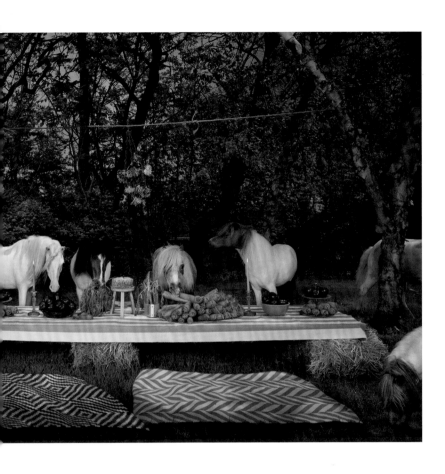

experiment fearlessly, because that is the key to unlocking uninhibited expression—but that is just the beginning. You must experiment in great quantity in order to build your capacity for quality. Curate the stories that you share with the world with meticulous care, because they are the lasting contribution that you make.

THE SHETLAND PONY FEAST

(2013)
From the series *The Fantastical Feasts.*

..

∞ RECOMMENDED VIEWING

Jiro Dreams of Sushi (2011), David Gelb

..

 INSPIRATION

Tim Walker
Kirsty Mitchell
Maggie Taylor
Gregory Colbert
Robert & Shana ParkeHarrison

Griffin Museum of Photography
art + commerce
Contrasto

CHAPTER 6 | *Wrap-Up*

We spend so much time, thought, and care crafting our images that it can be difficult to zoom out and see the work as a whole. This chapter emphasizes the importance of making conscious, consistent choices throughout the art-making and presentation process, because how you package and present your work will impact the responses you get from viewers. Strong presentation can support and elevate the work, but leaving it as an afterthought can distract, detract, or devalue it. This applies not just to presentation choices like frames and paper for printing, but also the big picture of what kinds of assignments you take, how you cultivate a series, and the medium that you use to showcase your work. Your relationship with your viewer is a two-way street, and this chapter also discusses considerations when soliciting and receiving feedback. Having a solid understanding of how the entirety of your work is experienced and understood by your audience relates directly back to your identity as an artist and the goals that you identified for your work.

The journey in this book started with a reflection on the legacy of the art you create. At the end of Chapter 6, you have arrived at the end of our journey only to find yourself back at the beginning again.

CONCLUSION

This book is a guide to a magical place, but as with any guidebook, you have to go to this place yourself to experience the magic.

By delving into an investigation of the purpose of art and what makes strong imagery, I've provided a framework with which to explore your own development as an artist: your personal vision, artistic roots, psyche, and areas of interest. I've also encouraged you to set aspirational goals to work toward.

With a conscious curation of experiences and inspiration, you'll engage with the world and your community in an interesting and adventurous way. This will inform your artwork and expand your life. While you explore all the wonders of this world, turn inward to investigate your internal world by tapping into the deep pools of your unconscious mind—the seat of all creativity and imagination through dreams, meditation, and working intuitively.

With an understanding and acceptance of some of the common creative psychological challenges inherent to the nature of artists—such as self-censorship, fear of failure or judgment, and paralyzing perfectionism—you can overcome personal obstacles and become more confident, productive, and positive. Intentionally make time to nurture your creative self with regular practice, play, failure, and experimentation in an environment conducive to real productivity that fits into your life in a sustainable way.

Ideas will flow freely and unencumbered as you are regularly inspired and exercise your skills in divergent thinking, free association, mind mapping, and mood boards. You now have all the tools to fully develop your concepts and turn any idea into a visualization. From there, all you need is a plan and a little organization, research, and resourcefulness as you gather all the elements to bring your visualization to life. Once on set, let your creativity run wild and surprise yourself with the results. Finally, editing, sequencing, post-production, and presentation considerations add the finishing touches to the work, making it ready to release your project into the world.

Throughout this book, I've mentioned the importance of being very clear with your own goals when creating work. In that spirit, my hopes for this book are that:

It has sparked some investigation into your inner thoughts and the world beyond.

You will generate personal concepts that allow you to express yourself artistically and uninhibitedly. You're driven to expand yourself personally and create deeper imagery. You begin to understand your own nature and psychology and are able to generate conditions that allow you to be more organized, productive, and efficient. You are constantly analyzing the strength of the work you produce, and you're being thoughtful at every step along the way. I have imparted some useful tools, not just inspiring you but empowering and motivating you to create work regularly and with confidence.

Finally, I hope that this artistic transformation is as powerful to your life overall as it is to your art-making process.

Artist

In the beginning of the book, I emphasized that the surest path to success is to define your own artistic identity and creative process. There are no formulas or steps, and this book is intended to support you in that process of self-discovery. To highlight the wonderfully diverse and personal nature of creating, I interviewed artists whose work and process I admire. Some of them are just embarking on their careers, while others are leaders in the field of photography. Their work ranges from commercial to fine art to documentary. These artists create work that is personal and truly theirs, express their vision with depth and originality, and explore concepts that matter. Here are their insights.

Interviews

MAGGIE STEBER

it is to be more informed or moved emotionally by what they see, or that they expand their understanding of how much more we are alike than different.

I want them to see beauty where they normally do not, a beauty that expands their hearts and minds. I want them to have an increased awareness and understanding about the struggles of others and how the human spirit always finds a way to free itself from the bondage of hate or indifference.

What are some of the important themes in your work? Are there concepts that you consistently revisit?

I'm always looking for ways to insert humanity into my photographs. I photograph people. I provide a platform for their stories, and I'm the blank page. With my camera, they can write their own story. I look for precise moments that define a situation, person, or place—how it feels to be in that place, or to be them, to walk in their shoes, to recognize ourselves in others. That's in my documentary work. With portraiture, I try to tell a story beyond just a picture of someone. I'm fond of saying it's not about what someone does, it's about who they are. I want to show who they are.

Why do you make pictures?

I make pictures to make sense of the world. Often it's a reaction to the awe and wonder of things—small moments or big events. I have so many questions about this world and about life. Taking a hard, long look at things helps resolve some issues for me. I also love that photography knows no boundaries; it's only we who limit it. Photography can be as imaginative as we can be. It offers a blank page or palette on which we can tell stories, real or imagined, because it's a universal language. All viewers bring their own understanding to it.

I hope when people see my photographs that they are somehow changed—whether

Most of my work is hopeful;

but lately I've delved into a darker side of life, and perhaps it reflects my own psyche.

Describe your creative process.

I try to imagine what I'm going to find when I go out to photograph. Then I imagine ways to elevate the situation to be more magical, more beautiful or tender, more dramatic or vibrant. I also look at the work of other photographers, starting with photographs that have nothing to do with my style that might be used as interpretative tools. I find looking back is just as rewarding as looking at contemporary photographers. I look at paintings and design, and I listen to music that I keep in my head while I'm shooting. I read poetry and essays, and sometimes I look at films—especially Federico Fellini and Alfred Hitchcock—both of whom managed to capture the different facets of the human spirit, both light and dark. I try to be inspired.

How similar are the final images you create to the initial ideas?

This depends on how much control I have over a situation. Sometimes they are better than what I imagined and sometimes not. If given the time, permission, and freedom, I usually come away with an image that is close to or better than I imagined. If I'm rushed or if a subject isn't collaborative, the result is usually less than I had hoped for. There's always a possible surprise

element that I hadn't counted on. Some things seem to happen on their own, as though they were meant to be. Of course, lots of factors play into the outcome, such as rain or sunny days, how the light falls in through a window, what a room looks like, someone's mood, my mood.

Sometimes, no matter what you do, you can't make it work. I'm surprised at how easy and fast some things fall into place. Other times, no matter how much you try, it never comes together. That's just the creative process—it's mercurial, the beauty and the suffering are what makes it interesting. I'd like to say I have control over all this, but I don't. I like to fly by the seat of my pants. I'm not as intrigued when things are too perfect. I'm not always looking for perfection.

What are your personal characteristics that enable/help you to make your work?

I'm wide open to a variety of photographic styles, but I'm also open to ideas, a variety of photographic approaches, various kinds of art and music. I have a curiosity and a willingness to learn and try to new things. Commitment to an idea is critical. Going with your gut or mood is important. Sometimes I want things to be perfect, and other times I prefer spontaneous, down and dirty. Life isn't perfect, it's messy in a lot of ways— understanding that creative work reflects that can assure a variety of visual ideas. I'm

someone who is full of ideas. I don't act on them all, but certain ones stick; those are the ones I'm interested in. I have a lively imagination, and I let it loose all the time.

Being generous, encouraging to others, kind, and angry about important things (which drives me to action with my work) are all characteristics that define me.

Do you have any places you visit or rituals to maintain your inspiration?

Before starting something new or going on assignment, I look at picture books. I often listen to music that I think of as background soundtracks to the mood. Art is important. Often I'll sit outside and listen to the birds singing. Birds were the first music; their songs drown out all the noise of our lives, put me in a peaceful frame of mind, and clear my head so I can think. Although not my favorite technique, I often dream about an assignment or a new experiment the night before I'm going to do it— everything that could possibly go wrong goes wrong in the dream. It's like a bad dress rehearsal that ensures a much better outcome.

Who are your favorite artists?

I have favorite photographers, such as Horst P. Horst, or little-known artists, such as Elmer Batters. Sebastião Salgado is a favorite because his work is so biblical, and I feel he captures the true essence of the people in his

pictures, which are about the people he is photographing, not him. I like Alex Webb. Raoul Dufy and Edward Hopper are among my favorite painters. I like the music of John Coltrane, Nina Simone, Miles Davis, and Henryk Górecki—really all—from Jay Z to Virginia Rodriguez.

I bore easily. I want to find something new, inspired, and courageous—not things I have seen before but things I haven't seen before.

What are your other interests outside of photography?

Film (foreign and film noir); music; art. On some days I dance. Reading.

How do you keep your work evolving while maintaining your personal vision?

My personal vision takes the upper hand when on assignment or documenting something, but I'm always looking to expand it. I don't like making the same kinds of pictures, even though that's why people hire you, for your personal style. I think it can trap you or limit you. I go out on a branch to try new things all the time. Some things work, others don't; but I think it's critical to take risks. We so often get pegged for our style; we are defined by it. Lately I've reached the point where I'm trying to break out of that style. Sometimes it causes me confusion, yet at the same time, it's very exciting. We have to keep growing, taking risks, and trying new things, because otherwise

we just repeat what we have done; at some point it becomes stale.

What do you do when things are not going well?

That's a good question and not easy to answer. I stop, take a deep breath, and dive in, trying different angles, collaborating more with a subject (for a portrait) to see what their ideas are, change scenes, going somewhere different. Sometimes no matter what you do, you can't make it better. I often go away for a few minutes and have a good talk with myself, because an interesting picture must be in there somewhere. Some days you just don't make good pictures, but that usually fuels the fire for the next day!

How do you process critique —how do you know when to listen to others and when to disregard?

Not everyone is going to like your work. Lots of people won't get it, and many people who have seen a ton of photos are harder to impress (picture editors, art directors).

Anyone who puts your work down hard is sometimes doing you the biggest favor—it makes you take a good, hard look at your work and consider whether you have brought something new to the story. Take the comments into consideration, and decide to let go of anything that stops you. Learn from the experience.

Does your process differ when making work for a client?

My process always changes, though I try to make my own work when working for someone else. Clients usually want something specific, but within those topics or ideas, you can play, take some risks, try new things, and explore a bit more. Some clients encourage you to explore, and those are the best assignments. In both controlled situations and out-of-control situations, some quirky things are going to happen that could be interesting. However, I also give the client what they need and want—just seen and photographed by me.

How do you find the people you work with? What qualities do you look for when finding a muse or selecting a team?

Trial and error. I look for people I like, who are accessible, and of like minds. I use word-of-mouth recommendations. I don't use many assistants, but when I do, I try to make it a teaching experience unless I need a real professional assistant. Don't hire friends; hire people who know how to make you look your best as a photographer.

What do you always have with you while shooting?

A light meter (old school, just in case), my iPhone for pictures and videos, and a list of ideas that I want to try. When I am confused, the list can put me back on track. I try to go light on equipment.

Any other advice?

If you want to be a

professional photographer, learn the business. I'm amazed by how many photographers I meet who, for example, want to work for magazines, but they don't buy the magazines, they don't know the magazines, they don't know the names of the picture editors, and they don't have any idea how to show their work or what to show. Go to the newsstands and look at the magazines you want to work for. Learn about them. What kinds of photos are they using? What stories are they doing? Look at magazines that are regional or that aren't mainstream.

To make it in the editorial world today, do a long-term project(s) on whatever moves you. In a project, a picture editor can tell how you tell a story, how you think about pictures opportunity-wise, how people respond to you. Build a project by going back again and again and always with ideas that expand the story. Do research! Look at work that has been done on the same subject—what can you do that is different? Do a project really well first, something that is different from what others have already done. Be original and think about how to tie it all into a larger picture.

(Previous Spread)
ANNIE WITH MIRROR
Courtesy of Maggie Steber

SLEEPING BEAUTY
Courtesy of Maggie Steber

ARTIST INFORMATION

Photographer Maggie Steber has worked in 64 countries, focusing on humanitarian, cultural, and social stories.

Her honors include the Leica Medal of Excellence; awards from the World Press Photo Foundation, Overseas Press Club, and Pictures of the Year; Medal of Honor for Distinguished Service to Journalism from the University of Missouri; Alicia Patterson and Ernst Haas Grants; and a Knight Foundation grant for the New American Newspaper project.

For over three decades, Steber has worked in Haiti. Aperture published her monograph, *Dancing On Fire*. In 2013 Steber was named as one of eleven Women of Vision by *National Geographic* magazine, publishing a book and touring an exhibition in five American cities. Steber has served as a *Newsweek* magazine contract photographer and as the Asst. Managing Editor of Photography and Features at *The Miami Herald*, overseeing staff projects that won the paper a Pulitzer and two finalist recognitions. Her work is included in the Library of Congress, The Richter Library, and in private collections. She has exhibited internationally. Clients include *National Geographic* magazine, *The New York Times Magazine, Smithsonian Magazine,* AARP, *The Guardian*, and *GEO* magazine, among others. Steber teaches workshops internationally, including at the World Press Joop Swart Masterclass, the International Center of Photography, Foundry Workshops, and the OBSCURA Festival of Photography.

maggiesteber.com
@maggiesteber

ROGER BALLEN

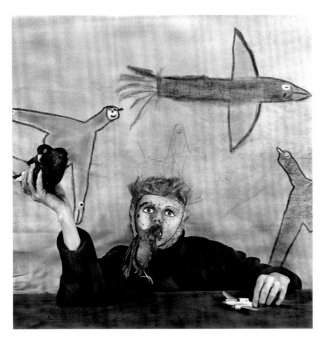

Why do you make pictures?

I make photographs to define the person that is referred to as Roger Ballen. It's my hope that my photographs will allow viewers to expand their knowledge of their core psyches.

What are some of the important themes in your work? Are there concepts that you consistently revisit?

I have been taking photographs for nearly 50 years, and my work has continually transformed itself. My work is fundamentally psychological and focuses on key aspects of the human condition, namely our inability to

control chaos or the future and to resolve our own identity.

In much of my work, I reflect on the relationships between human and animal, which I believe are fundamentally hostile.

Describe your creative process.

It's impossible to fathom how my mind creates. The concept of mind is one of the most enigmatic questions that I'm pondering, which is reflected in my most recent video, *Roger Ballen's Theatre of the Mind,* that I created recently in Sydney, Australia.

How similar are the final images you create to the initial ideas?

I go to a photographic shoot with a quiet mind and leave with a quiet mind. I would like to see myself like a sleeping cat that is awakened by the passing of a mouse; once I arrive at my destination, I become alert.

What are your personal characteristics that enable/ help you to make your work?

I'm disciplined, focused, hardworking, and passionate.

Do you have any places you visit or rituals to maintain your inspiration?

I do not work with inspiration. At certain times my best photographs were created when I did not feel well or when I felt unfocused.

Who are your favorite artists?

I do not have any favorite artists, although there are hundreds that I feel compatible with. If I had to choose my favorites, they might be the traditional artists from Papua New Guinea, Africa, or even those who were declared insane.

What are your other interests outside of photography?

I enjoy hiking and diving.

How do you keep your work evolving while maintaining your personal vision?

I do not concern myself with

this; there is no substitute for going out and continually taking photographs.

What do you do when things are not going well?

Nothing. I operate the same as when things are going well.

How do you process critique —how do you know when to listen to others and when to disregard?

I know in a matter of seconds whether the person I'm communicating with has something to say that bears what I might refer to as the truth.

How do you find the people you work with? What qualities do you look for when finding a muse or selecting a team?

For the past 30 years, I have been working solely with people and places on the margins of society. I have no specific ways to find the people I might work with, because it's a matter of chemistry as well as practicality.

Any practical production advice?

It has taken me decades to develop an aesthetic that is separate from anyone else that I know in photography. I must be in touch with my inner self and find the means to express this through the external world that is an integral part of photography. An assignment that I often give students is: Close your eyes, turn your eyeballs around, photograph what you see.

What do you always have with you while shooting?

Roger Ballen is with Roger Ballen and his camera.

ARTIST INFORMATION

Roger Ballen is one of the most notable photographers of his generation. He was born in New York in 1950, and for over 30 years he has lived and worked in South Africa.

His distinctive style of photography has evolved through the use of a simple square format in stark black and white. In earlier works, his connection to the tradition of documentary photography is clear, but through the 1990s he developed a style described as "documentary fiction." After 2000, the people he first discovered and documented living on the margins of South African society increasingly became a cast of actors, working with Ballen in the series *Outland and Shadow Chamber.*

The line between fantasy and reality in his more recent series *Boarding House and Asylum of the Birds* (Thames & Hudson, 2014) has become increasingly blurred, and he has employed drawing, painting, collage, and sculptural techniques to create elaborate sets. Ballen has invented a new hybrid aesthetic in these works but one still rooted firmly in photography.

His most recent film is the short psychological thriller, *Roger Ballen's Theatre of the Mind,* completed while exhibiting at the Sydney College of Arts, Australia.

The drawn line in his oeuvre was explored in the exhibition Lines, Marks, and Drawings: Through the Lens of Roger Ballen at the Smithsonian National Museum of African Art in Washington, D.C. (2013). Other recent exhibitions have taken place in Berlin, Germany; New York, United States; Oaxaca, Mexico; and Cape Town, South Africa.

Thames & Hudson recently published Roger Ballen's latest book, titled *The Theatre of Apparitions,* which was released with an accompanying video.

rogerballen.com
@rogerballen

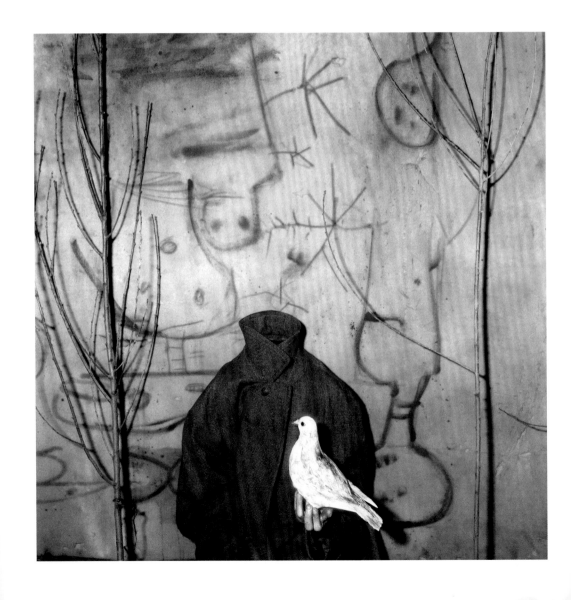

(Previous Spread)
Take Off, 2012

(Left)
Headless, 2006

(Right)
Ethereal, 2011

Images courtesy of Roger Ballen

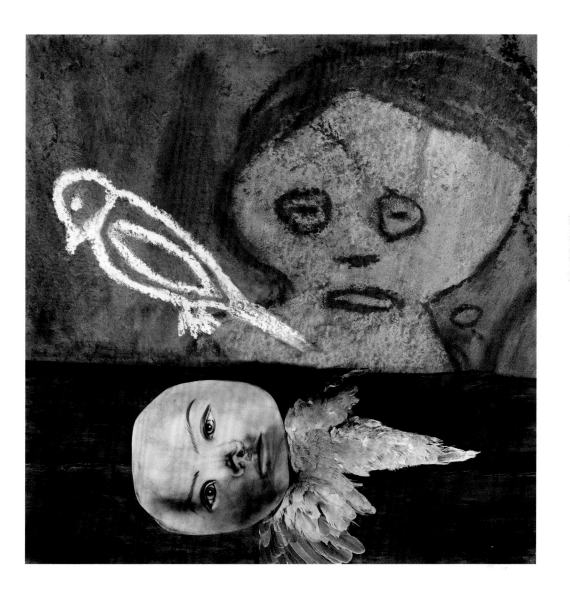

SARA LANDO

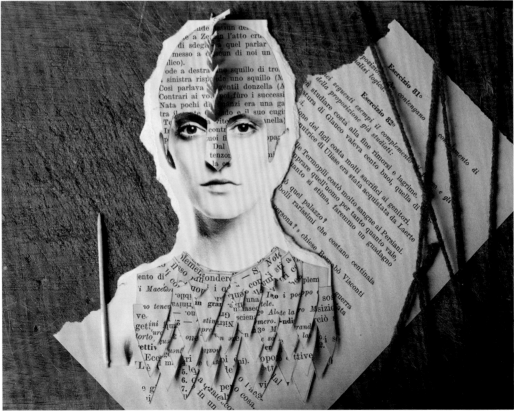

Why do you make pictures?

I make pictures in exchange for money—it's what pays my bills. However, I also make pictures because there are images stuck in my head and if I don't take them out, it feels like not scratching when it really itches. I can ignore it only for so long before my brain goes back to it, with more intensity, and drives me crazy.

When it's my commercial work, I'm solving my client's communication problems, and I want to make sure the viewer will perceive whatever my client needs them to perceive.

For my personal work, it's different. I believe most people will find it visually weird, or interesting, or meh, but a few people will feel something resonate inside them, and that will be like throwing a rope in a well to help something personal come to the surface.

What are some of the important themes in your work?

I'm obsessed with identity and memory, with how the passage of time shapes both. How do you know you're still the same person you were yesterday? Or 20 years ago? How do you know where "you" stops and "not you" begins? Can something be real but not true, and vice versa?

Describe your creative process.

I absorb random stuff as much as I can, take notes, forget about them. I daydream a lot. If you let ideas brew in a dark and humid environment, something might sprout. This part, I hate. I feel like nothing is moving, I become desperate. I feel like I'm barren. It's so frustrating.

I like to use things for different purposes than what they were meant for, mix media, experiment lazily while I'm alone, and get rid of everything that doesn't work until something interesting happens; and then I become obsessed and start to speed up the process until it usually becomes a frenzy; and I forget to stop until I'm exhausted and happy.

And then it's back to stillness again. You'd think I would have learned that it's part of the process, but I haven't. I still wonder if I still have new ideas in me, or if I'm just done.

What are your personal characteristics that enable/ help you to make your work?

I'm not very talented, but I'm relentless. I can work very long hours for a very long time, so when most people might give up because something is not working, I keep going until it does. I'm also extremely curious, and I'm never bored.

The other thing I have that allows me to be who I am as an artist is a support system of people who have known me forever, love me for who I am, and are there where I need emotional shelter: my family, my husband, my close friends. I know people who have way more talent and way more means than me but have no one in their corner, and that is crushing in the long run.

Do you have any places you visit or rituals to maintain your inspiration?

My bed is the first one that comes to mind. The moment before I fall asleep is where most of my ideas happen.

I also like being surrounded by trees: I'm lucky enough to live near the mountains, and walking in the woods is the fastest way to clear my head.

If I'm in a rut, I find out what's going on in Venice or Milan and go to an exhibition, preferably something that has nothing to do with photography.

Who are your favorite artists?

Francesca Woodman, Sarah Moon, Paolo Roversi, Sophie Calle, Jenny Saville, Gian Lorenzo Bernini, Hieronymus Bosch, Egon Schiele, Jenny Holzer, Cornelia Konrads, and some of Marina Abramović's performances are the first that come to mind. But I could go on for days and add illustrators, graphic designers, artisans, musicians, dancers, and more.

What are your other interests outside of photography?

I'm an avid reader. I love watching movies. I sew (my dad is a retired upholsterer, so I grew up surrounded by fabric). I run and practice yoga. I speak to old people while queuing at the post office. I love comic books

and graphic novels. I suck at calligraphy but still practice it.

How do you keep your work evolving while maintaining your personal vision?

I follow my obsessions and forget about style. I feel photography is a language, and how I say something depends on what I want to say and who I'm talking to. It would be insane to keep using the same tone for every conversation. Personal vision is just my voice. I don't have to worry about that, it's just there: How often do you worry about using your voice while you are speaking (unless you have laryngitis)?

What do you do when things are not going well?

I curl up in my husband's arm, watch *My Neighbor Totoro*, drink tea, give myself a little bit of time to despair and cry...until I find myself a little ridiculous. Then I sit down, break it down to smaller pieces, and figure out a way to make it work. Then I work until I'm out of the ditch.

How do you process critique—how do you know when to listen to others and when to disregard?

I appreciate feedback but had to learn that because someone has an opinion doesn't mean I'm required to change what I do according to it.

I have a piece of paper with eight names written on it. These are my people, and only two of them are

photographers. If they say that something I did disappointed them, I come to a screeching halt and figure out if I lost my compass. I need those eight people so that I don't become complacent and blind to my weaknesses. I know those people will be honest with me and that their honesty will come from a place of love.

If anybody else critiques my work, I thank them for their time, figure out if something they say might be useful to me, ignore the rest, and go back to doing what I want to do.

Does your process differ when making work for a client?

Absolutely.

In commercial photography, you are given a brief, and you deliver what is asked of you. It's not about you and what you like, but about the client, the budget, the deadline. You still need to have a clear voice, but there's a team of people counting on you not to drop the ball.

My personal work is done by myself, avoiding big productions, and more experimental. I have self-imposed limitations (nothing kills creativity like the lack of boundaries).

How do you find the people you work with? What qualities do you look for when finding a muse or selecting a team?

I meet people on commercial photo shoots or find them on the Internet, or I work with friends who become collaborators. I

work with people I like having around, and I tend to work with the same bunch of people. I don't care how talented you are: If you're a jerk, I'm not interested in working with you; it makes everybody miserable; it makes me miserable, and life is too short. I like people who are enthusiastic about what they do and who bring something to the table. I try to surround myself with people who are better than I am.

Any practical production advice?

Be assertive (think of yourself as a director or a pirate captain), do your homework, make sure everyone's on schedule.

I like to share mood boards with everyone working on a project to make sure they have the references clear.

Take advantage of technology (Evernote, Shared Google Docs, Basecamp), but don't shy away from old-school "meeting for coffee and talking."

Respect other people's work, and don't just expect they'll love to work for free. Feed people working for you (hungry people tend to be grumpy and not willing to do their best).

Ask. I found that a lot of times we assume people will say no to us, so we don't even ask: I've shot inside 1,790 theaters, just by asking nicely.

What do you always have with you while shooting?

Black gaffer tape, zip ties, a white plastic bag, roasted almonds.

ARTIST INFORMATION

Sara Lando is an Italian photographer specializing in portrait, beauty, and commercial photography... and playing with cardboard. Her work combines exquisite lighting, extreme creativity, and experimental techniques—blurring the lines between photography and fine art.

saralando.com
magpiestale.com
@holeinthefabric

GABRIELA IANCU

Why do you make pictures?

I'm interested in exploring the origin and evolution of life on Earth, through food's history, symbol, and form. I construct photographic still lifes to create a sense of time— a time that was before, now, and after existence. I hope to reconnect to what we have lost with nature and traditional knowledge about food. I investigate the primitive origin from which food takes form— the earth. I aim to unite culture and nature and document these expressions— as earth, a collective memory of transformation, and existence.

Describe your creative process.

I immerse myself in the idea, then I research it—self-initiated learning allows me to grow creatively. The process and the idea are equally important to me. I use objects to construct new meanings. Sometimes the process is intense, other times I relax and allow my unconscious to naturally create connections between ideas and solve problems. I don't force my ideas, I let the connections in my head and the ideas align. This creative energy helps me decide on the practical aspects of the project, too—such as the props I'll use (their traits, placement, lighting), which are stylistic and symbolic. I open myself up to everything around me emotionally,

mentally, and visually.

As inspiration, I turn to natural history, geology, geometry, painting, and cognitive studies to examine the origins of food and habits, the mental landscape, and the traditional culture. The archetype is important to me; it's a universal representation of form inherited from our ancestors. My interest expands from isolated powerful organic forms to symbolic shapes and processes that preserve something primordial.

How similar are the final images you create to the initial idea?

I allow myself a degree of experimentation in each project, but the outcome is typically very similar to what I originally had in mind. Although I like to know as much as possible about my idea, there will always be problems to solve when bringing ideal images to life.

What are your personal characteristics that enable/ help you to make your work?

I believe I can make my ideas happen and am very passionate. I have a lot of creative energy. I invest in learning. I also work on two projects at the same time, which allows me to return with a fresh set of eyes on one project if I encounter a

creative block on the other project or simply need a break. I like to recover and discover new creative outlets for my ideas, get exploitative (creatively speaking), and am persistent when ideas are resistant.

Do you have any places you visit or rituals to maintain your inspiration?

I'm a very active creative. I like the process of getting to "there." I invest time in learning and working with motion and visual design, which complement both my self-expression and my photographic practice. If I'm experiencing a creative block, I return to what has interested me in the past. Reading, listening to music, and watching documentaries on topics of interest trigger my inspiration.

Who are your favorite artists?

Laura Letinsky, Margriet Smulders, Barbara Kruger, Oscar Munoz, Anna Williams, Gentl & Hyers, Julia Hetta.

What are your other interests outside of photography?

Video editing, motion design, magazine and book design, sculpture, music, films.

What do you do when things are not going well?

I try keeping my creative

fantasy alive with improvisational ideas that don't need to become anything at all, until I reach that creative dialogue with myself again. If I have a slow time with business and I'm bursting with ideas, I'll start working on a personal project and continuously promote my work.

How do you process critique —how do you know when to listen to others and when to disregard?

I'm always listening and analyzing what others have to say about my work. This doesn't mean that their observations always apply. When it's appropriate, I try to incorporate feedback I receive to make my work better. Although I'm open to improvements, I want critique to motivate me to look for the things that better highlight my work. Therefore, I see the critique as a way to better understand the qualities of my work. I'm using both intuition and intellect to make an informed decision without forgetting that we're all constantly learning.

Does your process differ when making work for a client?

I have the same excitement, passion, and devotion for all projects. In commercial projects, the client comes with a particular vision and specific requirements. Therefore, the creative process might be less permissive. The selling point comes first, and there is no room to change the story. But as an artist you have to adapt. The restrictions

provide a creative challenge. In an editorial project, the client comes to me for my specific style, giving me a free hand to approach the story creatively. This creative process is similar to my personal projects. In all cases, I start with research on the client, their story or product, a mood board, and a list of props and suggestions. When making work for myself, I follow the same process, but I'm the art director and editor. The trigger is a personal experience or interest based on my artistic practice.

What do you always have with you while shooting?

A mood board, a reflector, and a tripod.

ARTIST INFORMATION

Romanian-born Gabriela Iancu is a multidisciplinary visual artist, focusing on photography, film production, and design. Her work addresses food and the natural environment from various historical perspectives. Gabriela graduated from the Savannah College of Art and Design in 2015 with a Master of Fine Arts in Photography. Gabriela is the founder and editor-in-chief of *Florilegium Magazine*, which explores contemporary visual media to cultivate the role of art in everyday life. Gabriela was awarded a Graduate Fellowship and Student Success Grant by SCAD and was included in the 57th Communication Arts Photography Annual.

gabrielaiancu.com
florilegium-magazine.com

Florilegium magazine

Gabriela is the founder and editor-in-chief of *Florilegium* magazine.

(Following Spread)

(Right)
RASPBERRIES (Expressions Around the Table)

(Left)
FRUGAL FEAST (Dor)

Images courtesy of Gabriela Iancu

ROBIN SCHWARTZ

control the shoot, my results are not as exciting for me.

What are your personal characteristics that enable/ help you to make your work?

I belong to a tribe of like-minded, animal people. This universal "tribe" connection and my prior photography projects earn me access and trust. Sometimes I think my lack of confidence helps me relate to people, but it can also hinder me.

Do you have any places you visit or rituals to maintain your inspiration?

I had been a regular visitor to the Metropolitan Museum of Art when my daughter was younger. This exposure influenced my work. These days I'm digital and find inspiration on the Internet.

Who are your favorite artists?

This is always a challenge to answer and to remember the eclectic mix of painters, illustrators, and photographers who inspire me—I grab inspiration wherever I can.

Photographers such as August Sander, Sally Mann, Diane Arbus, Mary Ellen Mark, Dorothea Lange, Helen Levitt, Eugène Atget, W. Eugene Smith, Sebastião Salgado, Erika Larsen, and painters such as Mark Ryden, Henri Rousseau, Margaret

Why do you make pictures?

My picture "making" has been a lifelong process that makes me happy. I'm inspired by my fantasy dreams and my need to memorialize my subjects and experiences.

I hope viewers consider that animals and people are fundamentally the same, both with relationships and feelings.

What are some of the important themes in your work?

Photography is an extension of drawings and paintings that I made as a child of the subjects I love and the artists I admire. My drive to represent animals and their relationships with people has been constant. As a child, I drew, painted, and photographed specific animals, sometimes with

girls. Unfortunately, I had to depart from my passion in college, but found myself again in graduate school.

Describe your creative process.

Photography and historical paintings ranging from medieval, Renaissance, and Impressionist periods, as well as contemporary art, inspire my work. I figure out how to apply the art I admire into my own photography with my own subjects.

How similar are the final images you create to your initial ideas?

My more meaningful results are always a surprise. My subjects are unpredictable, so I must go with the flow. A spontaneous element usually makes for a better image. When I attempt to

Keane, medieval paintings of the Virgin Mary, Vermeer for the light—as every photographer mentions—and a range of formal painted portraiture inspire me. There are so many more.

What are your other interests outside of photography?

My life and time overlap my photography because of my obsession with animal subjects. As a mother and a full-time professor of photography, my time has been a juggling act of demanding responsibilities. My students have sparked my ideas. As I said before, I will take inspiration wherever I can. I find events where I can watch animals, be it with friends or at organized activities such as lure coursing or animal fashion shows. I read a great deal and used to collect children's books.

Recently, I have readdressed an older photography project for my sabbatical year, photographing in Mexico indigenous Huichol artists and their families and communities.

How do you keep your work evolving while maintaining your personal vision?

Being true to what I'm obsessed with is my answer to what to do, to photograph what I care about, whether it's successful or not. I was waylaid in college by being embarrassed about what I loved. My professor in graduate school guided me back to photographing what I cared about, back to animals.

What do you do when things are not going well?

Things can always be better. I'm working on being part of a community in photography now. Working and being productive always makes me feel better, but my life is not my own. I have regretted giving up on an important project, because I did not know how to manage the opinions of others. Now, I work at not being derailed by others' judgments and my own lack of confidence. It's important to keep on going.

Does your process differ when making work for a client?

I have more of an adrenaline rush working for a client—my editor. I'm wired up by fear and work much harder, pulling out all I can think of until time is up. Fear of failure is a huge motivator to do everything I can think of beyond what was asked for.

Any practical production advice?

I kick myself each time I go on a shoot, as I have often forgotten something. I have procrastinated making a packing list and studio check-off list. Gentle persistence has gotten me through the disappointment of canceled and rescheduled shoot dates.

It's invaluable to have a photo community to ask questions of and share.

What do you always have with you while shooting?

Usually I bring gifts for my subjects.

ARTIST INFORMATION

Robin Schwartz is a 2016 Guggenheim Fellow. Her photographs are in the permanent collections of the Metropolitan Museum of Art, Museum of Modern Art, and Smithsonian American Art Museum, among others. Aperture published Schwartz's fourth monograph, *Amelia & the Animals.*

Schwartz's photographs have been published in *The New York Times Magazine, TIME LightBox, The New Yorker, The Oprah Magazine, Stern, The Telegraph, The Guardian,* and *Photography Speaks: 150 Photographers on Their Art*, published by the Aperture Foundation and The Chrysler Museum of Art (2004). Schwartz created and edited *National Geographic* magazine's "Your Shot" assignment, "The Animals We Love," and based on this assignment wrote a chapter in the book, *National Geographic: Getting Your Shot* (2015).

She has presented Master Talks at the National Geographic Photography Magazine Seminar, LOOK3 Festival of the Photograph, The Eddie Adams Workshop, Aperture Foundation, FotoDC, and The Chrysler Museum of Art.

Robin Schwartz is an Associate Professor in Photography at William Paterson University of New Jersey and has taught at The International Center of Photography in New York.

RobinSchwartz.net
@robin_schwartz

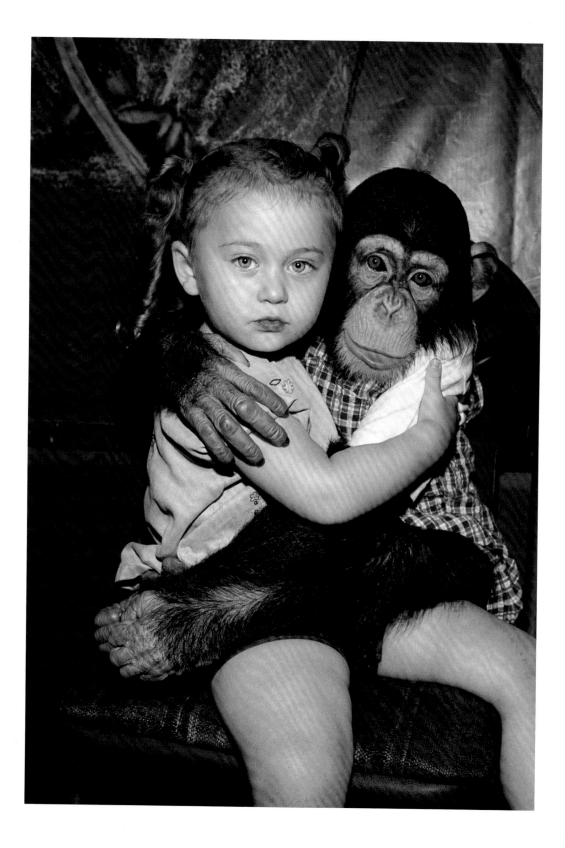

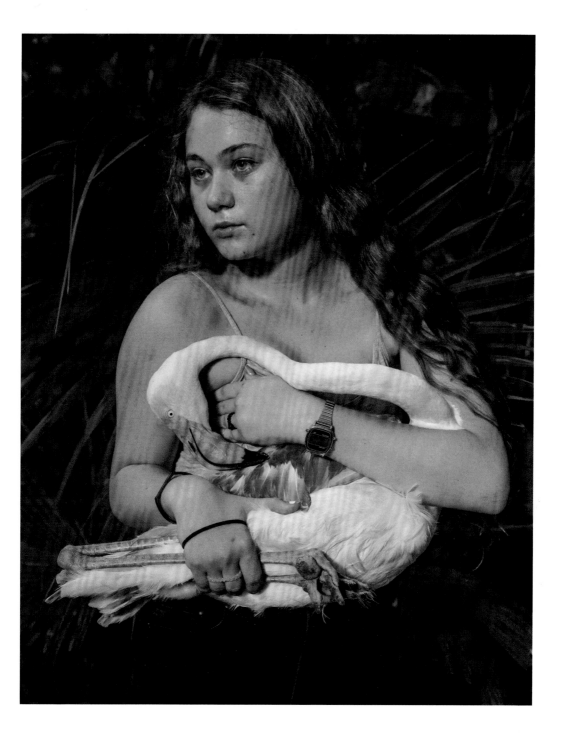

(Previous Spread)
GREYHOUND HAIR DOORS (2010)
Courtesy of Robin Schwartz

AMELIA AND RICKY (2002)
Courtesy of Robin Schwartz

FRANK FLAMINGO (2014)
Courtesy of Robin Schwartz

ELEANOR MACNAIR

Why do you make pictures?

My project was never intentional. I've spent my professional life looking at other people's pictures while working in press departments of museums, galleries, and for publishers. I think that *Photographs Rendered in Play-Doh* is a way of communicating all that I've seen and discovered over the years. My hope is to lead others to discover the photographs and the photographers I admire. Working in press, you don't really have a voice—you are a channel for other people's ideas, and *Photographs Rendered in Play-Doh* is a continuation of this.

Describe your creative process.

I hoard image files gleaned from the Internet—from online photography magazines, museum websites, and dozens of other sources. I draw from this hoard for the photographs that I remake in Play-Doh. I work late at night in my living room with amateur tools: a chopping board, a scalpel, and an empty wine bottle as a rolling pin. I select the colors when I start the photograph so that they work well together and then work backward from the background to the figures— much like painting. It's like trying to solve a problem, simplifying the images to

the simplest form that will express the original photograph. I then shoot the models in natural light in the morning, trying to reproduce the light and shadow from the original photograph. Play-Doh dries and spoils very easily, so I have to work on a small scale (around A4 size), and because it's so delicate, showing every fingerprint, I'm only able to spend limited time, a few hours, on each image I remake. After I have shot the models, I return the Play-Doh to the respective color pots, making it a disposable art project—similar to how we view images on the Internet and quickly move on.

How similar are the final images you create to the initial ideas?

I never know what the finished images will look like, which is in some ways very liberating and frees me from expectations for the final image. Each model I make is a surprise.

What are your personal characteristics that enable/ help you to make your work?

Bloody mindedness, curiosity, and too much spare time.

Do you have any places you visit or rituals to maintain your inspiration?

I'm inspired by exploring the Internet—like Alice down the rabbit hole.

Who are your favorite artists?

I have so many favorite artist photographers: Joseph Szabo, Colin Jones, William Eggleston, Clare Strand, Masahisa Fukase, Maude Schuyler Clay, Mary Ellen Mark, Judith Joy Ross, Robert Frank, Chris Killip, Alessandra Sanguinetti, Ed Van Der Elsken, Gordon Parks, Eikoh Hosoe, Will McBride, Seydou Keïta, Sarah Moon, August Sander, Alec Soth, Diane Arbus, Shōmei Tomatsu, Emmet Gowin, Malick Sidibé. The list is endless and constantly expanding.

What are your other interests outside of photography?

I've always done ballet, since I was four. I think that perhaps the discipline and determination learned from this is somehow translated into my working practice.

How do you keep your work evolving while maintaining your personal vision?

I jump back and forth in time and subject matter to keep my source images diverse. I'm constantly trying to surprise the audience and myself. I'm keen to keep my process as amateur as possible, but I'm always

refining the details in my images—how I make the eyes, the flow of fabric, the sky, and gestures of the hand.

What do you do when things are not going well?

Things are usually not going well at 2 a.m. in the morning when I'm cutting out 40 Play-Doh leaves and wondering what on earth I'm doing with my life. When this happens, I think of the battle scene in *Braveheart* (the film), where William Wallace tells his army to hold in the face of the galloping English cavalry...and I hang on until I shoot the model in the morning, because the works often look very different in the cold light of day.

How do you process critique —how do you know when to listen to others and when to disregard?

I have received feedback that my work lacks value and is flippant—but that is kind of the point of the whole project. When I hear this, I think I must be doing something right.

Does your process differ when making work for a client?

I think that clients have a certain idea of what I will produce, and usually the result is something completely different—a surprise to us both. I quite like commissions, because they give new constraints to work within, and allow me to be creative within them —like solving a problem with limited means.

Any practical production advice?

Finding white, black, or brown Play-Doh is surprisingly difficult. I only mix the flesh colors in my images, because I like keeping the ready-made Duchampian aspect of off-the-shelf Play-Doh. My advice is if you are out and about and see the colors you need, buy them. Frantically scouring London and the Internet for pots of white Play-Doh is not the ideal situation.

What do you always have with you while shooting?

A glass of water and music.

ARTIST INFORMATION

Eleanor Macnair began *Photographs Rendered in Play-Doh* in August 2013, and the project was published in book form by MacDonaldStrand/Photomonitor in October 2014. The book, featured in *The Observer's* "Best Photography Books of 2015," was described as "sublimely post-modern." The project was first exhibited at Atlas Gallery (London) in autumn 2015, followed by Kleinschmidt Fine Photographs (Wiesbaden, Germany) and Kopeikin Gallery (Los Angeles) in the spring of 2016. *Photographs Rendered in Play-Doh* has also been featured on the Instagram blog and in *Observer Magazine, The Guardian Online, The Telegraph's Seven Magazine, PDN Online, BBC Online, Hyperallergic, The Huffington Post, AnOther.com, Elephant Magazine, Art Info, El País, It's Nice That, Feature Shoot,*

Independent Review, The Creators Project, Los Angeles Times, and Design Week, among others.

eleanormacnair.com
@eleanormacnair

CONTRIBUTOR BIOGRAPHIES

BETH TAUBNER

Founder of Mercurylab, Beth Taubner has been a Brand Strategist and Creative Director working with strategy and creative communications for over 20 years. Beth has developed a proprietary approach to branding, using a combination of psychological, visual, and analytic processes. Her clients have ranged from well-known American brands such as A&E and Miramax Films to UK-based The Well-Fed Cuckoo, Condé Nast publications, *Newsweek International*, and retailers such as online fashion powerhouse Moda Operandi. She works on branding programs with esteemed artist representatives such as UK- and US-based Sarah Laird & Good Company and Début Art, and US-based agencies Kate Ryan and Apostrophe. She also works closely on brand identification, language communications, creative direction, visual development, and marketing with some of the top photographers in the world. Beth offers one-on-one consulting and coaching, and business consulting on brand and creative development and implementation worldwide.

ALESSIA GLAVIANO

Alessia Glaviano is the Senior Photo Editor for *Vogue Italia* and *L'Uomo Vogue*, and Web Editor of *Vogue.it*. In addition, she is the Artistic Director of events and exhibitions for *Vogue Italia* and *L'Uomo Vogue* at Condé Nast. Her interview series *Masters of Photography* for *Vogue Italia* online has acquired enormous popularity among the photographic community and is broadcast on the Italian Sky Arte channel.

Glaviano is the founder of Photo Vogue, an innovative platform where users from all over the world can share their photographs under the curatorial supervision of professional photo editors. Photo Vogue has reached over 120,000 users and launched a collaboration with the prestigious international agency, Art+Commerce, which represents some of the most esteemed names in fashion photography, including Steven Meisel, Sølve Sundsbø, Paolo Roversi, and Patrick Demarchelier.

Glaviano is a regular guest speaker at lectures and conferences for various institutes and universities such as IED, Bocconi

University and the Milan Polytechnic. She teaches IED's Master
courses in Milan. She has participated as a jury member in
numerous internationally acclaimed photography contests,
including the World Press Photo Contest, and in several
portfolio review sessions, including The New York Portfolio
Review, sponsored by *The New York Times Lens* blog.

REBECCA MANSON

Becci creates images. Some of her earliest memories from
England involve concocting something on paper. From
crayons, pencils, paints, and silk screens, this passion has
evolved to cameras and Photoshop.

For over 20 years, Becci has worked in London, Amsterdam, New
York, and Los Angeles as a sought-out digital retoucher for the
industry's leading photographers: Mark Seliger, Christopher
Griffith, Annie Leibovitz, and Rankin; and with the top
advertising agencies, including Droga5, 72andSunny, and BBDO
to create campaigns for household brands like Apple,
Samsung, Puma, and Toyota, in addition to editorial work
with magazines and newspapers.

When she is not working on high-end commissions, Becci turns
her retouching skills toward humanitarian projects, most
notably in Northeast Japan, after the devastating 2011 earthquake
and tsunami. Becci organized a worldwide network of remote
retouching volunteers and an army of locally based unskilled
volunteers that cleaned and restored damaged family photos
for victims of the natural disaster. Today her program has
been emulated in several disaster areas.

SPECIAL THANKS

This book would not have been possible without Lillie Rosen and Monica Kass Rogers.

ACKNOWLEDGMENTS

There are countless people who have supported my work, influenced my way of thinking, challenged and inspired me, exposed me to ideas or experiences, and/or connected me to important opportunities. My family—Mom and Dad, Lillie, Natalie, Charlotte, Camille, and Uncle Bob. Ron Haviv, the Big Apple Circus—Barry Lubin, Savannah College of Art & Design (SCAD)—Paula Wallace, Steve and Heidi Aishman, Tom Fischer, Craig Stevens, Steve Bliss, Travis Dodd, Alexandra Sachs, Lisa Micele, Bard College at Simon's Rock, Maine Media Workshops—Joyce Tenneson, Cig Harvey, Bobbi Lane, Drew Gardner, and Stephen Johnson. J.C. Svec, Eric Dominguez, Andy Foster, Patricia Selden, Pat Bell, Sam Barzilay & Laura Roumanos, Foundry Workshops—Eric Beecroft, Suzie Katz, Maggie Steber, Andrea Bruce, Adriana Zehbrauskas, Kael Alford, Kirsten Luce. Alison Morley, Kim Hubbard, Rebecca Manson, Robin Schwartz, Greg Heisler, Ryan Wilde, Alex Randall, Annie Greenberg, Samantha Adler, Tom Pisano, David Paul Larson, Lindsay Adler, Frances Denny, Nancy Laboz, Emma Mierop, Lily Hodge, Jennifer Burnley, Arlinda McIntosh, Oliver Solomon, Daniel Milnor, Hossein Farmani, Mohamed Somji, Hala Salhi, Lou Lesko, Andy Patrick, Beth Taubner, Mary Virginia Swanson, Debra Weiss, Julie Grahame, Monica Kass Rogers, Holly Hughes, Lauren Wendle, DynaLite—Jim Morton, Peter Poremba, Jason Etzel, liveBooks, and Hahnemühle—Carol Boss, Giorgio and Lisa Baravalle, and Valerie Witte.